ISLAND
JOURNAL
WAYPOINTS 1984–2009

This Island Journal was made possible by Sally Engelhard Pingree and the Charles Engelhard Foundation. Special and deepest thanks are due for their many years of loyal faith, friendship and generous support.

We would like to also acknowledge Frank E. Fowler, Lookout Mountain, Tennessee, and Warren Adelson, New York, for providing additional funds to print extra copies of this issue. This funding is given in memory and honor of their friend, Andrew Wyeth.

Editors: Philip Conkling & David A. Tyler
Art Director: Peter Ralston
Design & Production: Bridget Leavitt
Cartography: Shey Conover

Front Cover Photo: Peter Ralston
Back Cover Photo: Peter Ralston

This *Island Journal* is printed at J. S. McCarthy of Augusta, Maine where 100 percent of all electricity purchases are derived from wind power. *Island Journal* is printed on Chorus Art paper containing 50 percent recycled content including 25 percent post consumer waste. J. S. McCarthy uses highly pigmented non-hazardous vegetable based inks to provide the best quality images, while reducing the environmental impact.

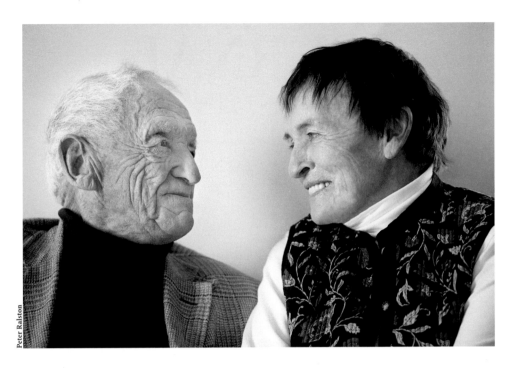

Peter Ralston

BETSY AND ANDREW WYETH

We dedicate this special 25th issue of *Island Journal* to Betsy and Andy Wyeth who were among the first founding members of the Island Institute as well as the inspiration behind *Island Journal*. Their creative vision, which was encoded in the DNA of the first *Island Journal*, and later in *The Working Waterfront*, was grounded in a view of the islands as traditional outposts of a self-sufficient way of life, as opposed to the use of Maine's islands as casual summer playgrounds.

Many of the ideas that shaped the early days of the Institute were hammered out on the stony anvils of Allen and Benner islands, where Andy and Betsy spent much of the last quarter of a century of their lives together. Andy was initially skeptical of Betsy's efforts to reclaim these two islands from the feral landscapes they had become after Allen and Benner's year-round community of 80 had moved ashore a half-century before Betsy bought Allen in 1979. Walt Anderson, Andy's great friend in Port Clyde, used to call Allen Island "Betsy's Folly," to Andy's immense delight.

Andy was attracted to the island's raw, sometimes brutal undercurrents, a view that was usually in dynamic tension with Betsy's more pastoral instincts to settle and tame island landscapes that served

as her "canvases." Island shores, in Andy's paintings, were places of chaotic beauty, where violent seas ravaged the shoreline and pirate lobstermen hauled each other's lobster traps under the cover of darkness. While Betsy built island ponds that attracted migrant waterfowl, Andy painted the predators of island seabirds attracted to those ponds. While Betsy cleared island forests to reestablish an island village, Andy disappeared into their dark interiors to find places where ravens hoarded their secret stashes. It is a testament to their undying love that such titanically opposing views could be contained in the confines of their highly embounded island worlds.

To the extent that the Island Institute was complicit with Betsy's pastoral instincts, the Institute was also subject to Andy's occasional ambivalence. Betsy helped build organizations; Andy avoided them at all costs.

As to their enthusiasm for *Island Journal*, however, they never wavered. They not only supported *Island Journal*'s initial launch 25 years ago with a generous donation that jump-started its production, but they also made it a better publication every year thereafter because we knew their sharp eyes were watching.

ISLAND JOURNAL
WAYPOINTS 1984–2009

TABLE OF CONTENTS

From the Helm

Peter Ralston was a freelance photographer and I was a freelance writer when Betsy Wyeth introduced us on Allen Island in 1980, three years before starting the Island Institute and four years before launching the first *Island Journal,* now 25 years ago.

Peter and I had both come from places where local beauty and local culture had been badly marred by the kind of thoughtless development that had trampled over our connections to places that had been important in our childhoods. We sensed the same would likely happen to Maine's islands if no one did anything about it.

Whatever else we thought we were doing in starting the Island Institute, we chose to organize around the only two tools we had readily at hand: a camera and pen, which is why we decided to launch the Island Institute with a publication, *Island Journal*. We nominated each other as editor and art director because there was no one to object. We recruited George Putz, a gifted writer and lunatic genius from Vinalhaven, as senior editor; Doug Alvord, a graphic artist, to design the first *Island Journal*; and Ted Rodman, whom we borrowed from the Hurricane Island Outward Bound School, to serve as production director.

To say that we were green is to say that the Irish countryside in spring is green. When an article did not fit on a page, we reduced the point size of the text or width of the column to make it fit. We had no real grasp of typography, grid, deadlines, printing costs, distribution or editorial consistency. But we thought we knew good writing when we read it and a good image when we saw one. George Putz picked the cover of the first *Island Journal*, "Sheep in a Dory," the instant he saw it, even though in Peter's mind it was an indifferent photograph.

For that first issue, we also contacted 40 writers to tell us what made Maine's islands meaningful to them and had an overwhelming response from islanders and writers to whom we could offer nothing other than space in the first issue. The section of the first *Island Journal* called "Radio Waves" contained columns from year-round islanders, which presaged *Inter-Island News* and *The Working Waterfront,* launched in 1987 and 1993 respectively. Many of those first voices are still with us: Donna Rogers still writes from Matinicus, Katy Boegel from Monhegan, and Steve Miller from Islesboro. Phil Crossman inherited his writerly voice from his mother, Pat Crossman, one of our original writers from Vinalhaven. Phil's musings initially appeared in *The Working Waterfront*, and later became the basis for his wry essay collection, *Away Happens.*

We believed, as only the young and naive can unblushingly believe, that we knew what made life on Maine islands rare and interesting. We wrote on the first page of *Island Journal*,

"Although we can and do brag about our nesting eagles, the antics of whales and seals and the hundreds of 'deserted' island beaches, it is really the Maine islanders and the resource-based culture on which islanders depend that makes the archipelago wholly unique in the nation."

That sentence remains the core editorial philosophy of *Island Journal*. The "look" of *Island Journal* has always been and remains the view through Peter Ralston's incredible eye,

and he is widely and rightly regarded as the most talented and enduring photographer working on the coast and islands today.

As the 25th anniversary of the first *Island Journal* approached, we began thinking about how to celebrate the milestone. We had already published "the best of," on *Island Journal*'s 20th anniversary. It occurred to us that because we publish *Island Journal* once a year, the articles and images that appear on its pages often represent the early-firing synapses of ideas, many of which ultimately mature into ongoing programs and activities we conduct with our year-round and summer island partners in Maine's 15 island communities and along Maine's 5,000-plus-mile saltwater coastline. As we look back over the past 25 years of *Island Journal*, we see stories from earlier issues as "waypoints" in the journey.

Early articles on island schools grew into today's large scholarship program to benefit island students and a technology education program (CREST) that provides students in remote communities with state-of-the-art tools and training in the context of place-based learning. The stories on working waterfronts grew into the passage of America's first constitutional referendum providing property tax relief for fishing properties along the coast and islands, one of the first community-supported fisheries projects in the United States. Stories written from the perspective of fishermen developed into a successful marketing and branding partnership with a group of conservation-minded Port Clyde fishermen. The focus on islanders struggling to maintain year-round communities grew into the Island Fellows program, in which over 70 recent college graduates with undergraduate or master's degrees have spent up to two years working on local community priorities. The folios highlighting island artists helped spark the Archipelago store and gallery in our Main Street building. Our newest program focuses on how to capture abundant island and offshore wind resources that have remained unexploited since the eclipse of the age of merchant sail a hundred years ago.

There are other examples from past stories that you can read about within these pages.

Today we are still a place where words and images, visions and revisions come together in ideas from countless sources that we help put to work.

We are looking forward to the next 25 years and always appreciate hearing from you.

Philip Conkling

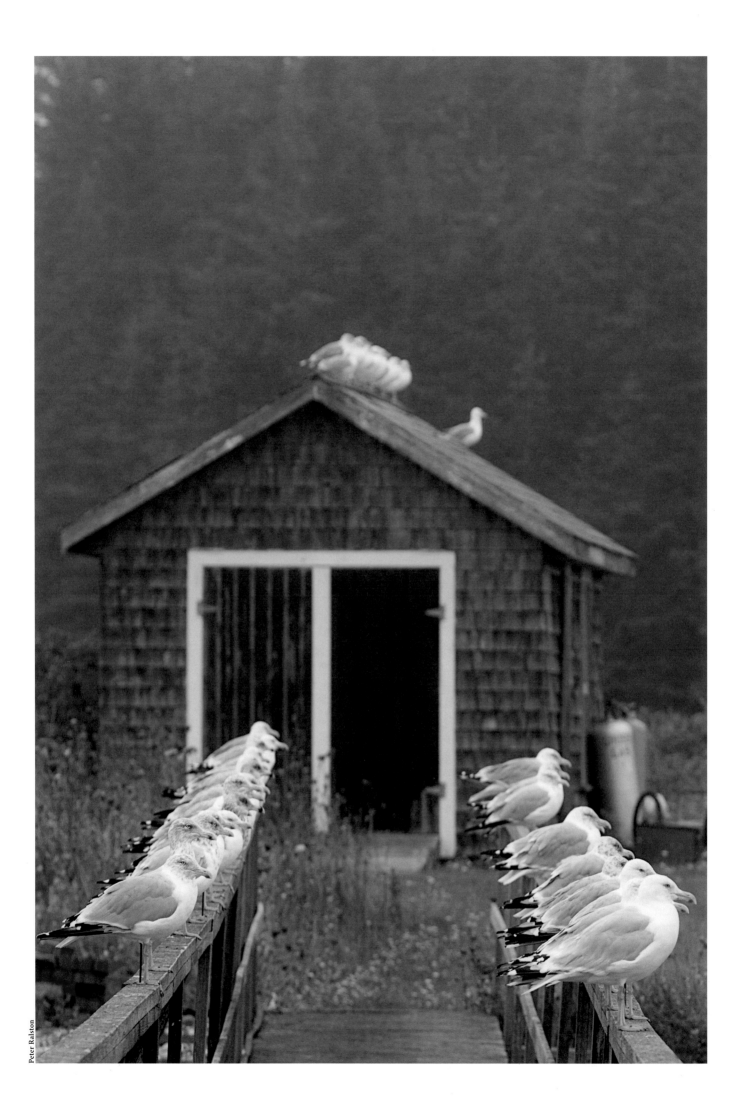

Communities

NANCY McLEOD CARTER

Heaven and hell, so the parable goes, are remarkably similar. Newly departed souls, given only a long-handled spoon, find themselves crowding around a great table in the middle of which is a steaming pot of soup. The spoons work well enough for reaching the pot, but it's impossible to actually maneuver the soup to one's mouth before it spills to the floor. There is, of course, one significant difference between the two final destinations: While the souls Down Below are howling with frustration and battling their fellow diners, those around the table Up Above are using the long spoons to feed each other, and no one is going hungry.

What does this metaphor for interdependence tell us about Maine's 15 year-round island communities? Ask most islanders if they can imagine living anywhere else, and they'll emphatically shake their heads, no. It's not just the islands' rugged beauty or the natural resource–based way of life, they insist. It's also the sense of belonging to a community where people take care of each other.

Islanders' strong commitment to civic engagement and volunteerism has, in fact, created something of a "heaven on earth" on the small, far-flung islands that make up Maine's archipelago. And, while most residents may be reluctant to tell you how many volunteer roles they fill in their community, the odds are good that they wear several hats. Perhaps it's the knowledge that, surrounded by water, they have no one to turn to for help but each other. Maybe it's just a magnified version of small towns everywhere. The truth is that most year-round islanders do much more than just make a living; they make living on their particular island better for everyone.

There's certainly no lack of unpaid jobs in island communities. The web of nonprofit organizations is tightly strung and can be difficult to elude, especially when the opportunities are so plentiful. You can serve on a town governing board, volunteer in the library, or get involved in one of the churches. You can help out in the community center, the school, or at the local history museum—visit the elderly, read to the

young, or practice fire and ambulance drills. The list is enormous, and with so much demand for assistance and such a short supply of people to meet the need, you could hardly blame a person for opting out. Why not just stay home, enjoy the stunning scenery, and leave it up to everybody else to run things?

What's astonishing is that so many island residents choose engagement over indifference, service over self-interest. Even after a long day of hauling traps, herding kindergartners or standing at a cash register, islanders show up to participate in community life. They come out in droves to town meetings, elections, school performances and benefit dinners, pitching in whenever, wherever and however they're needed most.

Alden Robinson, the 2006–2008 Louis B. Cabot Fellow on Long Island in Casco Bay, captured this strong, inclusive spirit of community in writing about his experience:

What's important, and what's so inspiring about the community on Long Island, is that all the opinions and rivalries and past conflicts can evaporate at a moment's notice when necessary. Lifelong antagonists can cooperate flawlessly on a rescue call. The guy who holds a grudge against the planning board can also go out of his way to help the town when it needs to store equipment on his land. Newcomers can work shoulder to shoulder with lifetime islanders on the affordable housing committee, even though they might both be competing for the same piece of land in the future. It's a cliché to say it, but that really is the magic of an island community.

While volunteer requirements may vary from one island community to the next and from one nonprofit to another, all that's really required is a sincere willingness to roll up your sleeves and tackle the job at hand. It doesn't matter much whether you're in high school or newly retired, a descendant of original settlers or a recent arrival "from away," a graduate of the School of Hard Knocks or a PhD. When leaders emerge, as they inevitably do, it's due to the power of their own commitment, not because they have any formal status or title. Everyone simply knows who they are.

Reinventing Islesford's Neighborhood House

Islanders come together to create a new future for a well-loved community center

BILL McGUINNESS

We were on the road making a documentary called *Driving Home*. Sonja and I had set out from New York in June 2002, hoping to rediscover our country on what was supposed to be a yearlong journey around the lower 48. Little did we know that when we pulled our '86 Buick Century, Mama Blue, into the parking lot of the Seawall Campground at Acadia National Park, our days of traveling were numbered, and that we would soon be moving to a small island off the coast.

But that's what we did just two months after first coming to Maine and paying a chance visit to Little Cranberry Island, known locally as Islesford. Standing in the pottery shop on that foggy August day talking with Marian Baker, Cindy Thomas, David Thomas and Lil Alley, listening to them describe life on the island, something happened. We got caught in the magnetic pull that radiates from certain spots on the earth, and we knew that we were going to spend some time there. In October, we loaded our belongings onto the mailboat with the notion of perhaps wintering in Maine and then returning to our travels. Six and a half years later, our road trip and our film still unfinished, Islesford has become our home.

Why have we stayed? There are lots of reasons to live on a Maine island. We love the way of life, the calm pace, the ocean, the air, the sound of the bell buoy. On a land mass smaller than one square mile there are wetlands, forests, and clear views of the mountains, and on any given day you've got them all to yourself. Bald eagles nest on the island, deer abound, blackberries and irises grow wild, and pink granite covers the beaches. However, while the charms of nature have surely worked their magic on us, something else keeps us connected to Islesford. It's what makes the

Sarah Corson

place unique, and what makes it home. It's the amazing community that the island possesses. We knew it that first day and we know it every day we are on the island. We know we are blessed to have found, and to have become part of, such a wonderful group of people.

There's an openness to the Islesford community that gives the place a special feeling. I'd be lying if I said there was none of the wariness with which any small town views newcomers, but by and large, on Islesford it's a warm welcome that greets a strange face. The folks in the pottery shop weren't put off when we mentioned our interest in living on the island; they encouraged us. And over the years, with a combination of curiosity, generosity, and a deep desire to see the population stay strong, others have been similarly encouraged, leading to the growth of a robust, colorful and diverse year-round community. In a population of under 100, you'll find lobstermen and dock workers, caretakers, cleaners, carpenters and contractors, gardeners, cooks and bakers, authors, artists and craftsmen, teachers and students, one librarian, two postal workers, and a trio of town employees; and

in warmer months, when the population swells to over 300, the variety only increases. Each person's life contributes to the life of the island and instills in its character a breadth and depth of experience, enriching the community and inspiring increased openness, so that when your feet hit the town dock on Islesford, you sense the energy of the islanders and feel welcomed by it.

The feeling builds as you walk up the hill past the Congregational Church, and by the time you reach the Islesford Neighborhood House it's palpable. Because of its size, Islesford has one building to do what it would take a half-dozen buildings to do on the mainland, and when you walk inside, you know instantly that the Neighborhood House is it. It's where we saw Danielle McCormick and Emily Thomas graduate from eighth grade that first spring, and where we attended our first Town Meeting. The main hall heard my mother sing an Italian love song—a cappella—while Sonja and I danced on our wedding day, and later that same year it heard the stories people told, crying and laughing, to mark the passing of Warren Fernald (a much-loved island elder who made it his business to make strangers feel welcome and to help new residents become established on the island). The building houses our library and our theater; it's where we do yoga and play Ping-Pong; it's the island's kitchen, dining room and living room. In its 96 years, the Neighborhood House has been the scene of countless moments, big and small, in the life of the community and all the people who've passed through its doors.

Island native Ted Spurling and his wife, Jeri, have three daughters. "The Neighborhood House is where Jeri and I had our wedding reception on a cold January day," he said. "It's where I graduated from eighth grade and where all

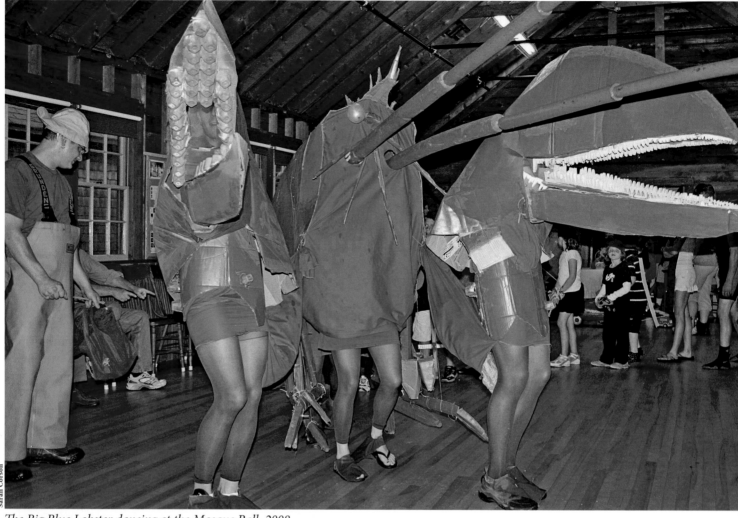

The Big Blue Lobster dancing at the Masque Ball, 2008

Bill McGuinness

my girls graduated. I can't imagine it not being there. It really is the center of our community."

I remember my first meeting as a newly minted trustee of the Islesford Neighborhood House Association (INHA), the nonprofit organization responsible for the care and operation of the building. (I'd been roped in during our first summer. Turns out, getting on a committee in a small town suffering from severe volunteer exhaustion is as easy as not saying no.) We were in Frannie Jo Bartlett's kitchen, and Gail Grandgent had brought cookies flavored with rose oil. I recall the rose flavor being very strong, and I also recall being very impressed by the other trustees and the seriousness with which they dis-

cussed the issues on the agenda. Though still not quite sure what I'd gotten myself into, I walked home that day excited to be a part of the board.

Over time I learned that the INHA board is responsible not simply for keeping the walls from falling down, but also for ensuring that the Neighborhood House remains relevant and responsive to the needs of the island. Historically, by listening to neighbors and looking for opportunities to be of service, the board has certainly lived up to its responsibility, always keeping the INH in good condition and altering or adding on to it when necessary. As needs have changed, so has the Neighborhood House, and it has admirably done all that the community has asked of it. But recently, perhaps attributable to the increasing outside pressures on small island populations, islanders are once again looking at the INH and wondering how else it might contribute to the continued viability of the island population.

In my time on the board, the most common suggestion has been to make the building a year-round facility. Here we have this tremendous asset, which is used so well in the summertime, going empty for more than half the year because it isn't insulated. How much stronger is a community that has a warm and comfortable center? Acting on this input, the board voted in the fall of 2007 to form a building subcommittee—Amanda Ravenhill (a former Cranberry Isles Island Institute Fellow), Cory Duggan and me—to explore the idea of winterizing the building and possibly making other improvements at the same time.

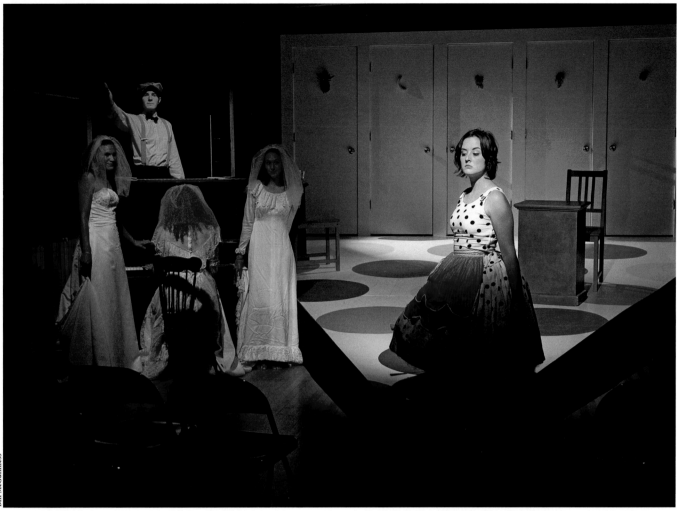

The Islesford Theater Project stages Pierre Marivaux's Game of Love and Chance at the Neighborhood House.

We started by simply putting it out there that we were looking for input from the community, and it quickly became clear that our fellow islanders had a lot of ideas about how the Neighborhood House could be improved. For Ann Fernald, who with her husband Warren Fernald raised six children on the island, it represents the future. "What price can we put on the value of our Neighborhood House?" Ann said. "Let us unite the nostalgic past with fresh, energized ideas and inspiration, for our use now as well as for future generations."

To capture those ideas and give community members a forum to communicate directly with one another about the INH, our next step was to organize a community "visioning" in August 2008. We gathered in the main hall, summer and year-round residents alike, old and young, native and transplant, and although most came with strong feelings about the building and what should or should not happen to it, all remained open-minded and participated fully in the process. Looking ahead, five years into the future, we began with a list of questions about what the Neighborhood House of 2013 might be like. Armed with Sharpies and Post-its, as the questions were read we scribbled down whatever answers came to mind, one per Post-it. There were no restrictions—answers could be fully articulated thoughts or single words—and we did this for fifteen minutes (although we could have gone on and on).

When it was time to stop writing, we then took the Post-its, over 300 of them, and stuck them to the walls, working as a group to put them into "clusters" of similar ideas. Next, we took each cluster and distilled the individual ideas into one overarching statement. Finally, putting all the "cluster statements" together, we had the foundation of a

The wedding reception for Lindsay Eysnogle and Jason Pickering, held at the Neighborhood House

community vision for a transformed Neighborhood House.

The vision was expansive. Beyond simply seeing a year-round space, the community saw a main hall big enough to accommodate our otherwise-crowded potluck suppers, wide enough for community dances, and with a high-enough ceiling for winter basketball. Folks saw a larger and better-equipped kitchen, a refurbished entryway and common room, a greater capacity to host cultural events and the potential for energy efficiency and generation.

Ravenhill, a member of the building subcommittee, said the Neighborhood House is the heart of the island, especially in the summer. "I dream of a time that it can mean the same for the winter population," she said. "If it were insulated and comfortable in the winter it would be used, no doubt, and it would beat like it does in the summer. It would be a place where all of us, regardless of age, could come together and eat, play games, converse and build community. A well-functioning Neighborhood House means a healthy community. A healthy community creates inspired people, and inspired people make the world a better place."

The INHA board was excited by all of the ideas, and decided to pursue a building renovation project. But how to get from the vision to its realization? Considering the amount of money that would be needed to make the proposed changes, the board authorized the development of a capital campaign in the fall of 2008. Considering the amount of work that would be needed to organize the project, the subcommittee was expanded to include a fourth trustee, Luke Abell, and seven other community members: Cindy Thomas, Denise McCormick, Barb Fernald, Sonja Moser, Caroline Sholl and

Dan and Cynthia Lief. Mindful of the other elements of the community vision—that the history of the Neighborhood House must be respected, that the building should retain its look and feel, that every effort should be made to preserve all that people love about it, and that decisions had to be made with the next 100 years in mind—the newly expanded sub-committee set about developing a plan. Working hand in hand with the community, we will launch our capital campaign at the annual Islesford Fair in the summer of 2009. In the current economic situation, we have our work cut out for us, but we are optimistic about this project, and confident that we will be able to finish it by the spring of 2013, in time for the 100th anniversary of the building's opening.

We have a ways to go before the community's vision for a year-round Islesford Neighborhood House is realized, but when this project is complete, I believe we will have done something that will benefit not just the folks living on the island today, but our children and grandchildren too. The experiences we share bind us closer to each other and deepen our sense of place. The more we are able to break bread together, to dance and play together, to simply *be* together, the stronger our community becomes. In the short time that we have lived on the island, the Islesford Neighborhood House has been the scene of some of the best moments of our life together, and when I think about our newborn son Finnegan's eighth-grade graduation, I know that it will be the scene of many more to come.

2009

An Extra Set of Hands

The Island Fellows program began, as do many efforts at the Island Institute, with an impromptu brainstorming session at a program review meeting one Monday morning in the late fall of 1998.

We were discussing the surprising success of an effort begun the previous summer to place interns aboard lobster boats in Penobscot Bay. The project was a collaboration with the University of Maine and Maine's Department of Marine Resources to record the number and location of juvenile lobsters, oversized lobsters, and "V-notched" females. Given the sensitivity of the data that was being collected from individual fishermen and the secrecy among them as to their fishing strategies, we were dubious about achieving our goal of recruiting 20 fishermen. But at the end of the first season, we were shocked to discover that 78 fishermen had participated.

We began to ask ourselves why this project had been so successful, and what we had learned that we might apply elsewhere.

The most obvious lesson was that the success of the student interns was because the lobstermen were being interviewed on their home turf— aboard their boats on the water where they fished and were most comfortable. Fishermen were not asked to share this information in some government office ashore. A second lesson was that the students aboard the boats were trained to listen respectfully, to ask questions and to record the information lobstermen might agree to share.

Given the fact that sea-sampling data could influence a pending federal determination of whether Maine lobsters were overfished, we thought it was worth extending the project to other areas. In the brainstorming mode, we knew that the winter lobster season on Monhegan would be opening in a few months, and maybe Monhegan lobstermen would want to participate. But if so, someone would have to live on the island. Our marine resource director at the time was a Bowdoin grad who suggested he might be able to find a Bowdoin student looking for a January field project topic for a senior thesis. And so it was that an island residency requirement was inserted into the still inchoate program.

We recruited Susan Little, an environmental studies major at Bowdoin, to work on the Monhegan sea-sampling program with local fishermen, and she lived and worked on the island for a month before returning to college. Since lobster sea-sampling information had not been collected in Casco Bay, it seemed logical to inquire whether Chebeague Island lobstermen wanted to participate that spring. Since Susan had already graduated, we wanted to distinguish her work from an internship, so we decided to call it a fellowship; thus the Island Fellows program began, and she became our first Island Fellow.

Since that time 10 years ago, the Island Institute has placed 76 Island Fellows in 20 different island and mainland communities. Communities now compete to participate in the Island Fellows program through an application process that awards points for collaborative projects that leverage the activities established by community-based nonprofits—schools, libraries, historical societies, and town offices. Depending on the nature of the work, Island Fellows projects last either one or two years, so projects are judged in part by plans for their long-term sustainability. How will the projects proceed after the Fellows are gone? Island advisors are also key. Collectively, the network of Island Fellow advisors have contributed over 20,000 hours of volunteer labor to help ensure a project's success.

Jess Stevens and Susan Little on Chebeague Island

What have Island Fellows projects accomplished? Island Fellows have initiated ongoing music, drama and arts programs in a handful of island communities. School and library catalogs have been computerized and integrated in many communities. Physical education programs in a number of island schools are another legacy. Town offices have hired Island Fellows for administrative support as a result of the increasing complexity of running island towns. Affordable housing projects have been staffed by Island Fellows. Island Fellows have helped prepare alternative energy plans in three island communities. A new health program has been established in another community.

These are real accomplishments—but there is another result that no one anticipated. Approximately 10 Island Fellows have remained on the islands where they were assigned, where some of these have married and now, *mirabile dictu*, there is a new generation of what we like to think of as Junior Fellows!

Although there are many notable legacies of the Island Fellows program, perhaps the most enduring contributions to community life have been the thousands of informal interactions between Island Fellows and often overextended community members momentarily overwhelmed by their roles in the enormous effort of trying to sustain a way of life in their isolated communities. At the end of the day, the biggest contributions of Island Fellows may be that, literally and figuratively, they are another set of hands carrying a part of the load during the endless process that builds and refreshes community life.

Philip Conkling

ALDEN ROBINSON
Long Island

To say that there's no privacy on an island isn't quite true, and it isn't fair to say that everybody knows what everybody else is doing all of the time. However, you do learn random things about people on an island that you wouldn't learn anywhere else. One family might have spent three years in India. Another might be installing a new septic system. One man might have lost a finger in a childhood sledding accident. Another woman might be getting her deck rebuilt.

Fragments of people's lives emerge bit by bit. It's not a voyeuristic thing; it's just the information economy that makes a place like this run. Early on I learned that you can't survive here without listening to all those stories. Any story you hear, I've learned, is actually two stories: the story itself, and the point of view of whoever is telling it. Unless you pay attention to both, you're apt to get yourself in trouble.

Looking back on a year of listening to those stories, I realize that this has been my first real introduction to politics. Of course, there were politics in high school and college, but they pale in comparison to the politics of a small town. Intellectually, I already knew there were "two sides to everything" before I came here, but until you get someone started on "whether we should have become a town" or "whether this guy's property line runs that close to the house" or "why this local organization just spent so much money on that piece of equipment," you don't really know what that means. None of it's bad; it's just the way people relate to each other, and in a small environment there's no avoiding it.

What's important, and what's so inspiring about the community on Long Island, is that all the opinions and rivalries and past conflicts can evaporate at a moment's notice when necessary. Lifelong antagonists can cooperate flawlessly on a rescue call. The guy who holds a grudge against the planning board can also go out of his way to help the town when it needs to store equipment on his land. Newcomers can work shoulder to shoulder with lifetime islanders on the affordable housing committee, even though they might both be competing for the same piece of land in the future.

It's a cliché to say it, but that really is the magic of an island community. You may disagree with your neighbors, but there's only one store, only one ferry back to town, only a few miles of road—and unless you want to be miserable, you may as well push your differences aside to say hello.

That smallness may sound claustrophobic, but it can also be thrilling. One of the paradoxes of island life is that most of the time, it's easy to forget you're surrounded by water. Unless you're riding on the ferry or driving all the way across the island, you only see water on one side at a time.

Several of my favorite impressions of the island have come from riding around the west end at night with friends, seeing all the closed-up summer houses, the dark ocean and the lighted buoys flashing in the sound, and the glow in the sky from Portland, and realizing what a small rock we're sitting on, in the darkness outside the big city.

Adjusting to life here took some doing. It's a challenging order: move to a tiny little town where everyone has known

Alden Robinson served as the Louis W. Cabot Fellowship Fellow on Long Island from 2006–2008.

everyone else forever and try to fit into the social fabric of the community. It doesn't seem like it should work, except that somehow, people are friendly, and we all get along and have fun, even though we're all different and we're all a little weird in our own ways. After a while it stopped mattering that I hadn't lived here forever, because there's only one store and only one boat back to town, and hanging out with the islanders eventually seemed like the logical thing to do. Recently, I've started thinking that if I lived with my friends in the city, I'd probably be lonely.

I'd probably also be bored. I didn't think there'd be much to do out on the island at first, but now I find myself wondering what happened to my free time. It's a struggle just to sit down and complete this portfolio project because, as I sit here, I'm getting phone calls about setting up our new property tax database, and I hear the sound of logging crews clearing tree damage on the pieces of land I mapped out for them. I haven't been counting, but I'm sitting on the porch as I write this, and I'm sure I know the names of everyone who's walked or driven past.

One of my friends lives in New York now. She regales me with the antics of the family in the apartment upstairs. They're hilarious, but she doesn't know their names. After this year, I can't imagine living like that. AUGUST 2007

SCOTT SELL
Frenchboro

For over two years I lived with the same 65 people on Frenchboro, working with them, eating with them, confiding in them and helping them in any way I could. The first few months on the island were like a dream. All my worries about being so far away from everything I knew disappeared as soon as I arrived, and I felt like I was able to jump into things with both feet.

My time in the school was immediately wonderful: I took to the children right away, and I think they took to me. I offered music, art, drama, physical education and creative

writing classes, providing support and acting as a resource for the two classroom teachers and the preschool teacher. I read to the kids at the end of every day. They made me be "it" for every game of freeze tag at recess, and they refused to play after I blew out my ankle (while chasing an especially quick kid down the cemetery hill). The younger ones demanded piggyback rides and the older ones wanted to show off their artwork and tell me their best stories.

The rest of my hours each day were spent with the townspeople of Frenchboro. It wasn't long before they noticed that I showed up everywhere, like some kind of bad penny, and I wasn't going away anytime soon. I assisted the Board of Selectmen on a number of community development projects, including working waterfront grants, town building renovations, and health-care issues. I also worked in both the library and the historical society, helping to organize and catalog materials for present and future use, to the benefit of the school, town and visitors to the island. After a while, I managed to get myself involved, in one way or another, in nearly every facet of island life, from coaching the children's baseball team and helping with school productions to calling numbers at bingo nights. I was convinced that I had the best job ever.

In a place that was so independent from the distractions of the mainland, it soon became clear to me what islanders hold dear: a productive school, a supportive community, and a healthy lobster fishery. My desire to understand every aspect of Frenchboro resulted in a friendship with the island's oldest lobster fisherman and a sternman job aboard his boat. I learned something new about the island and myself every time I went out with them. We told jokes, he told stories, we sang along to old country songs while we pushed and pulled through the day. But, perhaps more important than the physical work we did, I also learned so much more about the place where I lived: the dynamics of relationships that I'd previously only understood the surface of, the lobster business and the role it plays, the importance of tradition, diligent labor and thoughtful consideration for the island's future generations. By becoming an integral part of the town in this way, I was able to learn about the essence of what binds a community together.

On the night before I left Frenchboro, I drove down the hill to the ferry terminal. From here you can see bits of everything: some of Swan's Island, the Sisters, Harbor Island, Cadillac Mountain, and the whole of the sky. It's still and quiet and one of my favorite spots to be when the sun has just set. I sat and thought of what it means to be in love with a place, to be so acutely aware of the elation and heartache that goes along with being infatuated with where you live.

I feel that my time on the island, for the two years of my fellowship and for the foreseeable future, is like a torrid love affair, something thrilling and jarring both. And right now, we are on a break from each other. We have started seeing other people and other places. There are no hard feelings. I've gone my way, and the island will stay right there like it has for hundreds of years. And if (or more likely, when) I decide to return, even for a little while, it will accept me graciously. Small things will have changed and the children I knew so well will have grown in innumerable ways, and the smell might not be how I remember it. But I imagine I will know I'm home again; I'll be happy for the things that haven't changed, and I'll be reminded of this incredible opportunity I've had, and I know I'll feel nothing but grateful. APRIL 2009

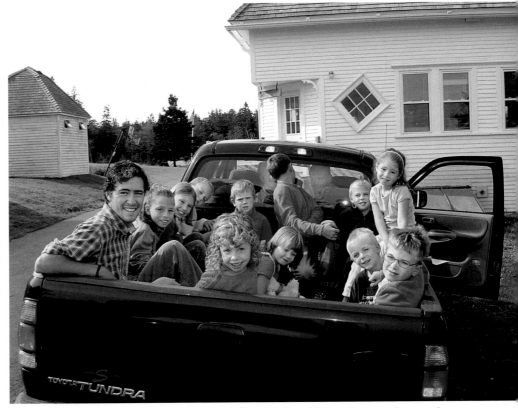

Scott Sell served as the William Bingham Fellow for Rural Education, working with the Frenchboro Elementary School, from 2006–2008.

MORGAN WITHAM
Isle au Haut

Last spring, on a predictably drizzle-filled Sunday, I found myself equipped with a nail gun, sheathing a roof. As someone who is fond of neither heights nor equipment heavier than a blender, it was not destined to rank among my favorite days. But the work needed to be done, and Isle au Haut was obviously short on able-bodied folks that weekend.

On the bright side, the experience stood me in good stead later, when the generous owner of my lodgings came to stay for a few weeks in the summer, his energetic entourage of dogs and daughters in tow. The instant family was fun, but it meant the quietest place to work was on the veranda roof outside my bedroom window. Minus the nail gun and exposed rafters, this height seemed downright pleasant. It also served

Morgan Witham served as the Isle au Haut Education and Library Fellow from 2007–2009.

to entertain passersby as they placed bets on whether I'd been banished from the house proper or was just contemplating a jump.

For anyone familiar with the Island Institute Fellows program, being driven to new heights is a pretty typical experience, and it illustrates how a fellowship works. You end up doing things you consider outside the realm of your ability, and the forced growth eventually proves serendipitous. I was forced to confront life from a heady new perspective, through foul weather and fair.

In the spring, I had also been pulled onto the Isle au Haut Comprehensive Planning Committee. Again, I didn't have much experience, but research and the written word don't make me nauseous, so I figured that was a good start. As a Fellow, my primary responsibility is to listen, and that is well within my comfort zone. At committee meetings, always scheduled at 7:00 p.m. on Friday nights, I couldn't help but be enthralled. Once again I was pushed to look out over the island, this view charted in facts and figures and shaped by community survey.

One thing islanders don't seem to lack is vision. Views on specific details may conflict, and walking that line between change and tradition is the most tense of high wires, but the ideas—the potential and the desire to adapt and sustain the community—they are all there, whether you're at committee meetings or the library, game nights or potlucks. Given their size and the social commitment required of the residents, Maine islands offer a unique opportunity to pilot and pioneer. When a population is so small and feels so finite, the individual's share of collective responsibility is amplified. This is empowering. It also burns people out.

Not a news flash, I know. The Fellows program was built with an eye toward providing an extra 40 to 80 man-hours a week that islanders couldn't otherwise afford. As the program has grown, so too have the expectations, and the realization of what can be accomplished. Being handy to sheathe a roof is great, but how about installing some solar panels while you're up there?

In eight months, my fellowship will be over. I'll be winding up my projects in the school and library, and moving on—but

hopefully not away. There's the comprehensive plan to work on, and the major inter-island issue of energy. There will be the crucial trick of making my own ends meet, and I might fail, fall, or yes, burn out—but living on what is called the High Island, I've grown to love the view. JANUARY 2009

SIOBHAN RYAN
Swan's Island

Usually the fire pager sounds like a fading Red Sox game on AM radio—you don't get any detail. That July morning at 3:30 a.m., I bolted up from bed and croaked, "Did I hear *library*?" My fiancé Isaac, a volunteer fireman and lobsterman, rushed out, saying he'd call.

Instead, I called him, and he didn't hesitate, even as sadness filled his voice: "It's gone," he said. "The library is gone." The fire had been so hot that it blew the windows 20 feet beyond the building, the skylights became vents for towers of flame, and the only thing left unscathed was the fire escape. A bolt of lightning probably caused the July 2008 fire that destroyed the Swan's Island Library.

In the fall of 2005, I had started a two-year fellowship for the Island Institute. The rest of the story happened like this: arrive on Swan's Island; hunker down in two century-old buildings—one my rental home, the other a refurbished schoolhouse that was the library; get set up on a blind date at a party after something resembling an inquisition at a Baptist Ladies' Aide meeting; fall in love with that blind date; get married.

That is why, even though I am no longer an Island Fellow, I still take the 6:45 a.m. ferry from Swan's Island, holding the cup of tea that my husband prepares most mornings, on my way to Bar Harbor and back again every day.

Before Bar Harbor, I'd spent two years working in the libraries on Swan's Island and Frenchboro. The work was described as fairly technical, as both island libraries wanted assistance with updating, or, in Frenchboro's case, creating a catalog, and maybe working on some grants and collection development. Candi Joyce, Ruth Davis and I picked away at all of those tasks. We wrote grants for software and hardware, audiobooks and DVDs, programming and capital improvement.

Our work was even recognized by the American Library Association when I was named an Emerging Leader, with all of us knowing that our team was making the progress happen. In reality, all of those grants, improvements and accolades were not what defined my fellowship. Being an Island Fellow was different from being a librarian, as it was the community that really breathed life into our projects. There were all of those raucous Garden Club meetings; the two-week period when 15 high school students moved an entire museum collection; that winter we spent lugging water from the fire station to wash hands and flush the toilet because the pipes had frozen; and a resident mouse that made it difficult to leave chocolate around.

Excitement in our work reached a high point with the First Annual Chowder Cook-Off. The Swan's Island Library had

Island Fellows gather at the 2008 annual dinner held to recognize their work.

promoted our cook-off fund-raiser for a few weeks, hoping to gain a few entries. Then, on the second Saturday in August 2006, 13 different people showed up with chowders ranging from jalapeño crab to the Manhattan variety. Other island-ers came armed with dollars, ready to vote for their favorite chowder. The event was a wild celebration of food and com-munity. Chowder was served freely, people talked trash, and the dollar bills mounted. When Donna Wiegle's chowder won the contest, the debate raged on for months as to why. Had her cheddar-baked biscuits helped sway the vote—or was it her salesmanship?

My fellowship was also largely defined by the circum-stances surrounding the introduction to my husband. Marion Stinson had called me after the meeting at Baptist Ladies' Aide, telling me that her son was having a party, and that he had asked her to "invite the new girl so she could meet some people." Isaac hadn't invited me. Marion only casually mentioned to him as he went to take a shower that a gal close to his age would be showing up at his party. He decided to shave.

My friends love the next part of this story. On an island of 350 people, I had already been invited to another gathering. I was going to skip meeting this "Isaac." When I told my party hosts, the Applins, about Marion's invitation, they decided to leave their home and go to Isaac's. That night, just as Isaac assumed the "new girl" wouldn't be coming, an additional 10 people descended upon his festivities. Even though I turned down his offer of a ride in his lobster boat to Frenchboro the next day for work, Isaac and I got married in August of 2008.

On that July morning, before our wedding, two years of my work and hundreds of hours of volunteer labor burned

Siobhan Ryan served as an Island Fellow from 2005–2007, working with the Swan's Island Library, the Frenchboro Library and Frenchboro Historical Society.

almost completely. I cried, and then became irate that all my work was gone. For over 12 hours the volunteer firemen con-tained the fire until only a smoking pile of rubble remained.

Even as the hot spots were squelched, the volunteers stayed. They combed through the wreckage, some on their knees, looking to save any scrap—a bit of a bottle, a charred book, or a rare island document from the archives. There was little to be salvaged. As they picked over the debris, I realized that it wasn't just my work that was gone, but the work of an entire community.

Reflecting on my time as an Island Fellow, and all the com-munity involvement in my work, I know we'll rebuild, and the work will continue. Perhaps when the new library rises, the pipes won't freeze and the mouse won't take up residency . . . but the chowder will still flow freely. APRIL 2009

2009

Separateness & Togetherness

Independence means Chebeague islanders can preserve their unique community

DAVID A. TYLER

"When you live on an island, every journey begins and ends with a boat ride."

These are the words of Chebeague Island resident Donna Colbeth, part of a PowerPoint presentation she wrote and narrated to help show Chebeague Island to Cumberland town officials.

For islanders, Colbeth's statement is a fact of life. But it's an aspect of island living that mainlanders never seem to get. The journey emphasizes the essential separateness of island communities: you have to cross an ocean to get there.

Islanders know the ferry is part of community life: everyone has to take the same boat to get where they want to go. On every ferry ride, islanders spend time with their neighbors catching up with the daily news—a ritual missing from the mainland.

The separateness of islands imposes a unique sense of togetherness that does not exist in suburban towns. The limitations imposed by a ferry schedule would seem incomprehensible to most mainlanders, for whom community is often the place with the best commute to and from work.

A powerful sense of togetherness allows island communities to accomplish remarkable things. But the increasing divergence between the mainland and islands means those on the mainland often don't even understand island issues, which only compounds the challenge of maintaining year-round island communities.

This problem is particularly acute in Casco Bay, where all the year-round communities on un-bridged islands are governed from the mainland, with the exception of Long Island. Casco Bay's island communities are the only ones along the Maine coast that do not run their own affairs.

Peter Ralston

The suburbanization of the mainland over the past 35 years in the Casco Bay area has led to a disconnect between island and mainland communities. In 2005 this disconnect led residents on three of Casco Bay's island communities—Cliff, Chebeague and Peaks—to consider seceding from the mainland governments that now run these islands. Cliff and Peaks are part of Portland, Maine's largest city, and Chebeague has long been part of Cumberland.

Although individual circumstances are different, what all these secession movements share is a passionate desire to preserve unique island communities and a belief that islanders—not mainland governments—know what is best for their own survival. The specific event that triggered Chebeague's independence movement was a proposal by School Administrative District 51 to remove the fourth and fifth grades from the island school. But the root cause is that island and mainland communities have been growing steadily apart.

In the 19th and early 20th century,

island and mainland shared a rural, maritime way of life. In the 1890s, 40 percent of Cumberland's population lived on the island. But in the 1960s, Cumberland grew by 48 percent, marking the start of the divergence between the island and the mainland.

As Cumberland changed from a farming village to a bedroom suburb of Portland, Chebeague maintained its age-old ties to the sea. On Chebeague, fishing remains the island's largest industry, with at least 47 residents working as lobstermen.

Chebeague remains a small, rural community of 350 where the median income is $32,000. Mainland Cumberland is a growing suburb of around 7,200 people where the median income is $73,000. Fewer than 5 percent of mainland Cumberland residents have lived in town for more than 30 years, compared to 40 percent of island residents.

As the mainland population grew and Cumberland abandoned the Town Meeting form of government, Chebeague residents increasingly felt they could no longer have a significant voice in the town's direction. They are outnumbered and often unable to attend government meetings on the mainland because of ferry schedules.

Islanders in Casco Bay don't blame mainlanders for the different goals each community has. But they believe passionately in their right to fight for their own way of life, which is rooted in the separateness of these islands and their unique geography.

Those who live on an island cherish that place, its landscape and its features, in a way that those in suburban communities, where the emphasis is on mobility and access to services, may not understand. The island is viewed as a shared resource, not a commodity to

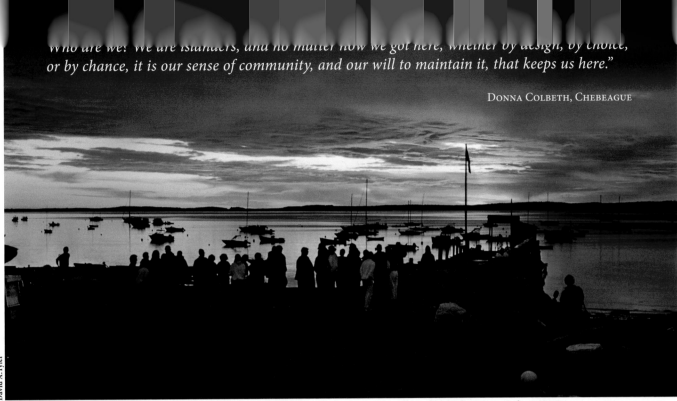

Who are we? We are islanders, and no matter how we got here, whether by design, by choice, or by chance, it is our sense of community, and our will to maintain it, that keeps us here."

Donna Colbeth, Chebeague

David A. Tyler

A NEW DAWN: *Islanders hold a sunrise service to celebrate Chebeague Island's independence on July 1, 2007.*

be sold to the highest bidder. On Chebeague and Cliff islands, many depend on the ocean and the land for their living; they are bound to land and sea in a way that has vanished in suburban towns.

"Most islanders have a sense of place, and we are on the road to reemphasizing that place," said Mabel Doughty, a secession representative, speaking at a public hearing on Chebeague Island's effort to become independent in August, 2005. Doughty, married to Sanford Doughty, a retired fisherman, has lived on Chebeague for 60 of her 83 years.

For many suburbanites, community and identity is no longer tied to a sense of place. Thomas Urquhart, former executive director of the Maine Audubon Society, wrote of the fundamental human desire to be connected to the land in his 2004 memoir, *For the Beauty of the Earth*:

"Better career opportunities have made us mobile beyond our grandparents' dreams, but our geographical roots continually erode until home is no longer an unqualified place," he wrote. "We have let the treasure of rootedness slip through our fingers."

Not only do islanders treasure that rootedness, but they are also prepared to fight for it. And to fight to preserve a unique community in the face of the

forces threatening it is a radical act. "We're concerned that we're going to be gentrified, we are going to be homogenized," says Chebeague Island resident Donna Damon, the island's representative on the Cumberland Town Council.

The secession movement in Casco Bay, particularly on Chebeague Island, is not, at its heart, a reaction to a specific event. It is the result of changes on the islands and the mainland over decades. "Separation is a step in reclaiming our values, in making our day-to-day decisions, and solving our own problems," said Doughty.

"What Chebeague is undertaking is just as American as apple pie and the Fourth of July," said Chebeague Island resident Phil Jordan, at a September 2005 secession hearing. "From the earliest days of this nation, people have decided that their future required them to separate and take charge of their own affairs."

It is a process of self-determination that began with the American Revolution. It continued in 1820, with the creation of the state of Maine. As more people settled here, and the needs and goals of different communities diverged, new towns were created. Four towns emerged from what was originally North Yarmouth: Freeport, Pownal, Cumberland and Yarmouth.

For Casco Bay residents, the rewards of self-governance are evident on Long Island, the only island community that achieved independence during a baywide secession movement in the early 1990s, when Cushing, Great and Little Diamond, Long and Peaks sought to secede from Portland. It took Long Island several years, but on July 1, 1993, it became its own town.

Many thought Long Island was crazy to go it alone. But 12 years later, the Town of Long Island has a stable tax rate, a new library and school addition, a new fire truck and its own rescue boat.

The metaphor Chebeague islanders have used for their independence movement is rooted in the family. "The time is right for us to leave our parents, and for them to wish us luck," said Doughty at the September secession meeting.

The negotiations between Chebeague and Cumberland, conducted with goodwill and civility, showed that islanders and mainland communities can remain on good terms, even as islanders make the case that they need the power, through secession and independence, to run their own governments and preserve their way of life.

2006

Bringing Hope

What keeps young people on islands?

CHERIE GALYEAN

Experience in early childhood education led Melissa Brown to open a licensed day-care business on Long Island.

It's a common refrain heard in all discussions about the future of Maine's islands: "We need to attract young people." Because "young people" bring with them energy, work and children—but most importantly, hope. A young family on an island means a viable workforce, new ideas, children in the school, a future. An island without young people is a dying place. The next step is usually a summer-only settlement.

Up and down the coast, communities can be heard discussing the difficulties they face. Without jobs there will be no young people. Without affordable housing there will be no young people. Without a good school, a strong library, a lively community center . . .there will be no young people. And in Maine, it's a statewide problem. The 2000 census showed that 18 percent of Maine's population was between the ages of 20 and 34, down from 24 percent in 1990. The general belief is that opportunities in Maine, and particularly in small communities like islands, are too limited, too low-paying and too rural to attract the younger generation.

But is it really true? Can island life, with its quirks and difficulties and uncertain future, be an attractive alternative to the younger people and families that are so desperately needed? What are the benefits for younger people? How can communities be more successful at recruiting and keeping this precious resource? Most important, what do young islanders need to keep them there?

Long Island
"A great opportunity to be involved"

Deciding to move back to Long Island after living in Portland was a positive choice for Melissa and Cade Brown. Both had strong links to the island: Melissa's parents, who were originally from Long but lived in Portland for a time, moved back to the island when she was in the fifth grade. Cade used to visit his mother on the island in the summer. When their son, Madison, was born, coming back to Long was the best way to build close family relationships. "Often, parents want to give their children the childhood they didn't have. I want my son to have the one I had living on Long Island," Melissa says.

Melissa and Cade consider family and community a priority. "I want him to live in a community where we know everyone's name and we all wave to each other." She thinks other people move back to the island for the same reasons. "There is another girl from my childhood who came back [after college], but she also has started her family. I don't see a lot of college graduates without families coming back to live."

Melissa also sees the other side growing up on the island. "Growing up on the island I heard many of my friends say (and I'm sure I said it too) that they couldn't wait to get off 'the rock.'" After fifth grade she experienced commuting to Portland daily for school. She ended up going to boarding school to finish high school, and is sympathetic to the difficulties that island living imposes: "Catching a boat at 6:45 to make it to an 8:00 class can be taxing on one's body. Not being able to play many sports, or join many clubs because the games and practices go past 5:45 is something many face. I stayed a lot—several days during the week—with friends on Peaks Island or in town."

Moving to the island, Melissa and Cade immediately faced a problem: few jobs. Although Cade was employed as a carpenter with an island builder, Melissa needed a job that would allow her to stay home with their young son. Her education and experience in early childhood education led her to open a fully licensed daycare on the island. "I am really lucky that there is a market for this," she says. But, despite having a full house of kids Monday through Friday, Melissa still needs a second job to help make ends meet. She works two days a week at Casco

Bay Lines in Portland. "Daycare providers don't make a lot of money, and the small paycheck that I get from Bay Lines helps cover our budget," she says. In addition, her business is subject to fluctuations in island population. "If people don't have children, I don't have a job."

Even with both Melissa and her husband working full time, "Staying on Long Island is certainly a topic that comes up from time to time, " she says. "Land and housing are currently beyond our budget, and in the next few years we may decide that we are ready to buy. Unfortunately, we may have to go off-island to find something."

Even with all of their jobs and a young son, Melissa and Cade still manage to volunteer. Melissa is a member of the school board and recreation committee, while Cade serves on the planning board and volunteers with the fire department. Both volunteer for the library. "Young people out here have a great opportunity to be involved. In another place, I never would have had the opportunity to be on the school board at my age," Melissa says. "We continue to ask ourselves: can we find a place to live that gives us what we want and have found here?"

Vinalhaven
"You live your job completely."

Mike and Keely Felton found that taking up permanent residence on Vinalhaven took several years and a lot of commuting. Keely, who calls herself a "fourth-generation summer person," had been coming to the island every summer since she was a child. She always knew she wanted to try winter living as well: "I was always sad to leave in the fall. I would hear people talking about their winter activities."

The summer after she graduated from college, she met Mike on the island, just as he was finishing up his first year as an Island Institute Fellow. After spending a year in Philadelphia, Keely also signed on as an Island Fellow in order to fulfill her wish to spend a year on the island. "I am the first member of my generation to live here year-round," she says proudly.

"If people don't have children, I don't have a job."

Unlike Keely, Mike knew very little about Vinalhaven at the beginning of his residence. During his senior year in college, a professor who had been working with the island school offered to bring Mike out to see the K–12 school. Mike almost didn't go because he had to get up so early catch the ferry, but at the last minute decided to take the adventure. "It was the longest boat ride I'd ever been on," he says. He was drawn immediately to the islanders, especially the children. "I liked the kids and the school and the honesty of the people. On the way back, the superintendent was on the ferry and he asked me if I wanted to come out for a year." Mike took up the offer and served as an Island Fellow for two years, teaching social studies in the school and working to improve student aspirations. He admits the first winter was hard and he thought of leaving several times. "Then in April, I took the kids to Boston [as part of a college awareness trip] and it was such a success that I decided to stay."

When his fellowship ended Mike began working at the Island Institute as its Education Outreach Officer. Keely became an Island Fellow on North Haven, living with Mike on Vinalhaven and commuting daily across the Fox Islands Thoroughfare between the two islands. With Keely spending time on North Haven and Mike commuting to the Island Institute in Rockland and spending many nights on the mainland, the two found island life to be challenging. In 2004, Mike finally quit the commute when he took the position as school leader on the island, a principal-like position he calls his "dream job." Keely's fellowship evolved into a position as the program director at the Waterman's Community Center on North Haven. Both consider themselves lucky in their positions. "There aren't a lot of career jobs out here," Keely says.

But, as Melissa Brown experienced on Long Island, what an island lacks in jobs, it can make up in opportunity. "Because of the size of the place, I can really see the difference when I do something. I can start projects that no one else is doing," says Keely. Mike sees the same thing, "I know the kids as people, and can tap into the community of resources. There are things you can do in a small school that would be much more difficult in a large school. I can really see the difference that I make." Few communities would consider hiring a twenty-something to head up their school, and possibly even fewer people that age would be willing to take such a job. Mike says he wanted the job because "I love the interaction of education and community. It is a very intense job, though really good. You live your job completely."

Both love living on the island, but Mike admits the isolation and smallness can get to him. Despite that, "There's nowhere else I want to be, nothing else I want to be doing," Mike says. "The more I go away, the happier I am that I live here."

Mike Felton, who heads Vinalhaven's K-12 school, with student Sam Rosen

Swan's Island
"When are you going to have kids?"

A Swan's Island native, Christal Applin never had to worry about breaking into her community—she was born into it. Christal has never lived off-island, with the exception of the four years she boarded on Mount Desert Island for high school. "I had planned to move off and go to college, but changed my mind," she says. "I didn't end up going to college, and I do have some regrets about it, but I think that if I had, my life would be totally different now."

Now a licensed real estate agent, Christal calls herself "very lucky to be one of the few women with a solid job that isn't physically intensive." But it wasn't always this way. Before moving full time into an island real estate firm, Christal worked a full array of jobs: at the town aquaculture project, as a town librarian, school librarian, lawn mower and clerk at a store in Southwest Harbor, all while she was assisting in the real estate office. "I used to wear many, many hats," she says, "and gradually I've been able to take them off."

Like many things in island life, the position at the real estate agency came about through luck, patience and knowing the right people. "It was only a two-person office, and one of the women wanted to retire. They wanted some fresh blood so they asked me." Christal now enjoys the freedom she has in her job: "With cell phones and the Internet, I can really work anywhere." But she doesn't take her good fortune for granted, "Jobwise, there is no incentive for young people to move out here. There are few jobs if you aren't a carpenter or fisherman."

Getting those jobs isn't always easy. Christal's husband, Josh, originally from Wiscasset, spent a summer after high school working as a sternman for a Swan's Island lobsterman. Attracted to the island and lobstering, he decided to move there permanently and begin fishing from Swan's. Christal

Christal Applin is a licensed real estate agent on Swan's Island.

explains, "It was during the decline of the urchin industry, and a lot of people were switching to lobstering. It was very competitive, and we had a lot of trouble." A friend in similar circumstances moved off the island because of the pressure, "but a lot of older folks on the island encouraged us to stay, to make a go of it. They kept telling us that young couples were too important." The two built a house on the island, and are now happily settled.

They aren't alone. "Of my class, I think the majority live on the island now," Christal says. Still, Christal notes, there can be a problem with community involvement among the younger generation. "There are very few younger people on committees. We need to encourage more of the younger people to be involved." She credits some of this reluctance to a fear of the pressures and conflicts that can come of taking a stand in a small community, but also something as simple as time. "I used to be on more boards; I used to have four meetings a week. I've dropped some because I just didn't have time to do them all well. I think people don't want to take on a board if they feel they don't have the time to devote to it."

The influx of younger people has brought kids to the island, where the school population has dropped in recent years. "When I was in school, there were 50–60 kids in the [K–8] school. This year I think there are 35. But the preschool has a good number now, so I think it is rebounding," she said. Babies are a special attraction in the community. "There was a new mother at the Thanksgiving dinner this year," Christal remembers, "and I don't think she held her baby through the whole dinner because she just kept getting passed around from person to person."

Islanders value children so much that Christal and Josh are feeling pressure. "We never planned on having children,

and we are always defending our decision. It seems like in a smaller community the sense of family is so great that the next logical step after marriage is to have kids, and if you fall out of that role, then you are an oddball. They say, 'You've been married nine years! When are you going to have kids?' "

Asked why she chose to stay on the island, Christal says, "My reasons for living on Swan's have changed. When I was a kid, I felt like it was all mine. The whole island was my playground. Later, I felt like I was living on an island where everyone was my parent. Now I love the security, knowing that if something happens, everyone is there to help." And as a real estate agent, Christal gets to relive her appreciation for the island over and over again. "Whenever I am showing someone the island, I get a real sense of pride to show them the island through my eyes," she says. "I don't plan on ever leaving. This is my home."

The benefits of island life for younger people are clear: strong communities that are good for kids; opportunities to create a unique life. Equally clear are the challenges. Without a concerted effort to develop employment opportunities and housing options, islands risk losing even the young people that love them.

Slightly murkier is figuring out what allows some young people to be successful in island living, while others find it stifling. It's partly temperament, plus the ability to be creative about lifestyle and to think as an entrepreneur. It's partly a function of the community, which must be willing to bend and be supportive of new families. Mostly, it is an equal combination of both of these ingredients, plus some perseverance, patience—and a little luck.

2006

A full report on the state of Maine's island communities is available at www.islandinstitute.org/islandindicators.

Schools & Education

RUTH KERMISH-ALLEN & SHEY CONOVER

On North Haven Island, students put on their muck boots and tramped around the island clam flats, investigating what happened to the clamming industry in their community. They interviewed families who had been clamming on the island for generations, and shared their data with the Maine Department of Marine Resources.

On islands, the school and the community are deeply connected, each learning from the other. Teachers embrace the resources the islands provide—the people and the sea—and engage students to make learning more relevant.

The Island Institute's education programming is grounded in the idea that the key to a sustainable island community is a healthy, thriving school. Island schools are a testament to what education should be—where all children are known by their teachers and other adults in the community, and no student is left behind. When class time is finished, island schools are places where the community gathers, to meet, cheer sports teams, share community meals, and celebrate holidays and special events. Islanders realize that if their school is in danger, so is the heart of their community.

Since 1985, the Island Institute has worked with Maine's 14 year-round island schools, providing support by fostering communication, offering professional development opportunities to teachers, and nurturing students' college and career aspirations. All of the Institute's education programming is based on the philosophy that statistics and test scores are incomplete measures of education. A closer look at what is working in island schools reveals what these schools can teach the state and nation about educating children.

Place-based education (PBE) is a powerful learning approach that draws curricular connections to meaningful issues students experience in their day-to-day lives. PBE is now seen as cutting-edge educational reform, but it has always been done in island schools. Island schools may not always have the same resources as mainland schools, but the creativity and ingenuity of islanders, along with the beauty of the islands themselves, have inspired teachers to use their islands as a platform for learning.

For example, on Chebeague Island students in grades three, four, and five conducted a study that looked at the impact the lobster industry has on their community. They interviewed lobster-

men, scientists, other students, business owners and many others. Then they partnered with Bowdoin College students and created a website, complete with videos, drawings and essays by students. By studying and tackling real community issues, students become community leaders, reinforcing the school as a local resource and empowering students to become engaged citizens.

Island teachers in partnership with the Island Institute are taking this philosophy to the next level. Schools on islands and the isolated Maine coast are some of the only places in the country looking at how to combine place-based education with cutting-edge technology to develop an educational model that could work in any rural school throughout the country.

As part of the clamming project, North Haven Community School students studied why their local clam flats were no longer viable. Using ethnographic interview techniques and digital video technology, students interviewed local elders to learn about the history of the resource. Students studied local clam population dynamics and used Geographic Information System (GIS) technology to map their findings. They talked with leading state scientists about why their clam flats were closed, and created websites to communicate their findings to the larger community. In this one example, students employed interdisciplinary techniques to study a local issue, meeting state and national learning standards while making valuable connections with their community.

New methods to connect island schools are being used via Information and Communications Technologies (ICT), such as webcasting, video conferencing, blogging and more. In the summer of 2008, over 150 island and remote coastal middle and high school students gathered for a week to work with their teachers on integrating technology into the school curriculum.

One afternoon, all 95 students and 45 teachers gathered in an auditorium to share their innovative work with students in Boston and leading education researchers throughout the country, all via video webcasting. For two hours, Maine's island students exchanged stories about their community-based technology learning experiences with students from Boston's inner city and with educators from the National Science Foundation. The event centered on fostering communication, and students accomplished this by sharing stories about how they make connections with their community through technology and education. Their presentations revealed that island schools are thriving, and can serve as a model for rural education across our nation.

Emerging communications technologies can provide the resources necessary to extend the walls of the classroom a little more each day: with a new island teacher mentoring program; inter-island teaching; and more opportunities for island kids to work together and socialize with other island students, across Maine and around the world. With the limitless creativity of island schoolteachers, the curiosity and technological expertise of today's students, and the support of island community members, the sky is the limit.

Backing into the Future

Through technology, kids gain an appreciation of community life

MURIEL L. HENDRIX

Students from the CREST Summer Institute, at Pemaquid Point, in the summer of 2006

Ruth Kermish-Allen

In December, students at Deer Isle-Stonington High School were searching through genealogy records in the extensive files of the Deer Isle Historical Society, writing down notes in the usual manner. However, the outcome of their work, thanks to a grant obtained by the Island Institute from the National Science Foundation, will be far from usual, involving up-to-date technologies and extensive training that island schools would not otherwise be able to afford.

CREST (Community for Rural Education Stewardship and Technology) encourages students to use technology as a tool in finding creative solutions to community challenges. It also seeks to promote students' awareness of and interest in technology-related careers they might pursue in Maine. At a weeklong CREST institute held at the Darling Marine Center last summer, students and teachers from Deer Isle and 10 other Maine schools began training in Web design, using GPS and GIS (global positioning and global information systems), operating a digital camcorder, and conducting ethnographic interviews.

CREST has already helped forge connections between these students and their communities. Volunteers at the Deer Isle and other historical societies have helped students with research; elderly residents of Vinalhaven have talked about the days when most of the island's shore was working waterfront; longtime residents have shared their knowledge about heirloom varieties of apples on Islesboro and productive clam flats on North Haven.

The Deer Isle students at the historical society were looking for information about the "Island Boys" from Deer Isle and Stonington who served as the entire crews for the DEFENDER and the COLUMBIA, winning yachts in the America's Cup Races of 1895 and 1899. Students plan to use this genealogical data and other historical information they find in the archives as a springboard for digital camcorder interviews with island residents who, when growing up in the area, heard stories about the crews.

Like students from other schools in the CREST program, students will edit their interviews with iMovie, which they were introduced to last summer, and then put the interviews and other completed work on the school's CREST website. Students also plan to present their material in some form at a community gathering.

By January, students on North Haven had recorded three interviews, using ethnographic

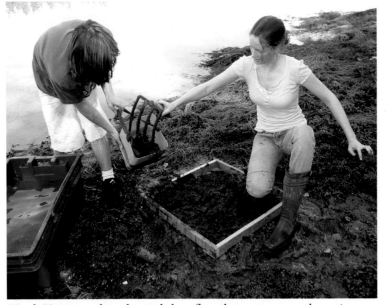

North Haven students located clam flats that were once a lucrative source of income for island residents.

skills taught at the summer institute by independent filmmaker Doug Campbell and Mike Kimball, assistant professor of anthropology at the University of Maine at Machias. Each interview investigated a different aspect of the island's once-thriving clam industry, now comprised of a few open flats and a small number of harvesters. Students plan to locate and reopen some of the flats that were formerly a lucrative source of income for island residents. As part of this project, teacher Louis Carrier says students hope to join the Department of Marine Resources' water-testing program that determines when flats need to be closed and when they are safe for reopening.

In one interview, Kate Quinn, a native islander whose father supported their family by clamming, explains how her mother prepared clams for the family and for sale to the public. Another records a cold, rainy day on the clam flats with Adam Campbell, Pulpit Harbor harbormaster, giving students lessons on how to locate clams and the equipment and technique for harvesting.

The third interview records Jen Litteral, marine programs officer for the Island Institute, as she explains the biology and physiology of clams. She also covers federal and state regulations for harvesting clams and gives details of the different pollutants and contaminants that clams can take in and the infections they can pass on to people.

Students in Islesboro Central School's horticulture class had begun to compile a list of island residents they hoped to interview to learn about the cultivation and use of the many apple varieties they had found on the island. They began with people who brought in apples for pressing on a donated apple press. They hoped to locate additional volunteers by putting out a flyer and a notice in the local paper to explain their project and invite people to share recollections.

On Vinalhaven, middle school students were also looking for volunteer participation by residents, in a quest to document changes that have occurred on the island and to determine if its historic way of life can be preserved. Teacher Rob Warren said that since students had not been able to find information on old maps about earlier marine use of property, they hoped to obtain it from island residents. In January, the teachers and 35 middle school students were working to expand their interviewing skills before proceeding. To stimulate interest in the project, they planned to attend various public meetings, explain their needs and ask people to volunteer for interviews.

Members of each island school CREST team and other students they have trained have begun to use their GPS/GIS skills to produce maps that will be useful to their communities.

Aided by Marine Technology and Trades teacher Tom Duym, students from Deer Isle-Stonington schools were putting together a complex series of map "layers," including water salinity, currents, temperature, pollution sources, benthic types and the presence of sea grass for the coastline of lobster management Zone C. This information can help organizers of a hatchery located at the Stonington Lobster Co-op determine the most favorable locations to release their juvenile lobsters. "We will provide the base maps," Duym said, "and then students from science classes can go out and take readings for some of the information." Once the map layers are in place, they will be cross-referenced with fishermen's firsthand knowledge of the nooks and crannies of the Deer Isle/Stonington shoreline, adding yet another dimension.

Student Luke Sarndon, who is working on these maps, is also downloading information from the town and state that students will use for another CREST project—determining the number of coastal property transfers from year-round to seasonal residents. In an additional mapping adventure, teacher Anne Douglas and a group of sixth graders have

researched the location of old tidal mills on the island. After writing down locations, they will visit sites, obtain GPS coordinates and return to their computers to transfer the waypoints to an area map.

On Islesboro, where kindergarten students are working with ninth-grade buddies to put together an Island ABC book, each team has been assigned a letter, and all are brainstorming to decide what place, activity, person or thing on the island their letter will represent. "Some letters are easy," said teacher Vicki Conover, "like Q could be for the water taxi, QUICKSILVER, but others, like U or X, are stretching imaginations." In their travels around the island, students were taking fresh looks to come up with ideas for their group's letter, and they had already searched through historical maps and books to find names of obscure coves and points.

Islesboro students working on the Orchard Project will also produce their own map, which will pinpoint the location of each apple tree or orchard they have found and label the variety of apple. They hope these maps can be layered over plans for development and help identify any unique varieties that may be endangered. "We can collect scion wood from the heirloom trees and graft them onto root stock," said John Pincence, who runs the horticulture program.

Like Deer Isle-Stonington students, Vinalhaven Middle School CREST participants are concerned about the loss of working waterfront property and lack of affordable housing. They will use GPS and GIS to map transfers of year-round working waterfront property to non-marine use, combining their data with information already collected by the Vinalhaven Land Trust.

Deer Isle-Stonington students presented their gathered information as a website they made themselves.

Vinalhaven High School students have taken a slightly different route in using new technology, relying on a digital tape recorder provided by the CREST program rather than a camcorder to interview fellow students who are participating in the voyage of the FREYA, the 30-foot steel sloop vocational students refurbished over the past three years. Before the FREYA left, students recorded hour-long interviews with the sailors who would be participating in the trip from Maine to St. Augustine, Florida, and when they returned, interviewed them again. Now, says teacher Jud Raven, students will use an editing program, Audacity, to reduce interviews into two-

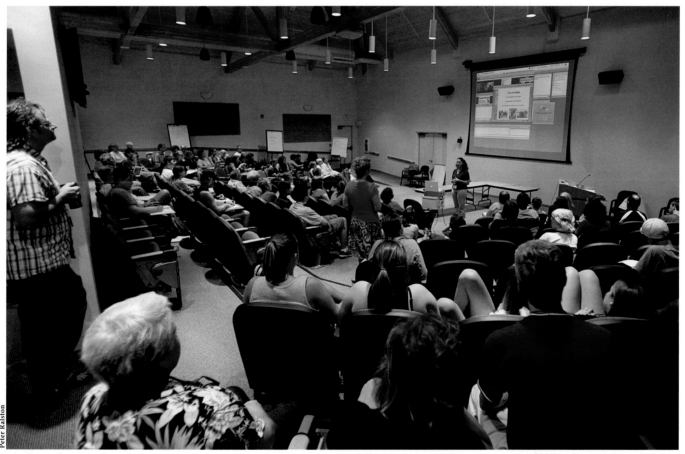

Students from each school present their projects at the 2008 CREST Summer Institute, in the Moore Auditorium of the Schoodic Education and Research Center.

Students from the 2007 CREST Summer Institute gather outside at the Schoodic Education and Research Center.

minute segments for broadcast on radio station WERU. In the future, students also would like to use their GIS skills to map the FREYA route and anchorages along the voyage, which they followed through journal entries posted on the FREYA website (http://vivasail.com) by fellow students Phil Hopkins, Niall Conlan and Chris Sawyer and teacher/captain Mark Jackson. Different students sailed on the voyage home, which began after February vacation.

By the end of this year, CREST participants are required to use their web-page training to set up a CREST website where they will share work completed on their respective schools' projects. Islesboro students, aided by Island Institute intern Ryan Albright, are also redesigning the Islesboro Central School's website.

At the Deer Isle Historical Society, volunteers Tinker Crouch, Connie Wiberg and Paul Stubing couldn't say enough about the pleasure of helping students with their CREST research. "They've been so wonderful," said Crouch, current president of the society. "We want to keep them all." Stubing added that when he served as president of the society, he tried several times to get school kids excited about the society's collections and their area's rich heritage. "This thrills us," he said. "We see that CREST is serving as a springboard, that some of the kids are becoming interested in more than just this particular project."

Joe Mills, who was looking for information on the "Island Boys" on that day in December, was one. "No," he said, looking up from an old newspaper clipping he was reading, "I haven't had any luck. I got sidetracked reading this."

2007

Learn more about this Island Institute program at www.islandinstitute.org/CREST.

Storing Knowledge

In a fishing community,
an interviewing project brings
young and old together

NANCY GRIFFIN

ILLUSTRATIONS BY JAN ADKINS

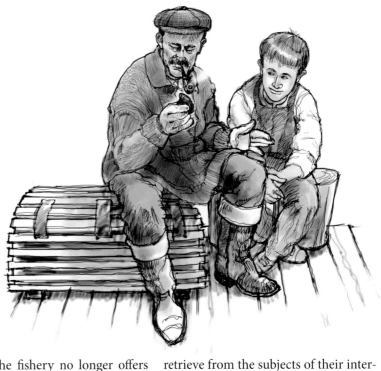

The world changes when you drive toward Jonesport from Route 1. Already communities have grown smaller than their counterparts to the south and west; houses are scattered here and there, as if the land had been stretched out, leaving long gaps between homes. The landscape and the light are, uniquely, Downeast Maine.

Sparsely populated Jonesport and Beals Island are true fishing communities, places where fishing—now mostly lobstering—is the economic mainstay, and where generations of fishermen followed their forebearers into the only way of life once imaginable.

In Jonesport, street signs are carved in the shape of lobster boats. Lobster traps serve as winter lawn decorations. In the off-season, lobster boats dominate dooryards. Boat dealers along the roadside display lobsterboat after lobsterboat. Sailboats and motor yachts are in short supply here, although one hand-lettered sign along the road read LOBSTER BOAT YACHT FOR SALE.

There's no escaping the fact that these are fishing towns, and as in many other towns nearby, families here count back generations of living by and from the sea. But what is happening in so many fishing towns everywhere is happening here as well. The fishing culture has been changing for many years and many reasons, including the loss of some traditional fisheries, more stringent regulations and fluctuations in the remaining resources.

And if the fishery no longer offers to provide a good, dependable living, the younger generation is less likely to be enticed into sticking with the family business. The kids know what's available in the rest of the world; even in towns like these, many youngsters know less than they should about the fishery, the fish and the traditional way of life that sustained their families for generations.

Enter the Local Fisheries Knowledge Project (LFKP) at Jonesport-Beals High School, funded by federal grants through the Rural School and Community Trust. This project is connecting youngsters with their town and often family histories through interviews they conduct with older town residents involved in some aspect of the fishery. All the information the students

retrieve from the subjects of their interviews is being loaded into a database at the National Oceanic and Atmospheric Administration (NOAA) for retrieval by scientists doing fisheries research, or by anyone who wants to read them. And the students have other, creative plans for their work.

The brainchild of a senior social scientist with the Office of Science and Technology within NOAA Fisheries, the LFKP began when Susan Abbott-Jamieson retired after 25 years as a professor at the University of Kentucky, took a new job and "heard three conversations going on at once" in her new office. Those conversations included the need for the Fisheries division of NOAA to do more outreach, a need to entice more young people into careers in the marine environment and talk about fishermen criticizing agency staff for failing to listen to or appreciate the knowledge fishermen have about fish, fishing and fish habitat.

"Over the years in Appalachia, I saw the effect of projects like Foxfire, in which students interviewed elders about their disappearing way of life," said Abbott-Jamieson. "Local fisheries knowledge is difficult for biologists to use, because of the way it's stored—it's usually in the form of stories. I thought we could put together a project that included all three."

She came up with the Local Fisheries Knowledge Project, an education, outreach and social science project in

which students would interview older community members involved in the fishery, videotape the interviews and share the interviews with the rest of the community. Interviews are transcribed verbatim and posted on the NOAA website (www.st.nmfs.gov/lfkproject) in a database that can be searched using many keywords.

The project is funded by a NOAA grant administered through the project's partner, Rural School and Community Trust, a national organization that works with rural schools throughout the country. During the first two years, Jonesport-Beals was joined in the project by Ellsworth High School, where students also conducted interviews. At Ellsworth High School, all 10th-grade students in English, science and social studies participated during the two-year project.

Of the eight interviews transcribed and loaded onto the NOAA database, six were done by the Ellsworth students, and include a shellfish dealer, two urchin divers, a seafood restaurant owner and a lobsterman. The two Jonesport interviews already posted are with two fishermen—Jonesport's Tuddy Urquhardt, 77, and John Faulkingham, 63, of Beals Island.

Interviews were not the focus of the 2005–2006 student group that worked on the project, partly because of the transcription backlog. This group, larger than previous teams, thought they would branch out to use the information as a fund-raiser, perhaps by preparing a calendar with pictures of the interviewees and studded with local historical information.

"They will use the pictures students have been taking over four years," said Linda Church, teacher of the "Entrepreneurship: We Mean Business" class at Jonesport-Beals High School and a project participant since the beginning. "When we interview the fishermen, we take pictures of the kids and the fishermen." So far, when interviews are conducted, all members of the student team have attended each interview.

"We created a PowerPoint presentation with music," said Church. "We have shown it locally and in Florida at a National Marine Science Foundation meeting." Equipment provided through the grant included a video camera, a scanner, a printer and a digital still camera.

Soundtrack music that students have recorded as part of the presentation includes Louis Armstrong's "What a Wonderful World" and Dan Fogelberg's "The Reach," said Jim Roberts, local project coordinator, teacher and consultant to the Rural School and Community Trust. "People are in tears when they see it."

The project affords students the opportunity to learn real-life aspects of history, science, social studies, economics, arts and language arts concepts and skills, say the teachers. As part of the curriculum supporting the project, students are assigned to read relevant books, such as Mark Kurlansky's *Cod*.

"There have been so many wonderful side effects of this project. One girl who got involved had no college aspirations. No one in her family had ever attended college," said Roberts. "But she liked the interviewing and discovered she had a talent for it. Now she's enrolled in the New England School of Communications."

Besides recording local fisheries history, the project has energized the historical society. "The Jonesport Historical society was just an idea," Roberts said, "We invited them to come talk about the project. Now the historical society has more than 130 members and NOAA has awarded them a grant of around $10,000 for technology to support their doing videos." Each year for three years, the students involved in the Local Fisheries Knowledge Project have presented the student work to the historical society.

Another development was the delivery by a local resident of a set of audiotapes made in the 1960s by a local historian, Alton Norton Jr. Norton interviewed local people who were old-timers back then, and in the background are the sounds of someone building a wooden trap. Students at Shead High School in Eastport offered to enhance the quality of the cassettes and convert them to digital format, using the school's state-of-the-art digital recording studio.

During the first years, students involved in the project were all older, but during the past school year, team members ran the gamut from freshmen to seniors. In Jonesport-Beals, if the interviewees are fishermen, there's a chance the interviewers are, too. At least three members of this year's team are fishermen themselves, and one is the grandson of a woman interviewed last year who spent many years working in a now-defunct sardine cannery. Lawrence Baillargeon, 18, of Beals Island fishes from his boat, THE HUNTER. Freshman Alan Crowley, 14 also from Beals Island, fishes 100 traps from his boat, LITTLE NOVI. Kristi Smith, 17, is a sixth-generation fisherman who started fishing in sixth grade. She fishes 500 traps from her boat, LITTLE UGLY. Pictures and short biographies of team members may be found on the NOAA project website.

"Ultimately, the point of this program is to preserve local knowledge," said Michael J. Kimball, associate professor of anthropology at the University of Maine at Machias. Kimball is the project advisor along with Jim Acheson, author of the iconic book about the Maine lobster fishery, *The Lobster Gangs of Maine*.

"I'm concerned about the science overrunning local knowledge—knowledge not from books, schools and diplomas, but handed down generation to generation," said Kimball.

The relationships students developed while doing the work in their community created "a tremendous appreciation of their heritage," added Kimball. Projects like LFKP are called "place-based education" in teachers' parlance, and their aim is not only to save local

knowledge, but also to give students an appreciation of their home.

Despite his interest in saving the local knowledge of coastal communities, Kimball is neither a Maine nor a coastal native. He was born and brought up in Western Massachusetts, hours away from the coast. But he developed an interest in archaeology that took him to an internship in Edinburgh. On the advice of an advisor, he didn't pursue his graduate studies in Scotland, but in Ireland, where the coast won his heart. He followed Ireland with Bar Harbor's College of the Atlantic and found Downeast Maine "similar to Ireland. I fell in love with it."

Kimball wrote a grant for his department to enable to help him to invite distinguished speakers to his class. "I did one on cultural conflict and consensus," he said. The invited speaker, a Harvard College faculty member, spoke not only to Kimball's class, but also to several of the LFKP students who were invited to the Machias campus. "We got my senior seminar students involved. The speaker led us through an interesting problem—the issue of coastal access and some beaches being off-limits in Jonesport-Beals. The kids blossomed. They got to talk about what they know best—their families, their town and the issue.

"One of the things traditionally missing from education is the notion that the place where you are is relevant," Kimball said. "If you travel, the place you go finds a place in your heart. It has all to do with your compass and caring for places not otherwise connected to you. If you start here and make connections to things going on in your community, it creates a sense of excitement, exploration and possibilities. We live in an age of information overload. The curious part that wants to go deeper often just goes to sleep. Projects like this ignite the spark."

And if the local kids from the multigenerational fishing families are benefitting from the chance to save their families' histories, they are not the only ones, said Kimball. Like the professor, some students learned to appreciate the coast after living somewhere else.

"One of the kids is from New York City. His dad was in the Coast Guard," said Kimball. "There were five shootings in his New York City school one year, so his dad looked on the Internet for a safe place with a good basketball team! He found Jonesport-Beals. This kid is so passionate about protecting coastal access. It's a powerful thing to watch these kids."

2006

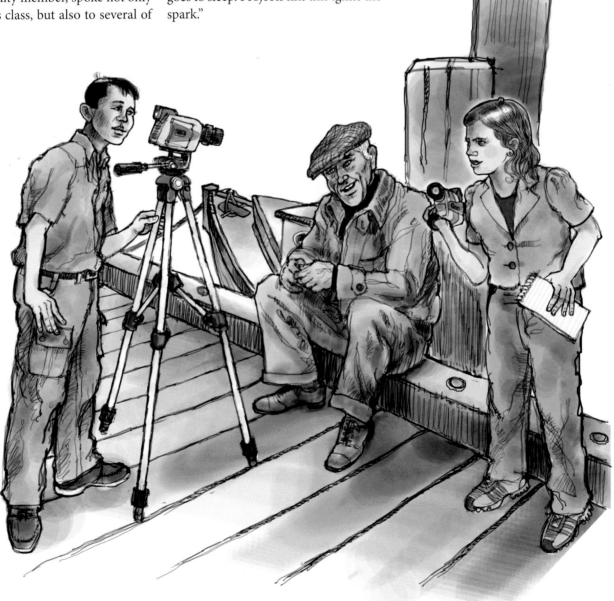

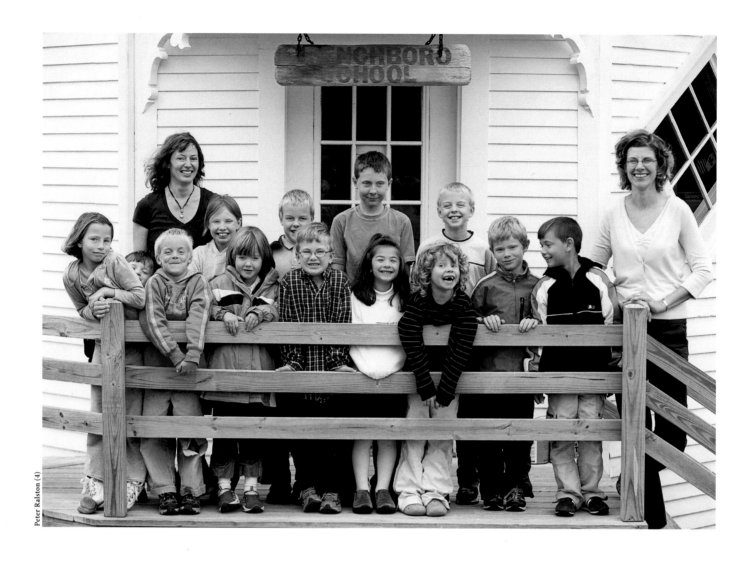

Peter Ralston (4)

The Sound of Youth

Frenchboro fills its school and finds its future

PHILIP CONKLING

PHOTOGRAPHS BY PETER RALSTON

In the early 1980s when the population of the one-room schoolhouse on Frenchboro had dwindled to a single student, David Lunt knew the island was at a life-threatening crossroads. Without children, there is no school; without a school, there are no young families; and without young families, an aging population just peters out—like a Shaker village.

A generational saga: Students in the above photo, taken in 1988, are now either parents of, or related to, several children in the photo to the left, taken in 2006.

David Lunt's solution was visionary, if improbable: The town would seek to obtain a piece of land, build a handful of new houses on it, and convince young families to settle there. David lobbied the town (where he was the first selectman) and the school (where he was board chair) to approve the concept. He convinced the highly territorial lobstermen (in Lunt Harbor, where he owned the only lobster-buying and bait operation) to make room for a few more young fishermen with families. He convinced the Rockefeller family, which owned a thousand undeveloped acres on Frenchboro, to donate 50 acres to the new, nonprofit, Frenchboro Future Development Corporation (FFDC), and he recruited a few off-island organizations, including the Island Institute and the Maine Sea Coast Mission, to help out.

By 1987 the FFDC had acquired a $450,000 low-interest loan from the Maine State Housing Authority to build seven new houses. Two years later the community began looking for young families, which some of the older, less-delicate islanders colorfully referred to as "breeders."

After a promising start, events quickly overtook the islanders. The national media picked up on the modest advertising Frenchboro had initiated. A headline in the National Star tabloid read "Come Live with Us on Fantasy Island." Unimaginable opportunities awaited anyone who applied for the seven houses that were virtually free for the asking, the article implied. Over a thousand applications poured in, each dutifully read by the committee of islanders Lunt had assembled to screen them.

The FFDC had asked applicants to detail how they proposed to make a living and pay their mortgage on an island where there were no stores (not to mention movies or entertainment), where there were no ready-made jobs, and where a ferry connected them to the mainland only once a week.

Many imaginative and idealistic people thought they had the answer. A cowboy proposed to graze his herd of 50 Texas longhorns on Frenchboro's thousand undeveloped acres. A woman writer had signed a book contract and needed peace and quiet to work on her manuscript, tentatively titled *Women Who Murder.*

After sifting through the applications and conducting face-to-face interviews on Frenchboro during a midwinter visit, the islanders had by 1990 selected the initial group of six families to come live with them on Reality Island. And reality proved to be harsh: Within three years, five of the six original families had "removed." Two were fishermen from Massachusetts, one of whom had suffered through a divorce. The other owned a small boat whose engine had failed offshore on a bitter winter day. A nasty northwest wind blew him farther and farther out, and he "kind of lost his courage," said David. The women among the settlers were more isolated than their husbands, and many felt estranged from their new community.

By 1998, the school population had bottomed out again—down to a single student. Still, several of the new houses had been rented by young, still-childless families who were deciding whether or not they wanted to make a long-term commitment to island living.

Slowly, however, nearly a decade after the first settlers had arrived, the waters around the island stopped reced-

ing. The island's schoolteachers were as instrumental as any in turning the tide. Becky Smart came to teach on Frenchboro in 1999 from Milo, her hometown, where she had returned fresh out of college with a teaching degree. She was impressed when the whole Frenchboro community turned out to meet her during her interview, after she had applied to teach the island's two students. She taught for two and a half years, during which she married Mike Lenfesty, who had originally come to the island to be a sternman for his sister's husband.

A few years earlier, a Methodist minister and his wife, Rob and Lorna Stuart, had sailed into Frenchboro and fallen in love with the island—an easy thing to do when you round up into Lunt Harbor on a summer's day and first see the picturesque anchorage framed by the church and school at its head. Something in the demeanor of the Stuarts apparently appealed to David Lunt, who offered to sell them a small piece of land he owned so they could build a house and retire to the island. In the spring of 2001, David asked Lorna Stuart to take over from Becky in the schoolhouse, where there were then three kids in school.

Rob Stuart credits his wife with helping to change the culture, first in the school and eventually on the entire island. "Lorna taught children always to look people in the eye and to introduce themselves and shake their hands," he says. Although islanders had always waved to each other when driving by, some had avoided simple eye contact in other contexts, especially with people they did not know well.

From that simple beginning, other changes began to happen. Becky remembers attending her first baby shower on the island: "People I did not even know came. They just wanted to hold the baby to see a new life on the island." Becky also remembers another turning point for her new family on Frenchboro. "Three years ago Mike lost his boat in a storm. It was smashed all to pieces on the rocks. It was a hard

day. But the community all got together. Several people dragged the pieces up on the shore to burn. One of the fishermen, Lewis Bishop, gave Mike a job as a sternman to make it through."

Meanwhile, the school population slowly increased as the initial batch of settlers' children reached school age. In 2004, the school population edged up from three to five. The following year it doubled to ten and Lorna needed a helper. Lorna and the school board,

David Lunt lobbied for new homes and settlers for Frenchboro.

where Becky was chairperson, recruited Rachel Bishop, the wife of lobsterman Lewis Bishop, to work half-time with Lorna. Rachel and Lewis's son, Lance, was the oldest student in the school, so Rachel was familiar with the school's limits as well as its opportunities.

"Things present themselves," said Alan Davis. The Davis family was among the original families who settled Frenchboro with the Lunts in the early 1800s. But Alan's father, Ben, a contemporary of David Lunt's in the early 1960s, left the island to pursue a career in the Boston area. "Mentally my father never left the island, even though he worked most of his life in a high-tech science career for Polaroid and bought a home in Massachusetts," recalls his son Alan. "He was always a Mainer; he always voted up here." Alan continues the story of his own return to Frenchboro with his wife and two little girls: "When my dad died and we got the house, I was working for a software start-up, and I realized I could telecommute from here. I had health insurance and a job and it was an opportunity."

Alan Davis and his wife, Erica, and

their two daughters, Lily and Hannah, had spent time every summer in the Davis house on the east side of the harbor. "When the girls would come up for the summer, there would be this big sigh of relief. They just knew they could go outside and get some sticks or something to play with. They could run around without shoes on. They could go down to the harbor by themselves and enjoy life like it was for kids 100 years ago. No play dates, no commitments and no schedules. So I watched that and wanted to get back here, the way my dad did."

When Rachel took over from Lorna, the Davises had been on the island during the school year. Erica Davis had taught third grade in Massachusetts for eight years. David Lunt asked Erica to work half-time with the upper grades. Things had just presented themselves. . . .

As the echo of the echo of the baby boom continued on Frenchboro, Becky, who has three children herself, decided to start a preschool program in 2003 to help young kids develop the kind of social skills that are very important in the small, multiage teaching environment of Frenchboro's one-room schoolhouse. Three of David Lunt's grandsons, Nate, Zach and Travis; a granddaughter, Kristy; and a niece, April, had settled down on the island. The 10th generation of Lunts all enrolled their kids in Becky's preschool program to help get them ready for school and, not coincidentally, get a break from the isolation of child-rearing that can overwhelm fishermen's wives.

Now, amazingly, the Frenchboro School is bursting with 13 students— seven in the younger grades taught by Rachel, and six in the upper grades taught by Erica. If you visit, you are likely to have the memorable experience that Rachel Bishop has continued for the younger grades: Students line up to introduce themselves to you, trying as hard as they can to look you in the eye as they greet you. It is good to meet you, Austin, Myron, Amber, Elijah, Hannah, Saylor, Brody and Ter-

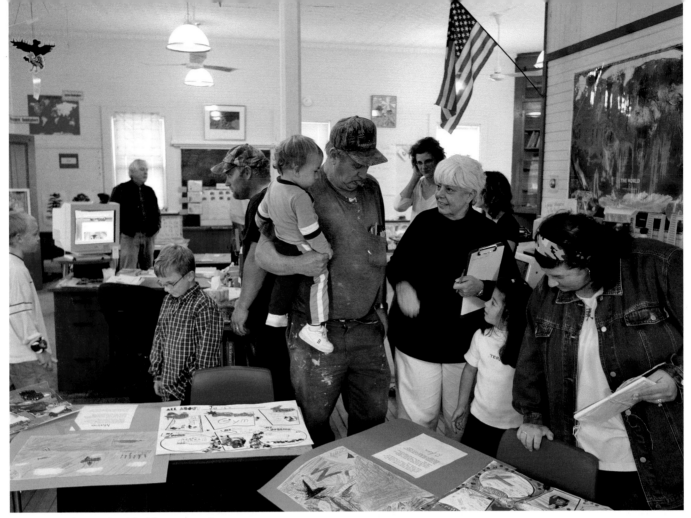

The Frenchboro school holds an open house.

essa. Across the room Erica is giving the older kids, Lance, Lily, Cody, Dylan and Jesse, reading assignments before they head downstairs to the newly conditioned "science lab" (and gym and art room), stocked with an aquarium full of both common and mysterious forms of sea life that lobstermen in the harbor have helped provide, as well as other materials.

Erica is amazed by this group of students. "The kids don't get here late," she said. "Whenever I get here, there are kids waiting to go to school. Kids love to be here."

When we at the Island Institute organize lessons about other Maine island communities that we work with, we ask the students for their definition of an island. Before the Frenchboro students get around to the definition of "water all around," their first three excited answers are "beaches," "sea smoke" and "sea glass," which all speak to their grounding in a strong sense of place.

Ask the new young families—or some of the old-timers—on Frenchboro why and how Frenchboro's wildly improbable homesteading plan has worked, and a number of themes keep emerging. First, people truly credit David Lunt's "tremendous insight, tremendous vision," in Alan Davis's words. Rob Stuart, currently a town selectman and also an Internet businessman who locates rare books for customers, remarked that David Lunt "did not have a lot of experience in process, but was successful because he didn't spend time worrying about the naysayers."

Frenchboro also presented itself as a welcoming community at the outset. However, cautions Alan, "We are a welcoming community under [certain] conditions: we are not giving away homes in a lottery." As Becky says laughingly, "They wanted us and now they have us."

Equally important, the community was willing to make changes as problems became evident. "It really changed after they opened up the opportunity to fishermen," Alan says. Now that there are 15 fishermen in the harbor, there is an added benefit, Becky says: The older fishermen are "happy to have a few more to help hold their ground."

The community was also willing to address some of its hardest cultural problems, matters it had been obliged to face as it bottomed out. As Alan Davis describes it, "I remember a lot of the older fishermen. It was a pretty rough place. They came in from fishing, bought their bottles, and drank until they ran out of money, and then went fishing again. Sternmen can earn $30,000 to 40,000 in a season of fishing. That's a lot of money for a young kid, and some of them wanted to raise a lot of hell. It's been flushed out of Frenchboro. The church had a lot to do with it. There's no need for that kind of escapism."

Frenchboro clearly faces a lot of challenges as it moves into the future. Alan describes the community as something "like a helicopter, with 40 different pieces moving in different directions—but somehow it flies." Nevertheless, it's just as clear that Frenchboro does have a future, captured in a collective sound. "All the older people say they know it's 11 o' clock when the kids get out for lunch," says Becky, "because they can hear the kids laughing and screaming around outside. It's the sound of youth!"

2007

31

Going "Up" to School

Some island commuters start at an early age

FRANCES LEFTKOWITZ

I t's a miserable day for a boat ride. At 7:15 a.m., it's dark, cold and threatening to snow. Clouds cast a gray pallor on the water and Peaks Island's bare trees, a grimness mirrored by the industrial gray of Fort Gorges and Portland's waterfront, even the battleship gray of the Casco Bay Lines ferry MACHIGONNE II.

With the precarious timing of the young, a group of seventh graders rounds the corner just as the boat pulls into the Peaks Island dock. Oblivious to the weather, the kids join others already lined up at the dock, wearing oversized backpacks and mingling with the nine-to-fivers in suits and heels, house painters carrying thermoses, teenagers with green hair and pierced faces. The ferry, with a capacity of 350, has standing room only, and kids are shouting at each other about homework, basketball practice and what was on TV last night.

Four of the islands in Casco Bay have elementary schools, for children in kindergarten through fifth grade. When the children reach sixth grade—a tender age for some—they head off-island to school. Chebeague Island kids go to Cumberland schools, while students from Cliff, Peaks and Long head to Portland, to King Middle School, then Portland High.

Going off-island for school is common for Maine's island residents, but in Casco Bay, the contrast between the island setting and big-city mainland schools is particularly stark. The children who make the crossing two times a day, five days a week, go from one-room and two-room schoolhouses into the largest, most cosmopolitan city in the state, a place where most of them have never visited without a parent.

"It's a major jump from the elementary school sector to the middle school sector," says Miriam Remar, director of elementary and secondary education for the Portland Public Schools. The kids are at an age, 11 and 12, when they are also negotiating jumps from childhood to adolescence and from dependence on their parents and families to independence. Going to a new larger school requires them to switch teachers and classroom for every subject, adding to the difficulty.

While there are always transitional issues for this age group, the issues are compounded for the island children. When they make the transition to sixth grade, they go "up to Portland" from a small town where everyone knows everybody, to the noise, traffic and crowds of the city.

"Here, they've had me for three years," says Paula Johnson, one of the two teachers at the Long Island elementary school. On Cliff Island, which has a one-room schoolhouse, the students have one teacher for six years. Still, commuting to Portland serves as a bridge between island and city, and may help with the child's other transitions as well.

Children gain confidence and self-reliance as they learn to navigate streets, pay phones and public transportation. "In fifth grade, if I had the choice to come 'up' by myself, I probably wouldn't have," says Tonya Mulkern, a seventh grader from Peaks Island. "But now if I had the choice, I probably would, because I know the area better." After sixth grade, most island kids make the trip on weekends and vacations with peers rather than parents.

On the MACHIGONNE II, Aaron Schuit and Isaiah Oliver, both seventh graders, climb the stairs to the second deck. "This is where our friends sit," explains Aaron, who is dark-haired and serious. "The kids who horse around hang out downstairs. Upstairs is quieter."

He and Isaiah take the 7:15 boat, except on days they have morning basketball practice; then they take the 6:15. A school bus meets them at the terminal, then brings them back for the 3:15 p.m. boat at the end of the day. If they have sports, clubs, or friends to visit after school, they walk to the terminal and take a later boat home.

The worst part of the commute is having to get up so early. "I used to just roll out of bed and into the school," says Aaron. While the logistics of commuting doesn't seem to bother these kids, getting them from the islands into King and Portland High is so complicated that hardly anyone seems to know exactly how it's done. Other than the children, the only ones who really know what's going on are the transporters—the bus drivers and boat crews who move them to and from the islands every day and make sure they get to school on time.

The boat pulls up to the terminal, and Isaiah and Aaron put on their packs and start down the stairs. Before going to King, Aaron had never gone into town by himself. Isaiah, taller and with sandy blond hair, used to do it "sometimes." But now they go almost every weekend. Today the boys have a deliberate non-

chalance, but one can imagine them as 11-year-olds, smaller, more timid, making the initial crossing. "The first day, all the kids from the island stuck together," says Aaron.

The school kids shoot off the boat and into the parking lot, where several yellow buses are idling. "Bus 17 is the one that the middle school kids get on," says Tonya Mulkern. The bus comes to a halt in front of the school, and the kids run off to find their in-town friends, who are tumbling out of other buses. Like Tonya, the other island kids enjoy parts of Portland, but would never, ever want to live in the city. One Portland

The kids say "hi" to the deckhands and settle into their seats, the middle-schoolers under the stairs, the high-schoolers by the doorway. Less than a hundred people ride this boat, and they all seem to know each other by sight. Less anonymous here, the kids seem more sedate than those who take the Peaks ferry. Then again, they may simply be tired.

"It's a long day," says Terra Parker, a freckle-faced sixth grader from Long Island. "You get up at five and you don't get back till seven if you have activities, and then you have to do your homework. But like the Peaks students, these

thing as simple as a visit with in-town friends seems daunting. But Terra's eighth grade sister, who has mellow red hair and a sophisticated manner, says, "It's not that hard."

On the day-to-day level, King Middle School teacher Karen MacDonald says, "One of the things that can be difficult is doing extracurricular activities. And that's really part of middle school." Long Island teacher and parent Paula Johnson points out that something as minor as a five-minute detention can throw off the whole delicate schedule of buses, boats and carpools. And unlike Peaks kids, who will wait no more than an hour for the next boat, "If the kids miss that boat at 2:45 p.m., they're stuck in Portland till 5:45 p.m. They wouldn't know what to do with themselves for three hours. And the parents wouldn't know why they didn't show up." Johnson has arrangements with the King teachers for kids to serve minor detentions at the island school, to help with this problem.

"Missing the bus is the kids' biggest worry," Johnson says. A parents club used to give watches to the graduating fifth-grade class, until they started showing up with them on their own. Now, those with digital watches like to set them to beep at 2:25 p.m., when the school bus leaves for the terminal. If they miss it, they have to walk 35 minutes through downtown Portland, then wait for the late boat by themselves.

girl, who likes to visit her friends on the island, says, "It's better out there." Her island friend, in a green coat and purple earmuffs, says, "You can stay out later," and the Portland girl adds, "It's not like Crime City."

By 2:45 p.m. a veneer of snow, the first of the year, covers the city. At the ferry terminal, the children scramble off the school buses and head for the benches on the dock. A couple of them go straight into the MAQUOIT II, which is waiting to take them to Great Diamond, Long, Chebeague, and, finally, Cliff, a whopping hour and fifteen minutes away.

kids are hardly fazed by the commute. Terra says, "The boat—it's really good—they have tables so we can do our homework." This year she played field hockey, along with her older sister, Billie, and her island friend, Moira Johnson. On practice days, the girls missed the bus and had to find another way to the boat. "We found a ride," says Terra matter-of-factly. "We didn't pay him. We gave him lobsters instead. He was our godmother's cousin."

While the Peaks ferry runs almost hourly from early morning to late at night, the boats to the outer islands are few and far between. Scheduling some-

Facing school in Portland, island kids worry about noise, crowds, and the school cafeteria. Sitting in her classroom at the island school, Paula Johnson says, "That's what they are afraid of. They don't know how they're going to get their food." She points to the 10 desks, arranged in a cozy horseshoe. "Here, we all eat at our desks." Her daughter Moira, who's at King now, says the cafeteria, "was strange at first. It's so loud; the kids all walk around."

On the boat, the girls elaborate on

the differences between the island and city schools. "On the island, the biggest grade has five or six people," says Billie Parker. "Some grades only have one or two," and the school has 20 students total. "At King," her sister Terra says, "There are hundreds of kids just in your grade." Both girls say they were "wicked nervous" on the first day of sixth grade, and Terra, who has only been commuting for three months, can still remember her first bus ride through the streets of Portland. When she tried to visualize the return trip, she felt overwhelmed. "It looked like a 'wrong way' from school. I thought if I ever missed the bus, I'd never find my way."

The boat slows down at Great Diamond, where today there is a lone passenger getting off: a girl wrapped in red pants, blue windbreaker and pink mittens. "She's a third grader," says Sam, another Long Islander. Diamond has no school, he explains, so she goes to Longfellow Elementary in Portland. She makes her way to the ramp, teetering a bit under the weight of her purple backpack and the roll of the boat. There's no school bus driver here to make sure she gets off at the right place. What if she misses her stop? "She won't," says Skyler, who's sitting next to Sam. "It's a feeling." He unplugs his Walkman from his ears. "Dude, you can fall asleep on this thing. I can tell when it slows down; only at Cliff, though."

Two students come over from Cliff Island. "There's me and my older brother," Skyler says. Of all the student commuters, they are the first to leave in the morning (6:15 a.m.) and the last to get home (4 p.m.). It's no wonder that "Sky," who is 12-going-on-40, says all he does on the boat is "Sleep—that's all there is to do."

"Transition is something we've worked on," says Long Island teacher Paula Johnson. She preps her students by taking them on lots of field trips into the city. "And when we're in there, we go for the day," she says. "That gets them used to being around other places."

Still, says Johnson, "transition is really hard. I'll hear it from the parents in the summer about how frantic their kids are." King sends a school map to incoming students, and one of Johnson's recent fifth graders spent the summer memorizing it.

"One thing that's made the transition easier is the crew of the boat," says Johnson. "They really look out for the kids." On Moira's first day, she was the only sixth grader, and the school had to arrange special transportation for her. When the bus didn't show up in Portland, the captain of the ferry called the school to get someone to come down and pick her up.

Like Remar, of the school department, Dudley Coyne, King assistant principal, explains that all sixth graders are anxious about going to middle school. And though the "down the bay" students and their parents are especially apprehensive, he says, "It seems to go away in the first couple of days of school. It's amazing how they get over it."

At the Long Island dock, Billie and Terra get a ride from their dad, while Sam, Moira and Darlene, freshmen at Portland High, walk up the street, waving at cars, yelling out to pedestrians. When she first started going, Moira says, Portland seemed "scary and strange." But now she's "sort of glad to be going off-island for school. It's a change. You feel older and you get to meet different people. And you get used to going to town by yourself."

Darlene and Sam, who live across the street from each other, head for home and Moira continues up the road. She describes her first visit to King. "They took us up and walked us around the school. We walked the bus route in case we ever missed the bus." That's all, she says, but her voice, disappearing in the late afternoon air, seems to say more.

Later, in the two-room schoolhouse where Moira spent most of her childhood, her mother talks about the first day. "There's usually a contingent of parents down there at the dock, taking pictures. But Moira was the only one in her grade last year." She pauses. "That's horrible, when you're the only one." Then she laughs. "We had Moira's older brother on the float in case she needed him to go with her. But she went by herself."

1997

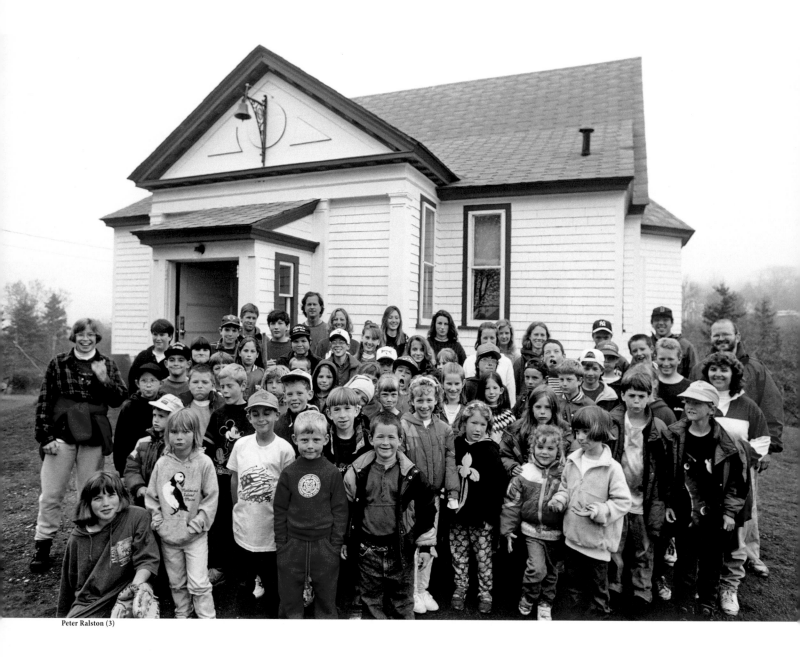

Peter Ralston (3)

Come Together

Island teachers, students and parents make new
connections to strengthen schools

JULIE ANN CANNIFF

FRENCHBORO
NOVEMBER 11, 1987

November is a risky month to go island school visiting, but the ferry to Frenchboro runs only once a week, and you have to take the invitation when you can get it. I boarded the boat at Bass Harbor, bound for my first visit to Frenchboro's one-room school, which, in November 1987, boasted a healthy population of nine students, ages five to 14. The ferry made its way past Black Island and Swan's before heading down the long passage into Frenchboro Harbor. The sky was gray and the wind cold; snow and ice covered the town in patches. I walked up the hill to the school, unmistakable with its new cedar-shingled, pyramid-style roof and prominent elevation.

Inside, teacher Annie Pye and children were competing with one another to answer trivia questions, ranging from geography to American presidents. Soon each "class" was busy working on math assignments while the teacher huddled with the kindergartners to test their counting skills.

After a busy, day which included practicing the songs for the Christmas program, I took a walk over to see the home sites which would soon house seven new families. The families will live year-round on Frenchboro under a creative "homesteading" program, started by the Frenchboro Future Development Corporation. Their goal was to strengthen the year-round population and safeguard the future of the school by guaranteeing a steady supply of children for years to come. The year-round and seasonal residents of Frenchboro recognized that without a stable, ongoing school population, the community would die within a few years. The risks were great—would the newcomers find satisfactory jobs; would they fit in; would they accept the isolation; would they support the one-room school, and be willing to send their children to the mainland in the ninth grade? It will be a few years before these questions are answered, but in the meantime, Frenchboro serves as a model for other island communities looking for ways to grow.

I woke the next morning and looked out the window of the Parsonage where I was staying. The wind was howling. It was starting to snow and the radio stated that ferries up and down the coast were not running. Like most mainlanders, I was anxious to return to shore to get on with my "normal activities." As luck would have it, we were able to locate a boat going ashore. A father needed to pick up a birthday present for his son and figured that since it was too nasty to go fishing, he would take a run into Bass Harbor. I signed on, and for the next hour "rode" that lobster boat like a contestant in a rodeo. I kept my eyes glued to the horizon whenever I could find it, while the captain lounged against the wheel and carried on a conversation with his crewmen and a variety of voices on the radio. We bounded into the wharf. I wobbled up the steps to uncover my car and steered it through a gathering blizzard.

The experience taught me my first lesson about working with island communities: Nature keeps her own schedule.

Maine island communities have not escaped the repercussions of today's transient society. All over America, the traditional community is a vanishing phenomenon. Today people live, work and play in different communities and are willing to pick up and move every three or four years following career or school opportunities. Like most other rural areas, the stability of an island community is directly tied to economic opportunity and diversity.

Just before World War II, most of the year-round islanders were self-sufficient, grew vegetables, raised livestock, fished and provided for education and recreation within the community. After the war, and as families began to recover from the Depression, island communities began to turn more consistently to the mainland for their services. Boats became larger and faster, designed for longer distances and equipped with technology to provide for safety in any weather. Basic necessities could be brought from the mainland, reducing the dependence on local suppliers. Outsiders bought homes, slowly reducing the number of year-round residents to maintain mail service, stores, schools and churches. As the economic diversity was reduced to one or two occupations, families began to move off the island, affecting school enrollment.

The population trend today is different for each island, but achieving a stable economic base so that young families can settle on the island and find permanent housing and productive jobs is a critical issue for most islands.

SWAN'S ISLAND
MARCH 8, 1988

My first impression of Swan's Island was how welcomed I felt—everywhere. With 50 students enrolled for the 1989–90 school year, Swan's is one of the largest K–8 island schools. There are three teachers for the eight grades: Kim Colbeth, Janice Staples and Helen Sanborn, along with a special education teacher and aides. Colbeth, who is also the school principal, works with the third, fourth and fifth grades. She explained some of the more exciting projects, including the whole-language reading and writing program, and the new home economics and woodworking classes. All three teachers cooperate on integrating units with each age group.

The Swan's Island Fishermen's Co-op is a major player in providing long-term stability for the community. Co-op manager Bruce Colbeth, who doubled as selectman until this past March, is also looking into affordable housing requirements on the island. With morale riding high, the community has embarked on building a $1.5 million school, scheduled to be finished in August 1990. The new school will also provide recreation and social space for islanders.

Before I retired for the night, I was treated to a videotape about the history of Swan's Island, written and performed by students in Helen Sanborn's sixth- to eighth- grade class. It made a strong impression. These students will always remember with pride the story of the island and the people who settled there. The next day I walked out to Burnt Cove Harbor Light and took in the view from the point. As I turned to go, a lobsterman, returning from a haul, leaned out of his boat and waved.

The Island Institute became involved with island schools in 1985. The issue then was communication—and it still is. Each school is part of a consolidated school district, school

union or community school. Most of them report to administrative offices on the mainland. Two of the schools, Matinicus and Monhegan, are part of the Unorganized Territories of Maine, and are served by state agents. The three high schools in Penobscot Bay are organized into two School Administrative Districts and one community school.

Until the first island school conference in 1985, most of the island schools did not communicate with one another. When a few parents, teachers and superintendents expressed a desire to meet with their counterparts on the other islands, a conference was scheduled on North Haven. From that experience, the conferences have continued each fall and spring, bringing teachers, school board members, parents, administrators and students together.

In doing so, the conferences have sparked yet another form of communication—school exchanges. During the past two years, students from Frenchboro, Great and Little Cranberry and Isle au Haut have traveled to one another's islands for classes, games and overnight fun. These exchanges have been facilitated enormously by the Sunbeam, the mission boat of the Maine Seacoast Missionary Society.

STONINGTON AND ISLE AU HAUT
JUNE 6–7, 1988

I am not a morning person, so meeting a 7 a.m. departure time at the Stonington dock requires a big pep talk at about 4 a.m. The mailboat didn't look large enough to accommodate 15 Cranberry Isles students, four teachers, plus me and any other passengers bound for Isle au Haut that spring morning. With all the gear piled three feet high in the center, and people arranged port, starboard and stern, we headed for the island.

Upon arrival, we walked the short distance to the school and dropped our gear. The children were assigned to silent reading and journal writing, while the adults quietly exchanged news about students and staff concerns. The rest of the morning we spent with the older children touring the island with

a visiting geologist, while the younger children played games at the ball field.

Getting right into the spirit of the thing, Isle au Haut parents set up a sumptuous potluck supper at the community building and extended the invitation island-wide. The beautiful June evening ended with a bonfire on the beach behind the school. The fire provided just enough light to find a comfortable spot to sit and watch the last of the sun, sing familiar songs and listen to a few stories before dividing up for bed. The younger children camped down in the school, while a few of the adults and older children made their way back to the community building and a couple of rented movies. I fell asleep before they figured out which to show first.

Island teachers are never without resources and generally earn their stripes by learning how to adapt everything in the universe to serve their goals. However, teachers turn over at a rapid rate in these isolated schools—on average every two years. Innovative units for teaching science, math, history, writing or geography to a class of 10 children, kindergarten through eighth grade, are often put in boxes and stored in the attic after the teacher leaves, never to be shared or developed.

The most recent program to benefit the staff and curriculum development of island teachers was initiated by the University of Maine, College of Science Education and the Island Institute. The first Summer Island Teachers Institute was held on Islesboro from June 24 through July 1, 1989. This program was made possible by grants from Title II Funds for Science and Mathematics, the Innovative Grant Program of the Maine Department of Educational and Cultural Services and the Clarence and Anne Dillon Dunwalke Trust.

ISLESBORO
JUNE 24, 1989

It had been raining for a week—not unusual for Maine in June. As I boarded the ferry in Lincolnville, I watched the clouds fight for position with the sun. The prospect of a week of rain for the 18 teachers about to start the first Summer Island Teachers Institute was not auspicious.

The ferry landed and a caravan of cars headed for Dark Harbor. Just as I turned down the driveway to the Clason home, our headquarters for the week, the sun came out and bathed the house's long wraparound porch in brilliant sunlight. Almost at the same time, early arrivals emerged from indoors to spread out on the porch and welcome the newcomers.

The next few hours were spent learning about one another as we met, chose bedrooms, rearranged furniture, checked out where the showers were, poked around the kitchen and discovered the beer and soft drinks. By dinnertime we had a pretty good take on the situation and headed out through the woods toward the school for our evening meal.

We were met by Superintendent Bill Dove and some of

the Islesboro teachers, who were also attending the institute. Picnic tables were set up outside the cafeteria door and dinner was served buffet style.

Back at the house, everyone gathered in the living room to hear Dr. Michael Brody and Dr. John Peterson outline the program for the week. The schedule didn't leave much time for goofing around, with lectures in the morning, field research in the afternoon and curriculum design class in the evening. Confident that things were off to a running start, I left the next day with plans to return on Friday, the program's last night.

Driving up to the house on Friday afternoon, and after a week of sunny weather, I noticed a very different feeling on the porch. People were lounging, reading or writing, but the pairings were different. The living and dining rooms looked well used, with piles of books and papers everywhere.

I was given a tour of the science lab at the school, where I inspected rows of saltwater aquariums, each filled with marine creatures resting on the bottom or climbing up the sides. Pride of ownership was evident as each teacher showed me his or her aquarium.

The evening session back at the house was very different from the first one, with people joking and teasing one another mercilessly. After concluding remarks by Dr. Brody, I asked the teachers to tell me why they had come, what they had learned and suggestions for the next time. Some common threads in their remarks were:

- It is good to study with other teachers who work in the same environment.

- It was great not to have to commute and to stay in one place and focus on the course.

- It was a chance to get to know people while not in a teaching role and to be with peers.

- It was a chance to work things through, follow through on ideas, and reality-test with other teachers doing the same thing.

- I thought I might leave teaching. This made me want to stay.

- It's all right in front of me. I don't need a bag of tricks, just the confidence to use simple things to expand my students' knowledge—and my own.

The Summer Institute will be held again in 1990. Teachers will once again get to work on a science curriculum focusing on the environment, or they can take a two-year course to develop a core curriculum of Maine Island Studies, from 1880 to 1980, including history, family life, music, art, literature, rites of passage, legends, architecture, immigration and the military.

What is the future for Maine island schools? Ask, rather, what is the future for the year-round Maine islands?

In the mid-1940s, Criehaven Island slowly disintegrated as a year-round community. The lobstering was exceptional, but the focus was no longer on the island; it was toward the mainland. Family houses were sold to outsiders. The store and mail service were offered only seasonally, then not at all. Finally, the island could no longer afford to hire a teacher and the school closed. The mothers moved off the island to put their children in a mainland school, and eventually the fathers followed. A once-vibrant village was turned into a seasonal fishing station.

That was more than 40 years ago, and from then until now the 14 year-round islands remaining have managed to keep their heads above water. But the specter of community collapse remains a real one, and many Maine islands are grappling with the complex questions it raises.

How can these islands provide enough housing for young families to come and settle? Some islands have an abundance of unfilled jobs and no workers. Other islands need to provide additional—and more diverse—job prospects. Once a commitment is made to provide options for growth in an island community, the school then becomes the means for perpetuating the vision.

By its centrality in the community, the school has a major influence on children's values and expectations, and can play two important roles. First, it can recognize the profound worth of the community and commit itself to the community's preservation. Second, it can help students clarify their values, expose them to options in the outside world, and support their choices either to leave the island, or to stay.

Teachers at isolated island schools need ways to interact with each other. They need an educational support system that validates their unique teaching assignment, and provides continued training for those who choose to work in small, multi-grade schools.

The great philosophical debate over the quality of America's educational system will go completely unnoticed by some of the country's tiniest schools. The 14 island schools of Maine are engaged in the simple task of teaching children—about their community, their world, and themselves. And they do it well.

1990

Arts & the Creative Economy

CARL LITTLE

The term *creative economy* was brought to national prominence earlier in this decade through the writings of the "maverick" regional economic development guru, Richard Florida, particularly with his landmark study, *The Rise of the Creative Class* (2002). In May 2004, Florida was the keynote speaker at the Blaine House Conference on the Creative Economy. The event showcased the contributions that creative individuals, businesses and nonprofits make to the Maine economy, even as it affirmed the potential for furthering the state's quality of life through support of innovative and inspired endeavors.

As a result of this conference, Governor John Baldacci established the Creative Economy Council to explore ways to tap the potential of this sector. At the same time, according to Donna McNeil, director of the Maine Arts Commission, communities across the state embraced the idea.

In the many materials related to the creative economy in Maine, there is barely a mention of island communities. Asked about this, McNeil cites Monhegan Island as "archetypal." Going back more than a century, the annual influx of artists has played a significant role in supporting the island's economy. Today, galleries, open studios and a five-star museum anchor a creative community in the summer, while a lobster fishery, itself based on an innovative concept of seasonal stewardship, helps carry it through the winter.

It could be argued that Maine island economies, by necessity, must be creative. While they may boast Wi-Fi and other communication amenities of the 21st century, these communities remain once removed. Creative individuals that choose to live on the archipelago must adapt and improvise to make a go of it.

If one were looking for a poster child for a Maine island creative economy, it might be Islesford, off the southeast end of Mount Desert Island. Barbara Fernald often showcases the island's resourcefulness in her column in *The Working Waterfront* and the local papers. Whether it's the boatbuilding school or a new community theater, she has plenty to report. Among 2008 highlights on Islesford was the trip islander Ashley Bryan took to New York City in December to be crowned a "Literary Lion" at the New York Public Library, for his life's work as an author and illustrator.

Fernald is herself a part of the island's creative economy, running a jewelry business from her home. In recent years

she has explored Precious Metal Clay (PMC), a moldable silver developed by Mitsubishi Materials in Japan in 1994. Her designs have earned Fernald a place in the wider world of fine art ornaments (she took second place in the PMC category at the 2006 international Saul Bell Design Award competition).

One of the drawbacks to working "on the island, Fernald says, is lack of contact with other jewelers. Through workshops at the Haystack Mountain School of Crafts, plus a few conferences, she has managed to keep a conversation going with other jewelers, although, she notes, "it is not the same as going down the road or walking into a studio next door to talk about design or technique." At the urging of island potter Marian Baker, Fernald recently launched a blog site.

Anne Sibley O'Brien, an award-winning children's book author, talks about the extra planning required to maintain a creative enterprise from a Maine island—in her case, Peaks Island in Casco Bay. "If I need to make copies or buy art supplies or run some other work-related errand," she relates, "I can't just take a quick drive somewhere; I have to plan a trip to town [Portland] on the ferry."

The advantages of remoteness for O'Brien, however, outweigh the hindrances. To begin with, there are few distractions and temptations to pull her away from her writing and illustrating. And there's the quiet.

Equally significant is community support. O'Brien reports excellent attendance at cultural events by part- and full-time islanders (around 75 people showed up for a book launch). "People are used to the lifestyles of self-employed artists," she notes, "so there's a high tolerance for strange hours and strange habits." O'Brien never feels judged; no one, she says, "suggests you should 'get a job.'"

When survival becomes the operative mode and the ripple effect of the recession spreads across the country, waving the creative economy flag becomes more difficult. Even so, states the Maine Arts Commission's Donna McNeil, economic woes "will strengthen the argument for creativity."

Meanwhile, McNeil reports, the Creative Economy Council has "morphed" into the Governor's Quality of Place Council, a new entity fostered by the findings of the GrowSmart Maine–commissioned *Charting Maine's Future* report by the Brookings Institution. Quality of place, McNeil explains, encompasses the sectors that will define Maine in the 21st century: "our historic downtowns, our beautiful natural landscape and our cultural resources."

Maine islands deserve special recognition in the inventory of this state's most cherished places. And we can learn a lot from islanders who are leading the way in terms of connecting ingenuity with economic development and nurturing the creative spirit.

ANDREW WYETH

A Man Who Loved Islands

CHRIS CROSMAN

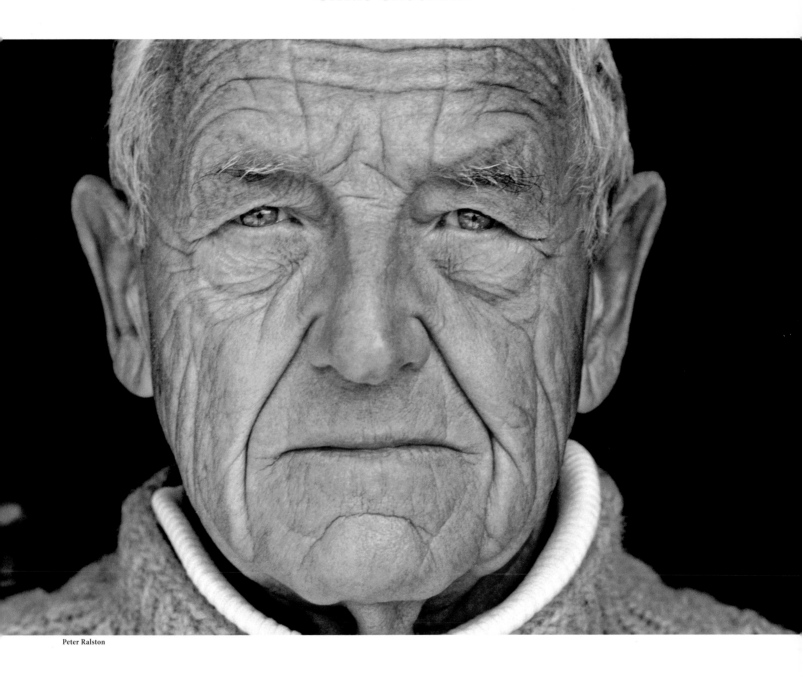

Peter Ralston

Then in the night, when the wind left off blowing in great gusts and volleys, as at sea, you felt that your island was a universe, infinite and old as the darkness; not an island at all, but an infinite dark world where all the souls from all the other bygone nights lived on, and the infinite distance was near . . . Strangely from your little island in space, you were gone forth into the dark, great realms of time, where all the souls that never die veer and swoop on their vast, strange errands. The little earthly island has dwindled, like a jumping-off place, you know not how, into the dark wide mystery of time, where the past is vastly alive, and the future is not separated off.

D. H. LAWRENCE, *The Man Who Loved Islands*, 1928

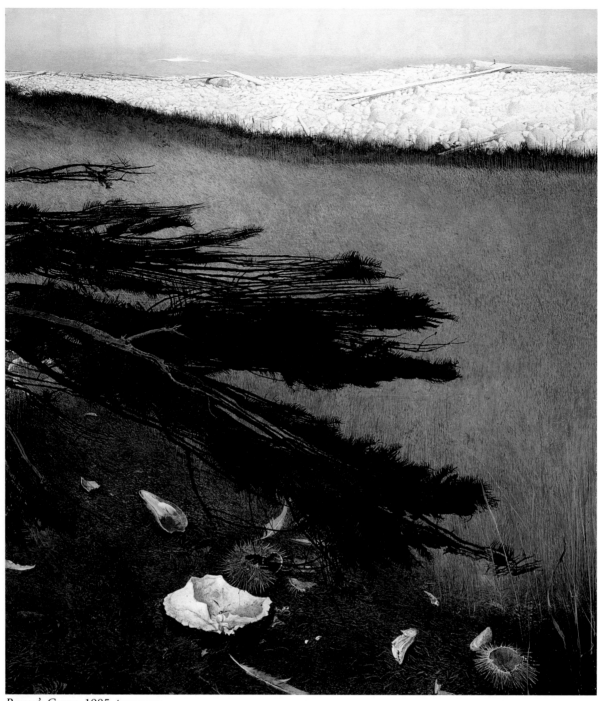

Raven's Grove, 1985, tempera

If it is true, as D. H. Lawrence observes elsewhere in his short story, that, ". . . even islands like to keep each other company," then Andrew and Betsy Wyeth have lived their long lives together as neighboring islands, each distinct and independent, attending to his and her own needs, interests and art. But not unlike Benner and Allen islands, they have shared close compass points, horizons and weather, emotional and otherwise.

While not an island scene as such, *Her Room* is among Wyeth's most powerful portraits of his wife and their maturing relationship. By the early 1960s, their children, Nicholas and Jamie, were becoming young men (with Jamie winning acclaim on his own with his first museum purchase by the Farnsworth museum in 1963, the year before *Her Room* was painted). As many have observed, the painting is strangely disquieting. The raking light from several directions at once

and an agitated St. George River threaten what is otherwise a portrait of calm and order—the carefully arranged and sparse furnishings, the precise order in ascending size of Betsy's seashells on the windowsill. Originally entitled *Eclipse* and referencing a solar eclipse occurring that summer, Wyeth evokes a psychological tension that is nearly palpable. Here is the uneasy equilibrium between an external wildness beyond sheltering windows and a vision of domestic imperturbability. A rising wind pushes against an open door—in the instant before the cracking shot of its slamming shut.

Downriver from the Bradford Point house and "her room" and many years earlier is where and when Andrew first encountered coot hunters and baitfish giggers engaged in the raw, wet work Maine watermen used to do to supplement meager incomes. They hold themselves perfectly poised to thrust or pull, second nature from countless hours of numbing rep-

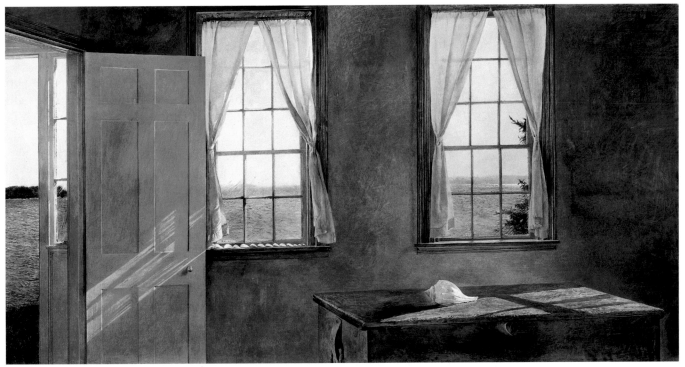

Her Room, 1963, tempera

etition in open dories and tossing punts. His early watercolors have a bravura quality, endowing his working-class subjects with Homeric prowess, strength and vitality. The watercolors are technically adventurous and recall another, later Homer—Winslow—one of the artist's heroes. They seem spontaneously to emerge out of free-ranging explorations of the intertidal zones near the family summer quarters in Port Clyde.

Teel Island was among Andrew's first offshore subjects, and it quickly became the place where he learned firsthand about island-ness and islanders. In *Coot Hunter,* Andrew's boyhood friend Walt Anderson is seen on Blubber Butt next to Teel Island. It marks a turning away from the dashed-off and technically facile watercolors that brought him early success to the mature works that are weightier, denser, darker and more grounded in everyday reality and experience. It also marks the beginning of Betsy's direct influence on her young husband's art, her insistence on the essential, told tersely, the telling moment or detail without unnecessary elaboration or anecdotal affectation.

Across from their family home in Port Clyde, "Eight Bells," Teel Island provided that emotional terseness found in utter simplicity—Henry Teel's skiff rotting in the weeds, the profile of the Teel house rising in the distance like a tombstone, the decaying, salt-encrusted rubber sea boots. For Wyeth, Henry Teel was like a character out of his father's illustrations for *Treasure Island* or Defoe's *Robinson Crusoe*—a retired pirate, perhaps, or simply a man who preferred his own company on an island where generations of Teels had subsisted before him in quiet, near exile, albeit self-imposed. *Teel's Island* and the tempera, *Sea Boots,* are posthumous portraits of Henry—used, battered and cast up by the sea. In the image of the empty rubber boots Teel was now doing, in Wyeth's imagination, "some soft walking," as Henry once described a drowned lobsterman whose body was never found.

Throughout Wyeth's work the nearness of death is coun-

tered by the brashness of youth, physical beauty and sexual potency. His long series of portraits of his closest Maine friend, Walt Anderson, is testament to this duality in Wyeth's art and captures, as much as anything, the sense of an individual insisting on being his own island—the willful independence, a wild, restless, even lawless disregard for rules and social conventions that seemed embodied in the life of his friend. In *Night Hauling,* young Walt is unquestionably hauling another fisherman's catch in the dark of night, a serious offense on the Maine coast where vigilante retribution is a far greater risk than punishment by law enforcement officials. In the ambiguously named *The Duel,* Wyeth had originally placed Walt sitting against the rock; in the final picture he is absent, and the portrait is couched in terms of endurance and ceaseless struggle, of men and the sea. In later works such as *Watch Cap,* and especially *Adrift,* a portrait of Walt lying in a dory, Walt's youthful indiscretions, his free-spirited dismissal of authority, are long past. Painted while Anderson was

Henry Teel watches Andrew Wyeth paint his dory on Teel Island in July, 1950.

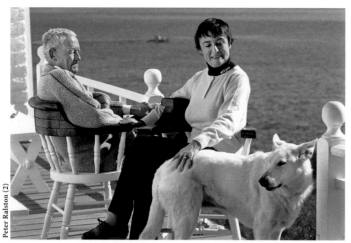

The Wyeths take in the sun on Southern Island.

dying of throat cancer, Wyeth somehow conveys impending death as a kind of primordial ritual and celebration, a Viking funeral, of being one with the sea, of Walt's undying individuality. In the distance waves are breaking over a submerged ledge, locally known as "The Brothers," and not coincidentally signifying an enduring bond and kinship between the artist and his unrepentant companion.

In 1978 Betsy purchased Southern Island at the entrance to Tenants Harbor. The ancient lighthouse had been decommissioned many years before and the attached lightkeeper's cottage was in serious disrepair. She intended the small but relatively accessible island to be a refuge for her husband and herself. Betsy quickly restored the island's structures, including a wooden bell tower, the interior of which, as a surprise gift for her husband, she meticulously transformed into a kind of stage set recalling Lord Nelson's quarters aboard his flagship at the Battle of Trafalgar. *Dr. Syn*, named for a fictional pirate as depicted in one of Wyeth's favorite vintage movies, is presented here as a skeleton/self-portrait in the bell-tower cabin. It was the artist's return gift to his wife. For both Andrew and Betsy, humor is an antidote to sometimes-difficult moments in their relationship. Paintings like *Columbus Day* and *Raven's Grove* convey not only isolation but distant and high horizons of a visually constricted world.

Wyeth's ambivalence toward islands—isolation and privacy on the one hand and freedom and escape on the other—informs nearly all of his Southern Island paintings. *Squall*, with Andrew's dark raingear and Betsy's dangling binoculars hanging next to her light yellow slicker suggests uneasiness as a condition of closeness and proximity. The surrogate protagonists are caught between a rising sea out the window and the steep, uphill pathway outside the door. Alternatively, the interior setting and raingear at the ready offer shelter and protection against external elements, and in their lives together. Rarely is there one way of looking at Andrew's art, especially when it comes to personal meanings and relationships.

Betsy is the woman who loves islands, to paraphrase Lawrence. Following a tip from her son, Jamie, she bought Allen Island, and subsequently, Benner Island, approximately equidistant between Port Clyde on the mainland and Monhegan Island. From Southern's mere yards to the mainland, now Andrew is miles out to sea; one can only imagine what went

through his head when he first heard the news.

His painting, *Skullcap*—a portrait of Susan Miller, a family friend, sometime island employee on Benner and Allen, and member of one of Maine's venerable fishing families—was painted nearly two decades after *Watch Cap*, the portrait of an aging and frail Walt Anderson. Like one of Wyeth's few heroes and antecedents, Edward Hopper, whose stylistic consistency remained throughout the entire arc of his career, and who also returned to subjects and ideas across decades, Wyeth reinvents and, indeed, reverses the emotional content of something he explored many years before. Susan, full of youthful vigor, her hair only partly controlled by the cap and spilling out behind her neck and back like cascading water, is, perhaps, Walt's younger, female alter ego. She is an "island girl," as tough, spirited and independent as Walt, and probably a good deal stronger and smarter, too.

The "Oar House" on Benner, as it is known by family and friends, became Andrew's final island home in Maine. The oar floating over the roof of the house, reputedly one of Henry Teel's own oars, serves as a simple, functional weathervane. The Oar House, whose exterior profile is a mirror image of Henry Teel's island home (the exterior masses are reversals of the two homes as if seen in a mirror), also serves as a fitting coda to Andrew's lifetime association with Maine islands and their inhabitants. It is featured in several of his late works, including *Airborne*, with its disconcerting hail of seagull feathers and the suggestion of unseen violence occurring just over the viewer's head. *Pentecost*, among Wyeth's most haunting later works, depicts drying seining nets on Allen Island. Allen was originally named Pentecost Island by the 17th century English explorer, George Waymouth, who discovered the island and conducted the first Protestant service in the New World there on Pentecost Sunday in 1605. Conjuring ghostly presences from its long history, as evidenced by Native American shell mounds, and as a way station for many generations of fishermen, the painting also evokes the fluttering curtains in *Wind from the Sea*, one of Wyeth's early, poetic renderings of Christina Olson, who was first introduced to Andrew by Betsy on the first day they met in 1939.

And there is no avoiding the poignancy of Andrew's final tempera painting, *Goodbye, My Love*, depicting Betsy Wyeth's newest addition to Allen Island and her "fishing village"—here an architecturally reimagined and exquisitely elegant Maine sail loft. Slipping out of view and heading beyond the frame, an antique Friendship sloop—once the mainstay of the nearshore fishing fleet—races toward the northern tip of the island (and, in a characteristically playful touch, requires an immediate tack to port if it is to avoid running up and onto the island itself). The title, *Goodbye, My Love*, was given by Betsy Wyeth, and likely, serves as a gently ironic reference to their ritual, weekly farewells as Andrew headed back to his mainland studio at the end of nearly every summer weekend. There is also the suggestion, as Betsy observed several years ago, that "a marriage that lasts as long as ours is a beat-up old ship."

Even without its title the painting points to the imminence of departures, its graying light fading not to black but to white—the color that Wyeth always associated with death—

and in the rippling, ethereal reflection of Betsy's sail loft in the deep gut between Allen and Benner islands. It's just like Andrew to throw a distorting wake into the still perfection of Betsy's world. It is telling, as well, that the artist's signature is nearly invisible, lightly incised letters AW inscribed by the blunt end of his brush into the shoreline embankment. Wyeth edited out the stone cross at the tip of Allen Island, commemorating George Waymouth's landing in 1605. Too topical? Like so many other island paintings over seven decades, this is not a work that stops time. It erases it, including tangible markers of mortality like the stone cross—most likely because it was pictorially inconvenient rather than because of its narrative content . . . although who can say? Most of all, its subject is in the artist's soft, shimmering touch, the way Wyeth seems to lift an image out of the supporting panel like a great pianist pulls rather than pushes music from the keys. The painting is the visual equivalent of an echoing finale, dimming imperceptibly and dissolving back into itself. Endings are also beginnings, as anyone who has ever walked an island can tell you.

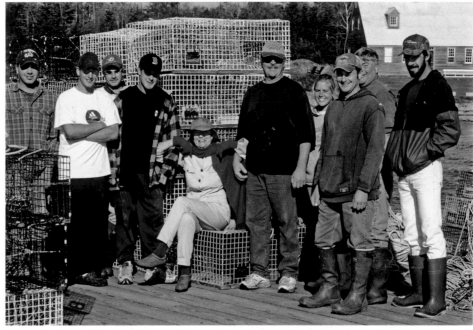

Betsy and "her" fishermen on Allen Island's dock.

~

If Andrew had given us a wider panorama of the shoreline in this painting, there would be a massive dock, far larger than necessary for typical pleasure craft or the needs of an island that is uninhabited for much of the year.

It is late summer, 2003. The families have come from Port Clyde and Friendship. Lobster boats and summer boats nuzzle the mammoth new dock erected over the past winter. Although the season is well under way, hundreds of lobster traps are neatly stacked along the edges of the dock and the nearby gravel road that leads up to several houses and outbuildings; even though they were built within the past several years, they look as though they have always been there. The buildings echo the once-thriving but long-abandoned fishing village on Allen, but this is no historical restoration. Scale, proportion, texture, color, utility, and what Betsy calls "the whisper of history" are what matter. This is Betsy's world, and her own late-in-life masterpiece where she has achieved, in the words of Philip Conkling, "a remarkable balance . . . between the natural and built environments—between the carefully developed 'island village' and the areas of the two islands that have remained wild and largely undeveloped."

The lobstermen and their families have come to celebrate her special gift to the heretofore rival and sometimes aggressively competitive mainland fishing communities located in the small coastal towns that bracket the entrance to Muscon-

gus Bay and the St. George River estuary—Friendship, Cushing and Port Clyde—one of the richest lobsterfishing grounds on the Maine coast. Children meander toward the barn and dozens of sheep dot the rocky field surrounding several houses, her island village of some 10 buildings.

The fishermen and their families (and their farming counterparts in Chadds Ford) are also the people the Wyeths care most about, and always have, stretching back to their earliest childhoods. Both Andrew and Betsy deeply respect and celebrate the ordinary, "real" people who populate their lives, imagination and art. The past, present and future of Maine islands are all here today. Part of Betsy Wyeth's genius is to knit time together and to provide elegant, simple solutions for messy, complex problems. Come to think of it, it's a trick her husband performed, too.

Betsy christens the Allen Island dock with a bottle of champagne and the party begins. Andrew is there, but on the edges of the convivial crowd, talking with his oldest son Nicholas and several of Betsy's staff assistants who are also family, friends and sometime models. He takes pains to not intrude on "Betsy's day."

On the dock Betsy dances with "her" fishermen like the rag doll she had been in Andy's arms as a seventeen-year-old in Rockland that night he asked her to marry him.

An ageless beauty, she is wearing a brilliant, red scarf—the color of Christina Olson's geraniums—wrapped casually around her white turtleneck. "The Lady in Red," her favorite pop ballad, drifts from the boom box across the dock and out to sea. Andrew's canyon-creased, weathered face relaxes in the sun and smiles with a lifetime's affection.

At this moment—as in their vastly alive past and not separated-off future—it can be truthfully said that Andrew Wyeth is a man who loved islands, as he so loved Betsy.

2009

More about Andrew Wyeth's life is online at www.islandinstitute.org/wyeth.

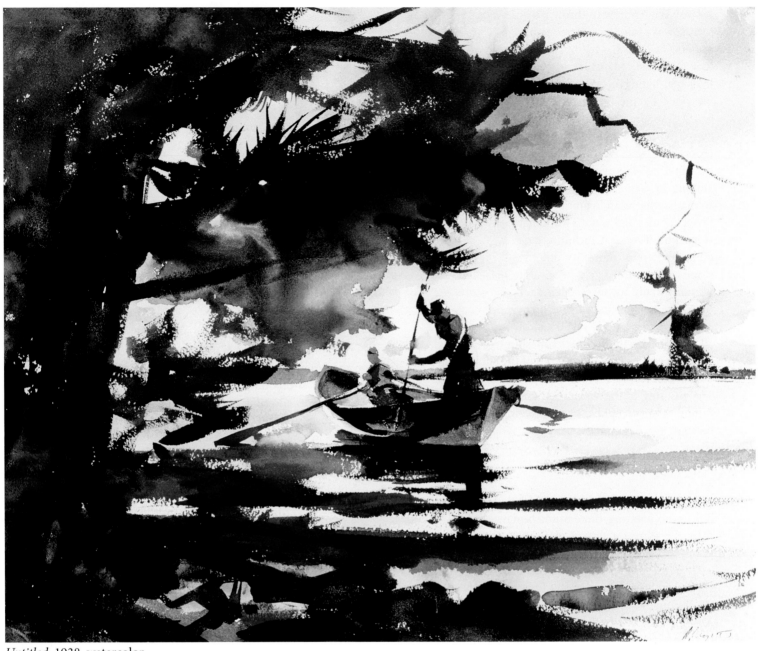

Untitled, 1938, watercolor

"I wasn't at either place to paint a nice group of pictures or bucolic memories or Maine images.
I was emotionally involved in the thing and I just had to get it out of my system. That's all."

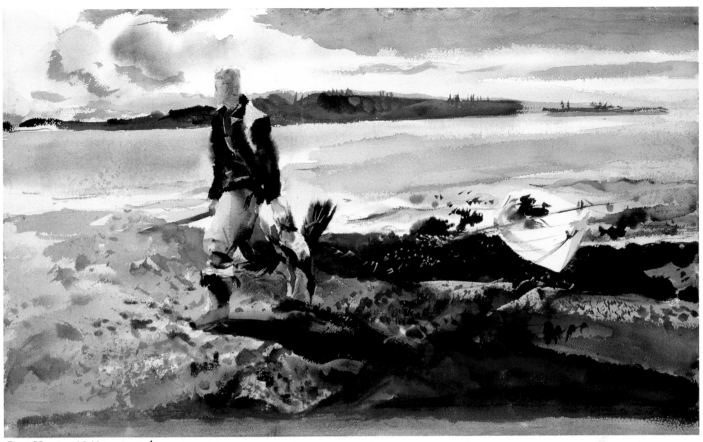

Coot Hunter, 1941, watercolor

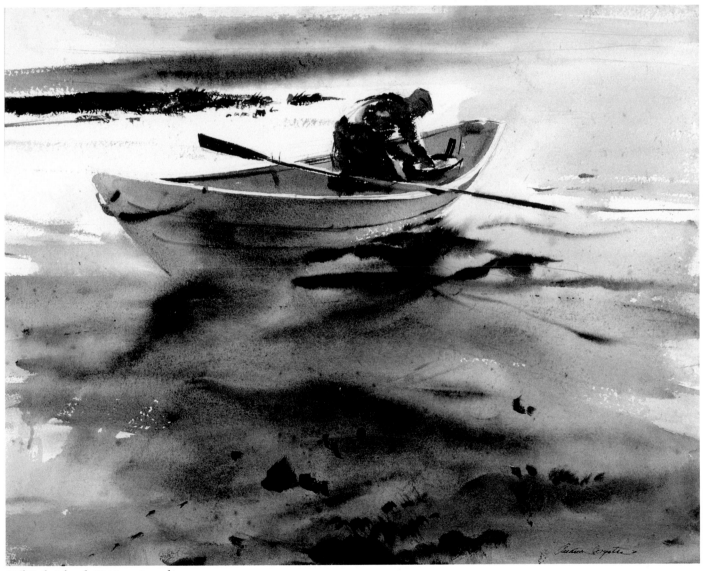

Off Teels Island, 1944, watercolor

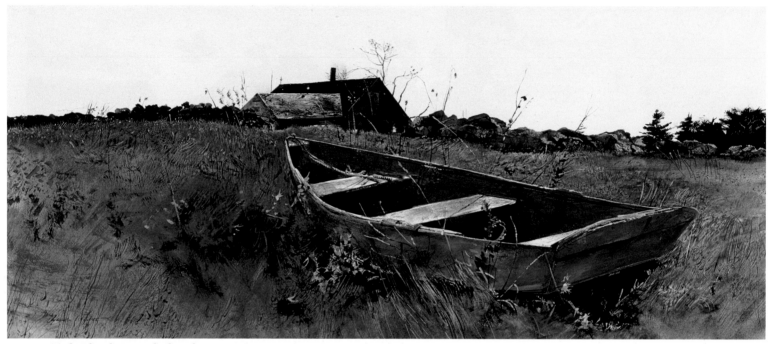

Teels Island, 1954, drybrush

"Henry Teel had a punt, and one day he hauled it up on the bank
and went to the mainland and died. I was struck by the ephemeral nature of life
when I saw the boat there just quietly going to pieces."

"I wanted to get down to the very essence of the man who wasn't there."

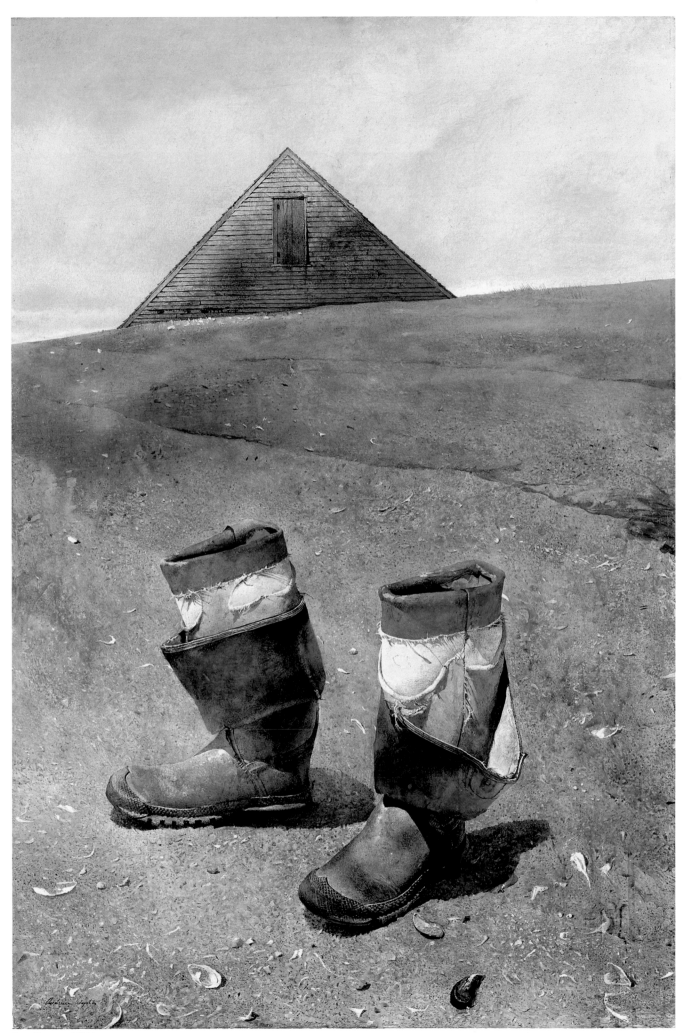

Sea Boots, 1976, tempera

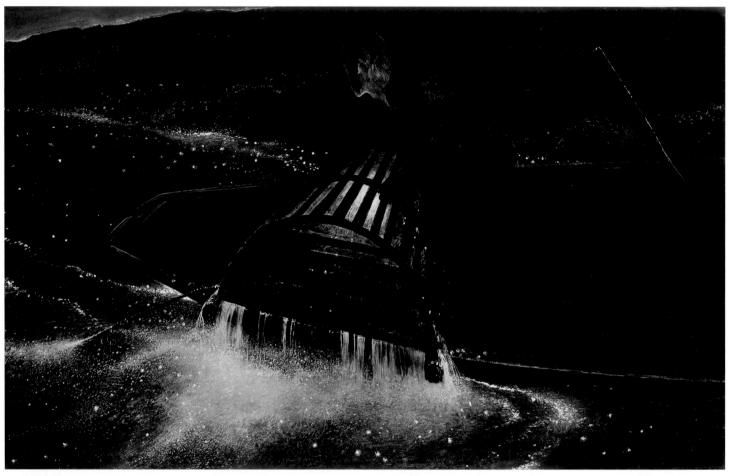

Night Hauling, 1944, tempera

"He was arrested once for stealing lobsters. I thought the court
had taken his license away and asked him what he was going to do. He laughed
and said he'd go get a license. The fact is, he'd never had one."

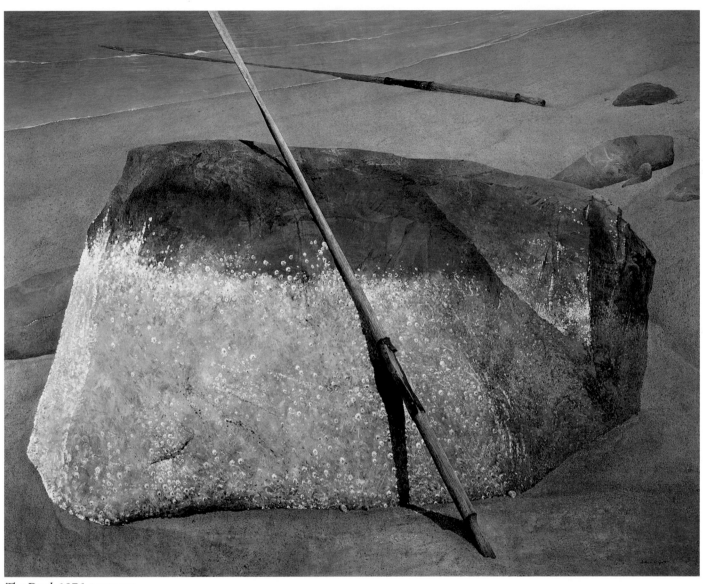

The Duel, 1976, tempera

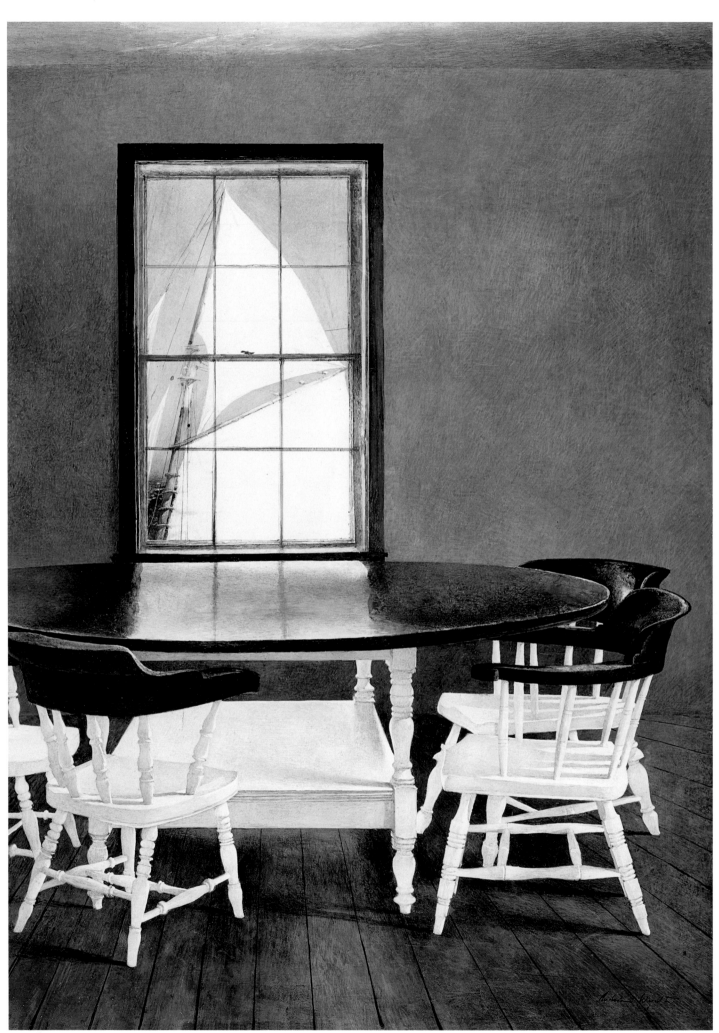

Boarding Party, 1984, tempera

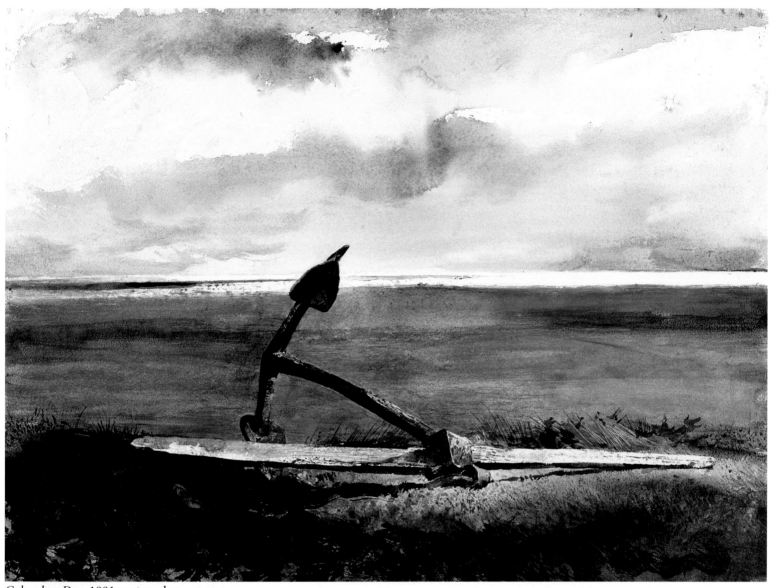

Columbus Day, 1981, watercolor

"Eventually I had to leave that island—it was too good. When I was there, I felt that I was getting out of touch with the earth. The island was too perfect for my personality. You see, I have to go against myself. I think it's interesting to reject things. Keeps me on my toes."

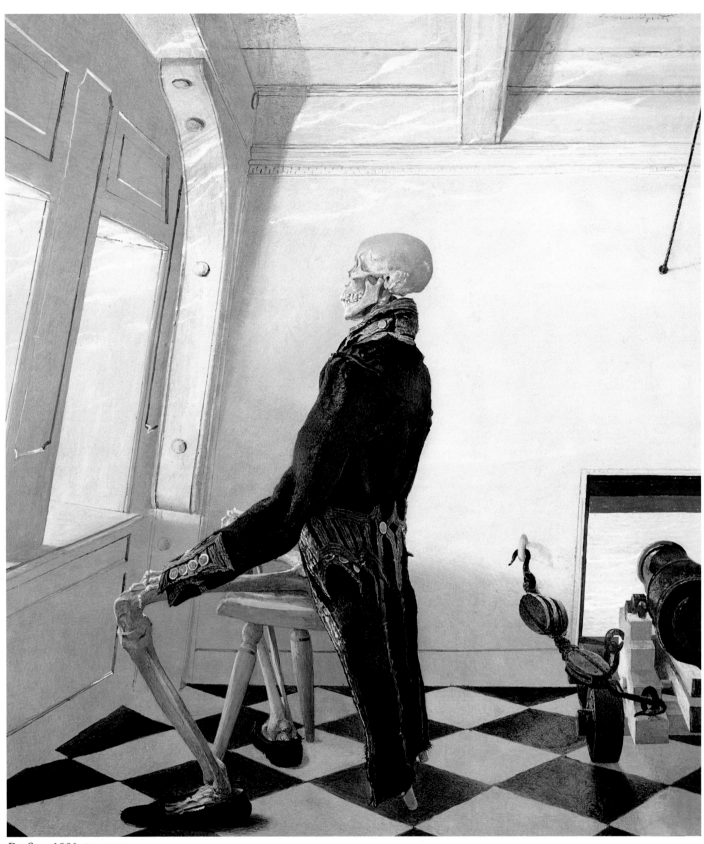

Dr. Syn, 1981, tempera

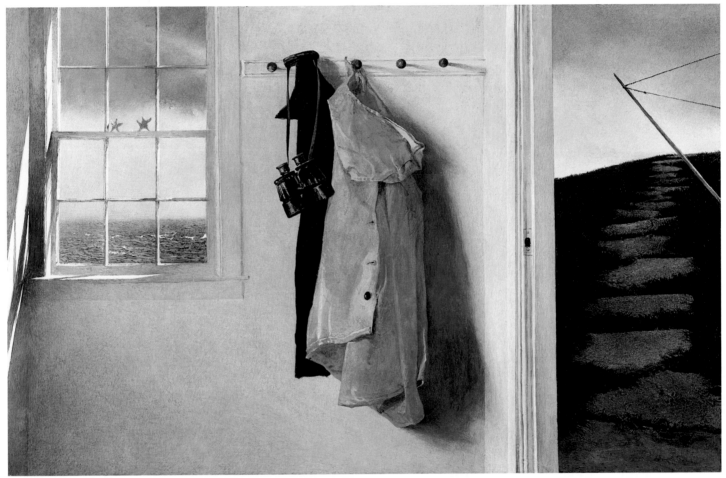

Squall, 1986, tempera

"My wife was sitting outside watching a regatta of Friendship sloops. I was inside. I did a watercolor of her looking at the distant boats . . . a series of squalls came up. Rains beat upon the windows, the sea churned up, whitecaps—a chilly feeling. Betsy's slicker is there, and her binoculars. Betsy's no longer in the picture, but she's still there."

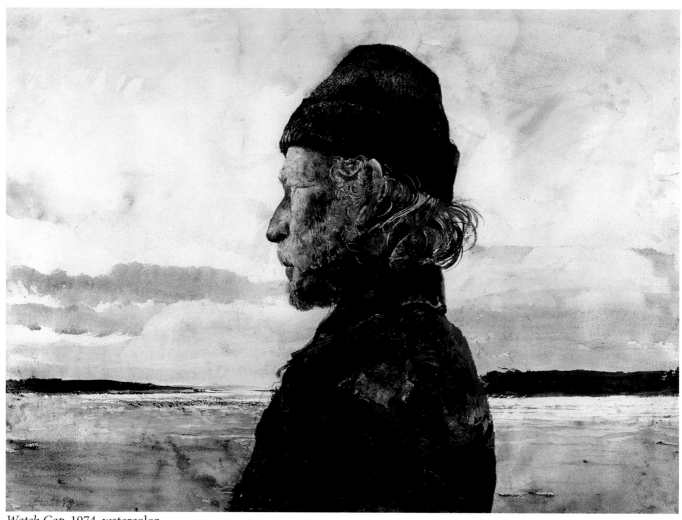

Watch Cap, 1974, watercolor

"Walter Anderson died at fifty-four. He was walking with me, carrying my watercolors, and he turned to me and said, 'What're you going to do when I can't carry your box anymore?' He died within the week. I almost never came back to Maine after that."

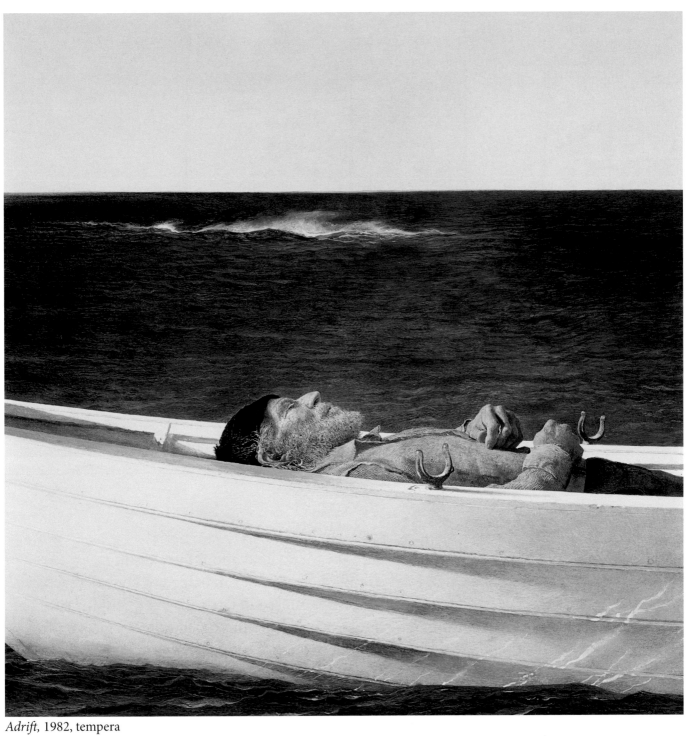

Adrift, 1982, tempera

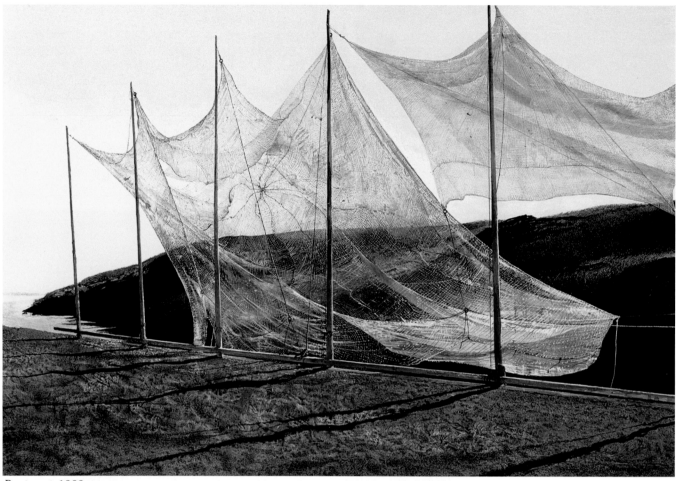

Pentecost, 1989, tempera

"I think it is beautiful, and I can't always say that about my paintings.
I felt the spirit of something when I did it, and I believe that I managed to convey that spirit.
You see . . . at that time a young girl was washed out to sea in a storm. They couldn't save her.
In time the body floated by off Pemaquid Point. I was thinking about that girl's body
floating there underwater, and the nets became her spirit."

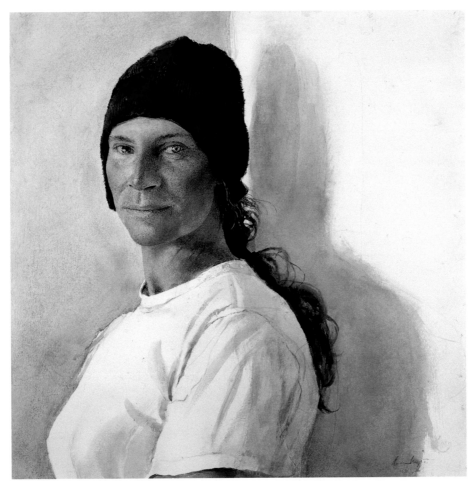

Skullcap, 1993, drybrush and watercolor

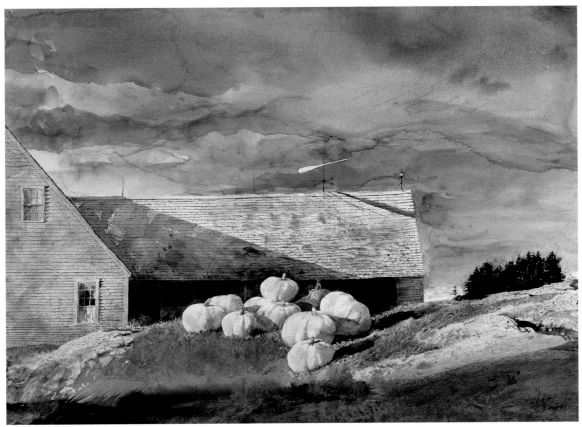

Albinos, 2002, watercolor

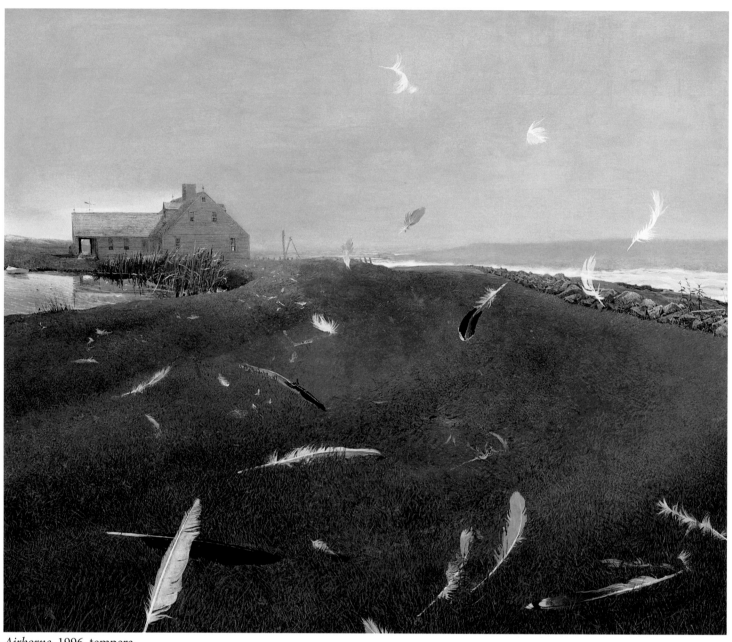

Airborne, 1996, tempera

"I'm very conscious of the ephemeral nature of the world. There are cycles.

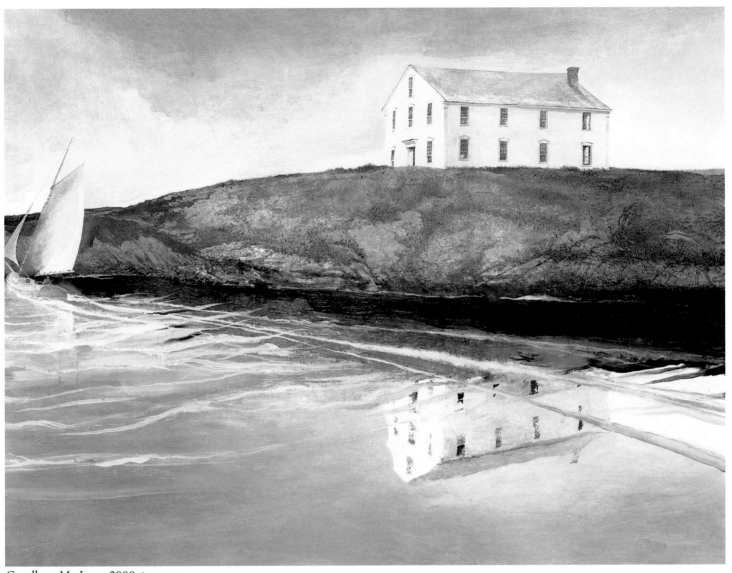

Goodbye, My Love, 2008, tempera

Things pass. They do not hold still. My father's death did that to me."

ANDREW NEWELL WYETH 1917-2009

In Residence

Coastal retreats perpetuate the tradition of Maine island artists

CARL LITTLE

When the photographer and watercolor painter George Daniell (1911–2002) visited Monhegan Island during his first trip to Maine in 1938—he left Ogunquit in search of relief from a bad case of hay fever—he rented The Lobster Pot, a fisherman's shack, for seven dollars a month (washroom facilities were at the nearby Monhegan House). He photographed the island and turned out, in his words, "countless splashy, undisciplined watercolors that I exhibited on my floor every night."

Long gone are the cut-rate rents Daniell and other artists enjoyed back in the day. Yet thanks to the vision and generosity of a number of nonprofits, foundations, a government agency and many individuals, including artists, opportunities to paint—and write and sculpt, photograph, film and dance—on Maine islands exist for those who can't afford the generally stiff rentals. In the past 20 years at least six residencies have been established on islands, from Westport, in the Midcoast, to Norton, way downeast. With distinct criteria and varying capacities, these programs offer experiences and opportunities for artists from Maine and from away—sometimes far away.

Great Cranberry

The newest Maine island residency can be found on Great Cranberry Island, at the former home of painters John Heliker (1909–2000) and Robert LaHotan (1927–2002). Lifelong partners, they created some of their finest work on the largest of the Cranberry Isles, a five-island archipelago off the southern end of Mount Desert Island. They also shared a vision that their island residence and studios should continue to be used by artists. Knowing that what they had been fortunate to have lay beyond the reach of many, they

Jo Weiss, director of the Washington Studio School, painting in the Heliker-LaHotan print-making studio, July 2007

created the Heliker-LaHotan Foundation in 1993 to fulfill their legacy. (When LaHotan asked his neighbor Gary Allen to be on the board of the foundation, he told him, "Get the lights back on. I want people back in there.")

After Heliker died in 2000 and LaHotan two years later, the foundation's board of trustees, led by Patricia Bailey, a lifelong friend of the artists and a professor of painting and drawing at Western Carolina University, began making plans to launch the residency. In 2006, the first two artists arrived; in 2007, the program welcomed eight.

The two-at-a-time residencies run three and four weeks and are open to "artists of established ability" wherever they may live, with preference given to those individuals who may not otherwise have an opportunity to work in Maine. Resident artists are encouraged to open their studios to islanders near the end of their stay and/or present a public program about their work.

Among last summer's residents was Lilian Cooper, an artist from Amsterdam, who is currently involved in a 20-year project to draw the North Atlantic coastal rim. "I'm drawing all the edges," Cooper told *Portland Press Herald* arts reporter Bob Keyes during her visit in July; "It wouldn't be complete without Maine."

In addition to a spectacular view of the Pool, the island's only tidal estuary, the residence itself is a gem. Enoch B. Stanley, a ship's captain, built the main residence in the 19th century. Heliker and LaHotan fixed it up and converted outbuildings into studios. They hosted a number of celebrated artists, including composer Samuel Barber and photographer Walker Evans. The island itself was a hotbed of East Coast artists. In addition to Heliker and LaHotan, the likes of Gretna Campbell, William Kienbusch, Dorothy Eisner and Carl Nelson made the island their seasonal art base.

Great Spruce Head Island

The Porter family home on Great Spruce Head in Penobscot Bay has an equally significant place in the history of American art. The island served as inspiration for the painter Fairfield Porter and his photographer brother Eliot Porter. The setting is remarkable: "that far-off island in Penobscot Bay," as poet James Schuyler referred to it, led to paintings by the former and photographs by the latter that are icons in their respective mediums.

Anina Porter Fuller, daughter of Fairfield's and Eliot's younger brother John, had been going to the island every summer since she was little. "When I arrived," she recalled recently, "Fairfield would come down and meet me at the dock and help carry my art supplies up." Wanting to share the island experience with other artists, Fuller struck upon the idea of hosting a one-week program. Inspired by a visit to the Haystack Mountain School of Crafts on Deer Isle in the summer of 1992, she invited a group of artist friends to come to the island for a week. The retreat was a success, and the Great Spruce Head Island Art Week was born.

Fuller's vision was of a residency without instruction. "It's not a workshop," she notes, "not a typical trip. This [experience] is so grounded, even for people who don't come from Maine. They're away from it all, in a special space."

The residency is intense and almost nonstop, often beginning with explorations of the island and culminating with a sharing of work on the Friday night before the group departs. Painters and writers predominate, with an occasional photographer, musician and sculptor joining them. The decks on the main house double as studios. There is a nominal fee to cover food and transportation, but nearly half the 12 slots are covered by scholarships.

In recent years a number of Maine artists have attended, many of them learning about the program through word of mouth. Printmaker Siri Beckman, poets Linda Buckmaster and Elizabeth Garber, sculptors Squidge Davis and Sharon Townsend, jeweler Fred Woell, book artist Rebecca Goodale

Jim Lynch paints, in residence.

and painters Tom Curry, Brita Holmquist and Lydia Cassatt are among past visitors.

The residency permits husband and wife to attend together if they are both artists. In 2002 two couples were on island: songwriter/composer Gordon Bok, who carved small relief sculptures, and his wife, harpist Carol Rohl; and artist MaJo Keleshian and her husband, poet Sylvester Pollet. Among a group of 60 haiku-esque poems that Pollet wrote during his stay is one that relates to Rohl:

takes one hell of an imagination
plus the right woman
to sail with a harp aboard

Norton Island

It takes a bit of pioneering spirit to apply for the Eastern Frontier Education Foundation's Norton Island residency way downeast. Among the criteria for attending is, in founder Stephen Dunn's words, "an ability to live rustically and mostly alone for 18 days on an island in the northern Atlantic ocean." Since its launching in 2000, the island program has accommodated 140 residents, "10 of whom," Dunn reports, "left early, and 130 of whom are fanatic fans of the program."

Having purchased the 150-acre island on the south side of Moosabec Reach, Dunn felt it was too magnificent a site for private use only and

Painters in residence

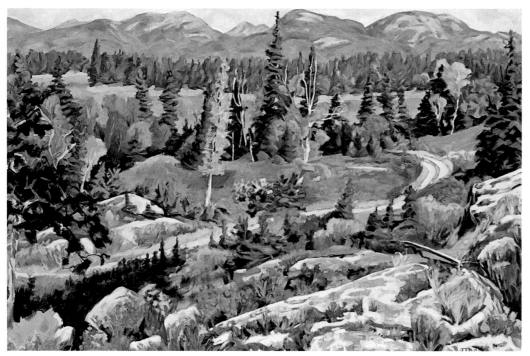

High Meadow, Big Cranberry Island, Looking Toward Mt. Desert,
Joellyn Duesberry, oil on linen, 2006

should be shared. "I was unaware of the vast world of residencies, to be honest," he recounts. "I simply thought that this large, beautiful island in an out-of-the-way location would be a great place for artists, writers and musicians to congregate and work on their art."

The residency has a landing next to Busters' lobster dock in Jonesport. The boat ride across Moosabec Reach is less than a mile. Jonesport and Beals are visible from the northern shore; on the south side, which features large slabs of granite, there is open ocean speckled with islands.

Over three years Dunn built the "humble infrastructure" that makes the program possible. A workshop-barn offers an art studio and equipment for wood and metalworking, along with two attached studios. Seven one-person cottages for writers and a small conservatory with a piano round out the accommodations.

Dunn likes to point to the prize-winning authors who have been to the island, among them Kiran Desai, whose book *The Inheritance of Loss* won a Man Booker Prize in 2006. In a testimonial on the residency's website, Desai offers a poetic description of an island sanctuary, "this perfectly hatched island among a whole shoal of pine furry islands." She also reports editing "an entire manuscript of 450 pages" in a place "wild and devoid of that sanitary, academic, uptight atmosphere of so many of these centers."

MacNamara Foundation

Nevada-based advertising professional and educator Maureen MacNamara Barrett founded the Robert M. MacNamara Foundation in 1987 in honor of her father, an attorney and former FBI agent whose lifelong vocation was to help others recognize the importance of education. The year-round residency, with six-week sessions (the longest of the residencies described here) in winter, spring, summer and fall, was established in 2002 as a means for assisting artists to fulfill their creative vision.

The program is centered in a Pennsylvania barn relocated to Maine. The airy structure with studios is situated on three acres fronted by the Sheepscot River and backed by a tidal, saltwater marsh. A nearby family-owned compound of more than 250 acres provides additional accommodations and studio space for visiting artists.

Quilt artist Duncan Slade from nearby Edgecomb has been studio manager at the MacNamara residency for the past three years. The program seeks mid-career artists that need time to work on a project, he explains. On occasion the program will accept artists who have either been away from their work for a while or are making a shift. The program, says Slade, seeks a mix of disciplines in each session. One cohort might consist of two painters, a videographer, a writer, a composer and an installation artist.

Among the Maine island residency programs, the MacNamara is among the best equipped for a range of artistic pursuits. Facilities include ceramics/pottery studios with kilns, potter's wheel, etc.; a Mac digital media center featuring a variety of printers; and accommodations for artists involved in fiber arts, painting, photography, sculpture, woodworking and writing.

The artists are also free to roam: A recent resident, a printmaker from New York, spent nearly his whole time on the grounds of the nearby 68-acre Bonyun Preserve, which was opened to the public in 2006. "If people can afford to give themselves the luxury of six weeks and can see themselves in an environment where they're going to be with a group of people at mealtimes," Slade observes, "then a lot can happen."

Artists have arrived from six different continents to work at the MacNamara Foundation. Among Maine-based artists who have attended are diorama artist John Kimball, fresco painter Barbara Sullivan, sculptor Phyllis Janto and mixed-media artist Patricia Wheeler.

F. Scott Hess, a Los Angeles-based painter, has been a resident twice, in 2003 and 2007. "I've worked as an artist for thirty years, with plenty of studio time," he writes, "so I'm not just after the hours that the MacNamara Foundation affords its residents." Rather, Hess enjoys the "shake-up" of his surroundings, finding the Maine coast a "soul-refreshing switch" from Southern California.

Hess also enjoys the community aspect of the residency. "As a painter I've spent massive hours of my life alone, facing the wall of my studio," he explains.

Being thrown in with six strangers, all of them engaged in the same profession, but from different backgrounds and countries, and working in other mediums, he finds wonderful. "You have a chance to exchange ideas, argue about theories and become friends," he says.

An unexpected fruit of Hess's 2003 residency is the painting Fresnel's Boots, inspired by a boat trip to Seguin Island. Hess doesn't usually do landscapes, but the weather was superb, and the view spectacular: "a 360-degree panorama that sparkled and made you feel glad to be alive." He had a video camera and recorded the trip. Having accomplished what he had planned to do at MacNamara in the first three weeks, he looked for something new to develop and settled on the lighthouse.

Acadia Artist-in-Residence

Set on another large Maine island connected to the mainland, the Artist-in-Residence or A-I-R program at Acadia National Park accepted its first artists in 1994. (The late painter and environmental activist Alan Gussow initiated the national "artists in the parks" program.) A-I-R carries on a rich tradition of art on Mount Desert Island that stretches from Hudson River School artists Thomas Cole and Frederick Church in the mid-1800s to Richard Estes and Joellyn Duesberry today.

Last year 11 artists took part in the residency program, two in the spring and nine in the summer/fall season. The addition of residency housing at Schoodic Point has allowed the program to grow over the past several years. Generally, spring artists are housed on Mount Desert Island and those that participate from August through November are housed at Schoodic.

Each visiting artist is expected to present one program for every week of his or her residency, with most residencies three weeks in duration. Spring artists tend to work with local school groups or do public programs. Summer and fall artists may interact with the YMCA, local school groups, the public, or the park's residential education program, the Schoodic Education Adventure program.

Fresnel Boots, F. Scott Hess, 2003, oil on canvas

Monhegan

The oldest and longest-running Maine island artist residency changed its name this year after the space that served as its home for 19 years was sold. Started in 1989, the Carina House residency—now the Monhegan Island Artist Residency—was the shared dream of Peter and Raquel Boehmer and fabric artist Robert Semple, former owners of the modest structure on the island's main thoroughfare. Knowing the expense of renting on Monhegan, they sought to provide time and space for Maine-based artists to work on-island.

Monhegan has nurtured one of the most remarkable legacies in the history of American art, boasting a virtual Who's Who of artists, from George Bellows, Edward Hopper and Rockwell Kent to Reuben Tam, Elena Jahn and Jamie Wyeth. "The five-week residency is designed to give back to Maine artists a part of their heritage, which includes a tradition of creative experimentation and exploration," says Gail Scott, art historian and chair of the Monhegan Artists' Residency Corporation (MARC), which oversees the residency.

Painters, photographers, sculptors and mixed-media artists have benefited from the residencies. In many cases the experience has led to a profound transition in their work. Painter Sarah Knock

of Freeport, who was a resident in 1989, was focusing on the figure when she arrived on Monhegan. By the time she left, she had shifted to landscape. "When I returned home, which was inland," she wrote on the occasion of the exhibition "Carina House: The First Decade" at the Farnsworth Art Museum in 1999, "I found myself longing to be on or near the water on a daily basis."

Loosely modeled on the McDowell Colony and Vermont Studio programs, the five-week residency is viewed as an opportunity for artistic development. Open only to Maine residents, the program seeks applications from artists with limited financial resources who otherwise could not afford an extended stay on Monhegan. This summer's resident will stay at the Hitchcock House and have access to a studio in the Black Duck fish house.

It seems that every island in the Maine archipelago has, at one time or another, captured the heart of an artist, but the economics of the day are working against creative individuals making that special connection—aesthetic, physical, spiritual. While addressing this issue, the increasing number of artist residencies may also serve to inspire others to consider creating a Maine island artist legacy of their own.

2008

Structure of the Old Wharf, 2007, oil on archival board

Daud Akhriev

The spirit of the place

SCOTT SELL

Isnuck into Daud Akhriev's studio early one morning before anyone woke, to figure out what it is that is so compelling about his paintings. I stood before a spread of canvases that included stark portraits, Florentine rooftops and the harbor of Frenchboro and decided what was most remarkable was his ability to transform something enduring into something brand new, as if you're seeing it for the first time. His sense of the past—and from what I gather, parts of his own past—is apparent, and is woven together with the form and light and color from an artist who could only have been painting in the 21st century. But I also realized it's the man, not just his academic training or his worldviews, that shape each painting. When Daud speaks of beauty that only he has seen, you are there with him and that beauty is shared. And on Frenchboro, he has found a place that has inspired him, and in turn, anyone who stands before his canvases.

It's fairly easy to find Daud when he's on the island: simply look for the only person who is standing still. On typical summer workdays, while everyone else on Frenchboro is moving from one chore to the other, Daud is at the head

of the harbor or among stacks of traps on the wharves, working with plenty around him to feed his imagination. Daud and his family have been coming to the island during the summer months since 1993. His wife, Melissa Hefferlin, and his son, Timur, are also trained and talented painters, and in the two months they stay, they are constantly amazed at how productive they can be, how the place informs some of their finest work.

"There's something very mystic, shimmering about a place like Frenchboro," Daud says. "Every time I'm there, I'm that much closer to my thoughts."

After almost two decades of painting on Frenchboro, Daud has adopted an intensive process, completing what he can *en plein air* in oil and then, using photographs and pastel and pencil studies, he returns to his home and studio in Chattanooga to continue working on his original ideas. Although he often wishes he could complete entire paintings on the island, he's confident in his

memory of those hours at work and his ability to create a plan for himself once in the studio.

Once he's there, Daud analyzes how it needs to be, how he remembers it best. *After the Rain*, for example, is presented as if from a recurring dream, as if the translucence of the water and the stones beneath it were all that filled his mind. The rendering of this piece, with its attention to distance and scale, offers us a profound sense of placement and movement within the island environment. In this way, Daud likes to start something that resounds with him and return to it again and again: the playfulness of the light on the Gooseberry Point rocks, the curious eyes of Frenchboro children standing on the wharves, the way the boats sit on the water. In others, such as *Frenchboro Harbor*, there is a learned and deliberate approach to his landscapes, a deep connection to the natural world and his willingness to work patiently within it. In these paintings, there is a sense of union between

the water and the sky and everything that exists in between that makes the island as sublime as Daud knows it to be. He continually reminds himself that nothing is for free in nature.

"You have to work for it," he says. "You spend a cloudy day painting and the sun suddenly hits a few spots on the water and a breeze comes along and everything changes. I like that challenge—to be as connected to nature as possible, to let it help push me to try new things."

Daud speaks of these challenges with joy. For him, the one "moment" where everything fits together like puzzle pieces is the very reason he paints. This is the moment when he forgets everything he knows and was taught and works purely from instinct, from what he has in front of him: the temperatures of the colors, the cool colors of the fog and water and the brightness of the sky.

"You're like a thermometer," he says excitedly. "You change the temperature according to what you see. It's not the

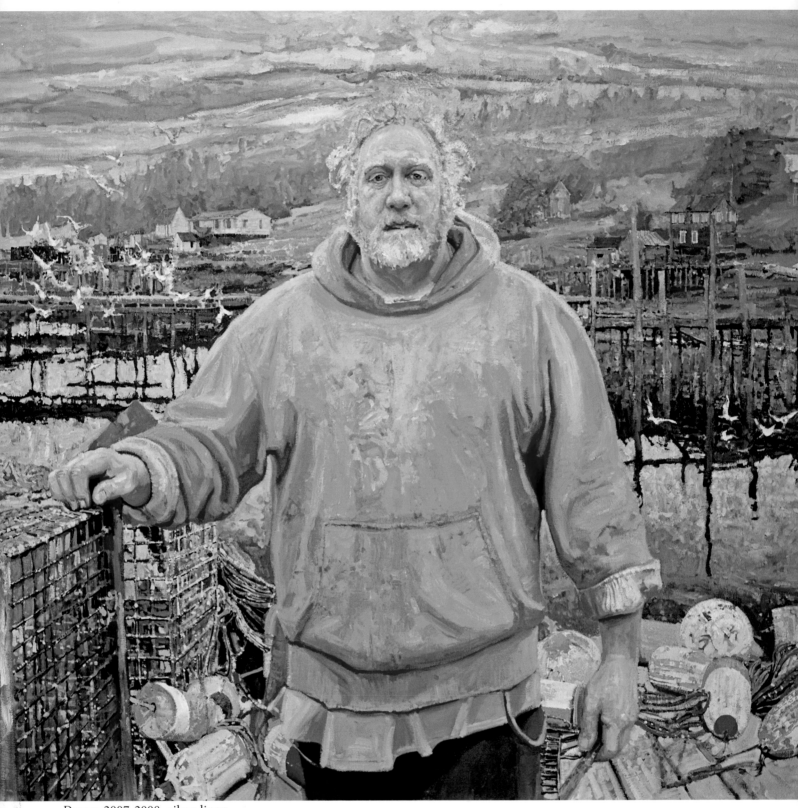

Danny, 2007-2008, oil on linen

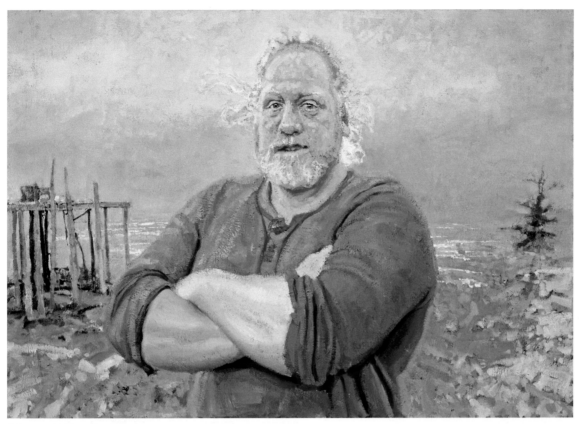

Mainer, 2007, oil on linen

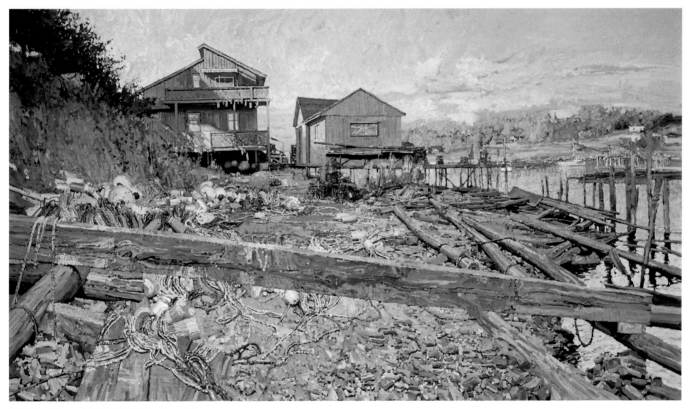

Harbor Sunset, 2005-2009, oil on linen

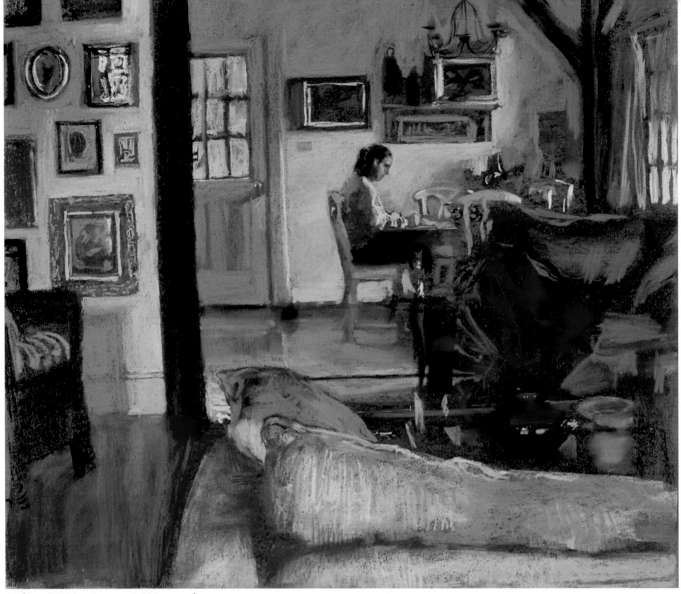

Melissa Writing Letters, 2005, pastel on paper

brightness that's incredible, it's the combination of colors and how the neutral colors bring out the more unusually bright ones. That's what nature does. And it gives you what you need and the effect you want is there all of a sudden."

I first met Daud and his family at the end of a summer on Frenchboro. A dinner party was being held out on the point, and we sat next to the fire, watching a sunset that was, for lack of a better word, unreal. It sunk slowly behind Swan's Island and Daud and Timur gasped, shook their heads in disbelief and made notes on what they liked best about the way the sun and the sky looked as it changed ever so slightly. "This is the time of day that is so exciting to paint," Daud said, turning to me and grinning. "I like to try to catch the light as it's going away. And it goes away so slowly here."

What struck me right away about Daud was his boundless enthusiasm. No artist I have ever encountered has spoken with such honesty and certainty about what it is that motivates him. It

is his almost childlike joy and giddiness about each facet of the natural and social world he experiences that becomes so evident in his work. His eyes flicker at the mention of something comical or exciting or profound. He is a man who talks quickly with his hands, as well as his mouth, and his tight smile is something that seems to never go away. And it is his voice that demands attention, a purposeful and heavy Russian accent that strangely never feels out of place in Maine.

Before he emigrated to America, Daud grew up in the former Soviet Union, his roots going back to Ingushetia, a region in the Northern Caucasus. Being born in exile in the village of Pavlodar, and growing up in the city of Vladikavkaz, Daud knew his opportunities would be limited. His own parents, military officials and architects, were forced to become laborers. But his family and friends recognized his talent early on and urged him to pursue his education in visual arts. Despite it all, he was able to study classical painting

and drawing for 14 years. "They didn't baby me much at the academy," he says. "My teachers would help me develop, but never through praise, mostly critiquing." Under the tutelage of Andrei Mylnikov and the late Piotr Fomin, this method of teaching only reinforced Daud's skill, and he became a steady and serious worker.

Several of Daud's paintings maintain a strong semblance to his homeland, images rooted deeply in the Russian classical tradition. *After the Party*, an ethereal scene seemingly out of a myth, depicts a group of women strolling down a hillside, a brilliant sky spreading behind them. This may very well be Daud's homage—one of many—to the female form and to women themselves. And to Daud's women as well. Included in the painting are his friends and family: his longtime model, Kate, several acquaintances, and Melissa, who has been his primary source of inspiration for close to 20 years now, appearing in countless paintings and always by his side.

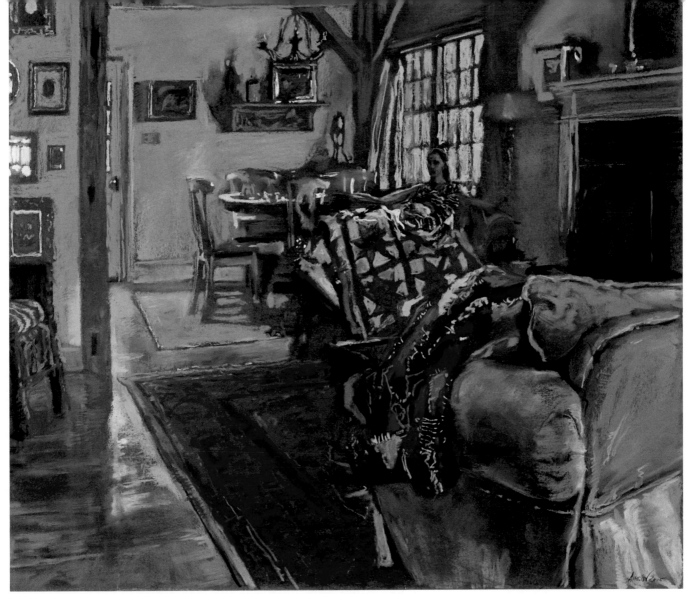

Melissa With Quilts, 2005, pastel on paper

The two met at a party in 1991, when they were both attending the Repin Institute of Art in St. Petersburg, Russia. Melissa liked Daud right away and, in him, she found the artwork that spoke volumes to her. "We went into his studio and I immediately loved what he was doing," Melissa says. "It was the kind of stuff that I had gone to school to learn how to do. They had spirit and purpose, not just aimless representations of things from life. I understood his life looking at those few paintings."

The following spring, when Daud received his degree—with honors—the two left Russia together. Daud received a visa and they moved to the United States, intending to go to California so Melissa could finish her schooling. But instead, they stayed in her home state where she received her degree from The University of Tennessee at Chattanooga and created a home and studio next door to her childhood home. After establishing themselves in Chattanooga, Daud and Melissa began traveling extensively, teaching painting and art

history, and exhibiting their work internationally. Most recently, Daud won an award of excellence from Oil Painters of America. This is something that he often keeps to himself because, in keeping with his better qualities, he maintains an extraordinary humbleness.

One could comment on Daud's late arrival to Frenchboro, that his roots are not deeply planted in Maine, or that he is merely a summer person who paints. But simply put: he does Frenchboro justice and communicates something very special about it. His commitment to accuracy and revealing the spirit of the place is clear, particularly in *Structure of the Old Wharf.* Here, we are able to see the geometry of the island wharves as they once stood and what they have become, a simple examination of time and what nature and man have both been able to do within it. This acts as a microcosm of the island itself, showing its elemental beauty not only through his choice of colors or composition, but his intense study of Frenchboro as a place in time: how it has seen count-

less changes while retaining the qualities of over 200 years ago, when the first houses were built on the hills on either side of Lunt Harbor. Indeed, it was the history of the islands, as well as their splendor, that pulled he and his family in right away.

"The northeast, and Maine in particular, has always been mysterious and ancient to me," Daud says, "and in some way, it has always been connected to the Wyeth family, because of their images of traditional art. Along with the Italian and French masters, Andew Wyeth has had a big influence on our family. We owe a lot to him and the guys who worked in the field of realism. I talked to my friends from Russia and passed on the news about Andrew's death and they said, 'Tonight, we will have a toast to the Wyeth family.' "

Like the Wyeths, the thing that is most striking about Daud's landscapes are their ability to present a complex idea about Maine and its coast: its wildness and isolation, but also its familiarity and captivating grandeur. They also

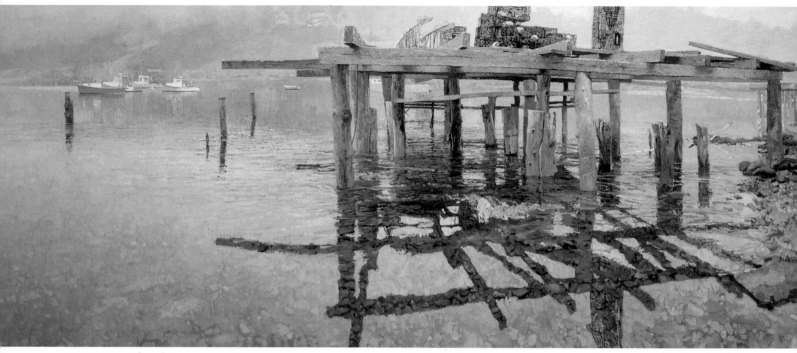

Mist, 2005, oil on linen

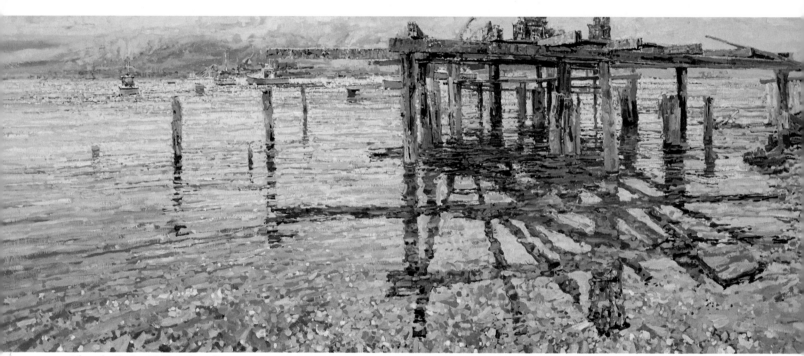

After the Rain, 2008, oil on linen

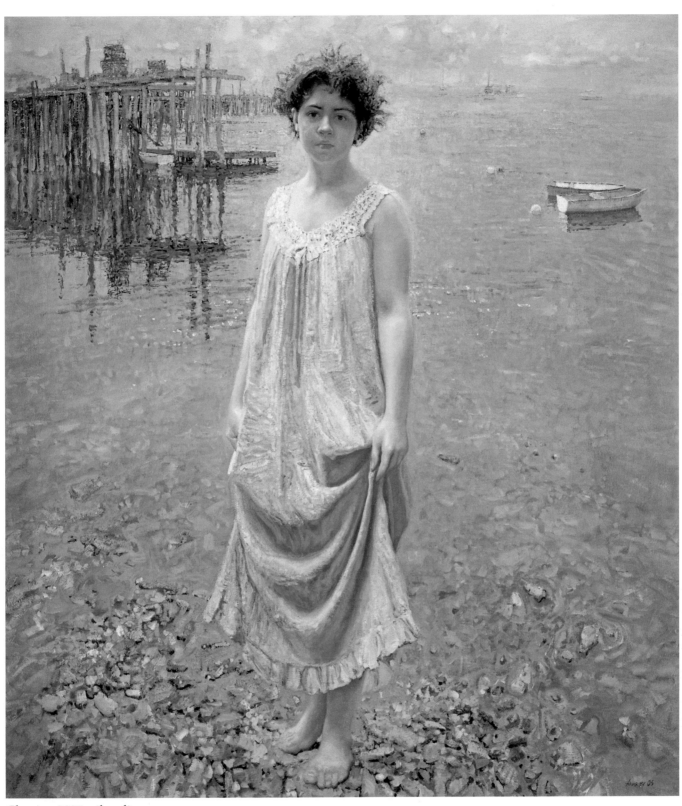

Clearing, 2007, oil on linen

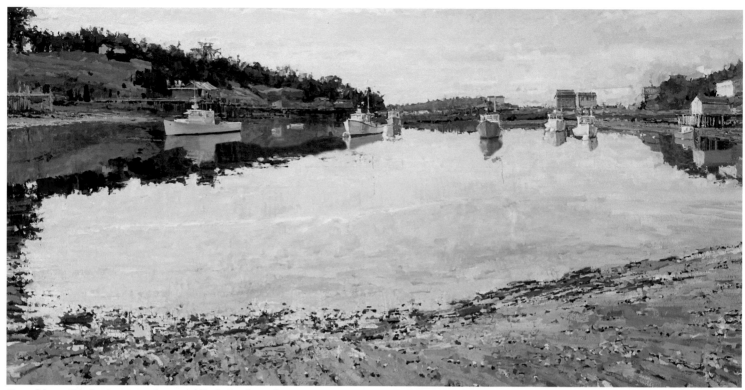

Frenchboro Harbor, 2006, oil on cradled clay board

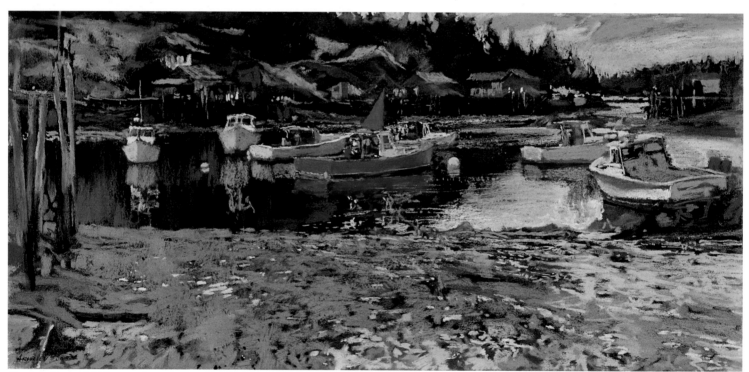

Resting Boats, 2005, pastel

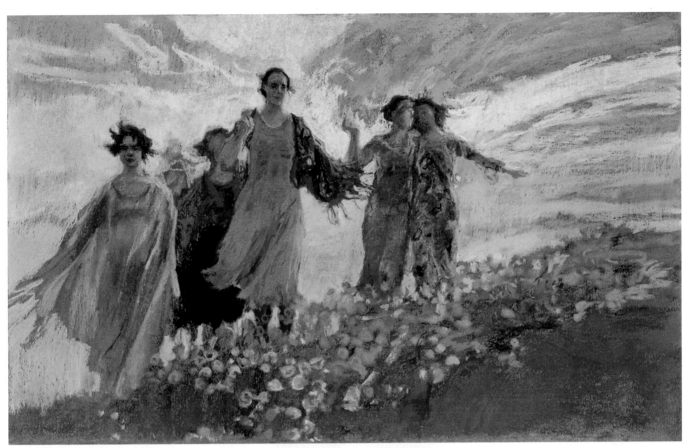

After the Party, 2005, oil on linen

Daud Akhriev

Joe Thomas

speak to the inhabitants of the coast, often depicting their presence subtly: a buoy, a skiff, a lobster crate. Years ago, Daud painted a collection called *Weathered People* which dealt with the fishermen and mountaineers of Northern Russia, those who worked off the land. Much of the material he drew from what he saw and, of course, his own imagination. But on Frenchboro, he has had the good fortune to get to know the people he is painting and understand the intricacies of their lives and their home that much better.

"These guys humble me," he says. "They're up in the middle of the night and going out in terrible weather to fish for hours and then they come in and help fix a boat or the wharves or build new traps. How can you not respect someone like that?"

"Harbor Sunset," as well as others, speaks of the admiration Daud has for the people making a living on Frenchboro. Here, the harbor lies behind the Sawyer's house, the sky above drawing more from the Impressionist tradition, the clouds swirling in a way that brings Alfred Sisley to mind. The shore in the foreground is covered with rope and buoys and the essential trappings for lobster fishing. Seeming to be debris at first glance, everything here has its place on the island, as Daud realizes each time he paints within Frenchboro's daily goings-on.

"I actually like when you get on the wharf to paint and everything is sort of messed up," he says. "The guys come ashore after being out and they take gear off their boats and drop it anywhere, but they know exactly where everything is!

I was painting near the town wharf once and finished up for the day and came back to the same spot in the morning and Nate [Lunt] said, 'Oh, jeez, I'm sorry. We thought you had finished and we moved stuff in your way.' And I said, 'You live your life the way you live it. If you move something, I'll move it in the painting. I want to do exactly what you do.' Everyone is always looking out for us, which makes us feel very welcome. It's wonderful to be working in a place like that."

Every year, a few days before leaving the island, Daud laments about what he wasn't able to accomplish, but excitedly thinks about a plan for the following summer, thinking about the light and the people and the hold Frenchboro has on him. This is what feeds Daud Akhriev: noticing with eyes that see possibility in everything, documenting a world he feels nothing short of appreciative to be a part of. And after all of these years of noticing and appreciating and creating on the island, Daud's favorite thing is the fog. One only needs to go as far as *Mist* to notice the delight he takes in rendering a scene that is shrouded in fog.

"In the fog, it's not like a chocolate cake, not one large mass," he says. "It's more like salt and pepper and bread. The water is moving, the fog is moving, there's plain, weathered buildings and there's bright colors from the oil clothes and buoys. And there's silver everywhere. What I like best is that the island is what it is."

2009

See more images from this artist online at www.islandinstitute.org/daudakhriev.

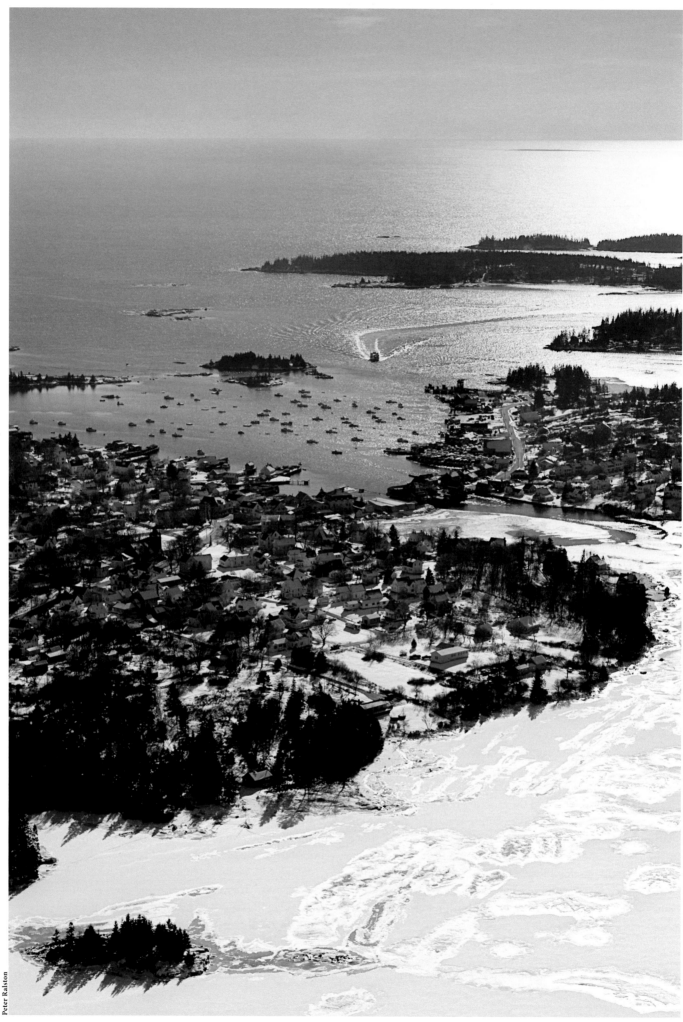

Environments

PHILIP CONKLING

More than any other landscape on the globe, islands and their cultures are shaped and sculpted by their all-encompassing, all-encroaching and omnipresent seas. From their seas spring the environmental forces that have carved out local island cultures. In the case of the islands of the Gulf of Maine, salt, water, waves and wind work above and beneath its restless surface to shape life and death along the archipelago. To understand the environments of islands, and hence, their cultures, you must begin with the sea.

The islands of Maine are mountaintops and ridgelines isolated by seas that rose above the complex bathymetry of the Gulf of Maine as the glaciers melted. The seaward edge of the Gulf of Maine is bounded on the Canadian side by the bedrock upper arm of Brown's Bank, which extends southwest from Nova Scotia, and by the legendary glacial sand and gravel-capped forearm of Georges Bank, which extends northeast from Cape Cod. Offshore of Brown's and Georges, Northeast Channel provides a narrow, deep entrance for oceanic waters that surge into the partially enclosed Gulf of Maine from the expanse of the North Atlantic. Inshore of these banks lie an intricate maze of basins, ledges, grounds and guzzles, each with its distinctive marine community.

In 1978 the United States extended its seaward territorial jurisdiction to 200 miles—largely at the insistence of New England states that protested the decimation of historic fish stocks on Georges Bank by foreign fishing fleets, just beyond the then-12-mile territorial sea limit. The imposition of the 200-mile limit led ineluctably to the question of who would control the rich fishing rights in the Gulf of Maine and on Georges Bank, which led ultimately to the division of the Gulf of Maine between Canada and the United States, along what we now call the Hague Line. We now have two systems, if one Gulf.

During the last two decades of sophisticated oceanographic observations, we've learned that the marine environments of the Gulf of Maine are influenced not just by the deepwater connection to the North Atlantic, but also by the interplay of cold arctic waters with the warmer waters of the Gulf Stream that run as countercurrents to each other just outside the boundary of the Gulf of Maine. Occasionally a surface eddy off the Gulf Stream will sweep over Georges Bank and drastically alter the marine ecology, swiping away an entire year-class of larval fish that will thereafter be missing from

the system—a loss that will reverberate throughout the marine food web for years to come. On other occasions, the temperature of the bottom water entering Northeast Channel will be distinctly colder than normal, circulating deep within the Gulf of Maine along the margins of the coasts of the Canadian Maritimes and northern New England during the following six-month circulation period, causing bottom temperatures to decrease and creatures like lobsters to change their patterns of behavior.

In recent years, the marine research community has begun to ponder how oceanic currents that cycle in a vast counterclockwise gyre throughout the Gulf of Maine will be affected by changes in the Arctic, as sea ice melts and Greenland's glaciers and ice cap pour new rivers of freshwater into the salty northern seas. Enormous changes in the marine ecology of the Gulf of Maine have occurred at least once before. Archaeological research has revealed one dramatic climate change five thousand years ago: Indigenous Indians who inhabited the islands of Maine left records of their subsistence diet in bone deposits of swordfish and deer, characteristic of a warm climate—until different bone fragments deposited later reveal a rapid shift in diet to moose and cod, characteristic

of a colder climate. It is hard to imagine that such a rapid reorganization of marine and terrestrial ecosystems in the Gulf of Maine five thousand years ago did not also coincide with an equally dramatic shift in marine currents.

Today the ecology of the Gulf of Maine and its islands is also influenced by strong westerly winds that pick up speed offshore and blow across the gulf's surface—harder in the winter than in the summer. One of the ecological effects of these winds is to stir the water column and re-suspend nutrients. Maine islands were settled because the rich inshore fishing grounds—in combination with abundant wind power along the offshore islands and the local boat-building talent—enabled fishermen and mariners to exploit a valuable resource and then harness the local wind energy to export this bounty from the Gulf of Maine to the rest of the world. Islanders on Vinalhaven, North Haven, Monhegan, Swan's, Frenchboro, Grand Manan and elsewhere are now back at the forefront of a new technology to harness the wind energy of the Gulf of Maine to light their communities, heat their homes and export this resource to the mainland.

Environmental history, like nature itself, runs in cycles.

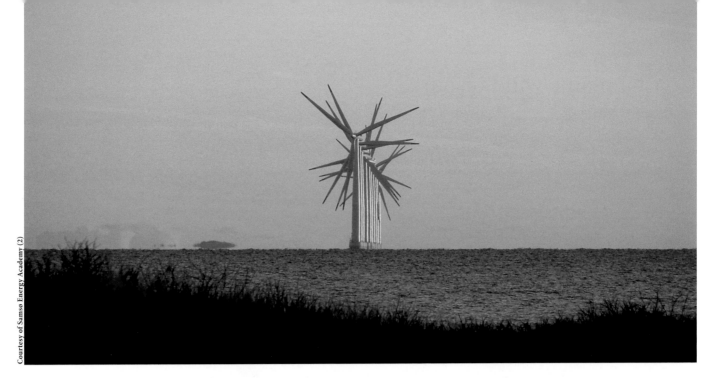

Island Wind

Gateway to offshore wind

PHILIP CONKLING

On Samsø Island in Denmark's part of the southern Baltic Sea, the wind whistles across a beautiful agrarian landscape of farmers' fields and tourist beaches. In 1997 when the Danish government initiated a national competition challenging local communities to present a plan to achieve complete energy independence within 10 years, a few Samsø islanders decided to enter the competition. Samsø not only won the competition, but also succeeded in achieving their ambitious goal two years ahead of schedule. Søren Hermansen, the director of the Samsø's Energy Academy, helped lead the island community into an alternative-energy future, and became an international environmental hero in the process.

According to Hermansen, Samsø islanders were motivated to explore alternative energy not because of any grand environmental concerns, but because pragmatic islanders were worried that the cost of energy for their small island community was driving year-round islanders back to the mainland. This is essentially the same concern on many Maine islands, so it seemed like a good idea to invite Søren Hermansen to visit to see what islanders here might learn from Samsø's story.

Hermansen is a very engaging character and spoke to enthusiastic audiences in Portland, Chebeague, Vinalhaven, and North Haven. He was also the keynote speaker at the Island Institute's Sustainable Island Liv-ing Conference in Belfast in November 2008. He has an easy rapport with islanders, because he *is* an islander. He makes humorous references to the stubbornness of islanders, their resistance to change, and other familiar insular traits that suggest the cultural distance between Samsø and Maine islands is not most accurately measured in miles.

Hermansen told island audiences how he had cajoled his fellow islanders into investing their own money in wind turbines. First they built five turbines, then added six more on the island, and finally, they installed 11 turbines in the waters near Samsø. Of the final 11 off-shore turbines, private investors own half, the town owns one and another is owned by summer people who wanted

Søren Hermansen speaking at the Island Institute's 2008 Sustainable Island Living Conference

81

Coastal maine wind resource

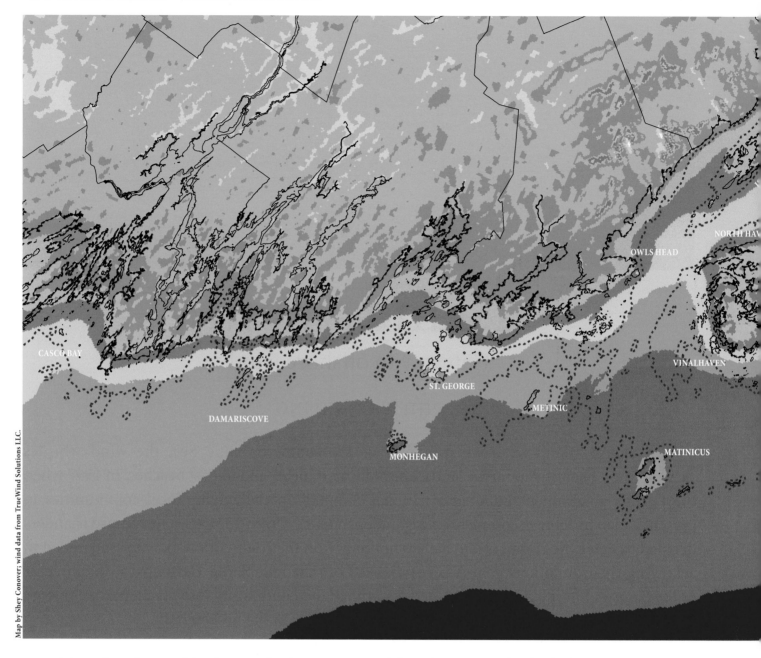

NORTH HAV
OWLS HEAD
CASCO BAY
VINALHAVEN
DAMARISCOVE
ST. GEORGE
METINIC
MONHEGAN
MATINICUS

Map by Shey Conover; wind data from TrueWind Solutions LLC.

to participate. At each stage of development, there was the opportunity for lots of public input. "It was an open process so people could see what was happening," he said, adding, "It took quite a lot of coffee and Danish, and quite a lot of beer."

In his concluding remarks to the Sustainable Island Living conference, Hermansen keyed in on the value of small island communities as demonstration sites. "I believe that islands are the center of anybody's universe. We have a much easier way to identify where we belong, of where we feel responsible for what we do, for how we live. It's kind of a burden, really, because we have to be responsible for so many things. But it is also a good thing because when we

make decisions, we can define who we are—who is in the community and who is outside the community. This is very difficult in urban areas. An island has the opportunity to identify the responsible area of the community and become responsible for our own future."

Along the Maine coast, Søren Hermansen's counterpart is an unlikely individual. George Baker is a seasonal resident of Maine's smallest island community, Frenchboro, the volunteer treasurer of the Swan's Island Electric Co-op, and a professor at Harvard Business School. Because Baker was somewhat miraculously on a yearlong sabbatical from his teaching duties last year, he volunteered to analyze the fundamental economics of wind power for both the

Swan's Island Electric Co-op and the Fox Islands Electric Co-op which serves Vinalhaven and North Haven. By analyzing the hourly wind-speed data collected by anemometers on Vinalhaven with the hourly electric demand from the Fox Islands Electric Co-op records over the course of a year, Baker recognized there was an opportunity for islanders to bring their high energy costs down to lower levels through a wind-power development plan.

A lot of islanders had already reached a similar conclusion. But how to pull it off? Inviting in an outside developer seemed like the only viable strategy to the Fox Islands Electric Co-op board. But Baker suggested that the Fox Islands might be able to structure a deal to take

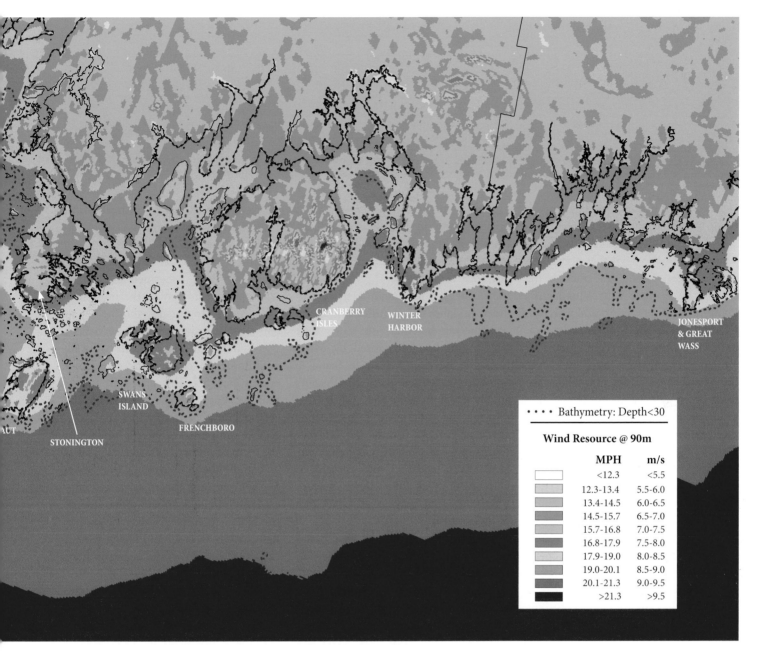

CRANBERRY
ISLES

WINTER
HARBOR

JONESPORT
& GREAT
WASS

SWANS
ISLAND

FRENCHBORO

STONINGTON

•••• Bathymetry: Depth<30

Wind Resource @ 90m

	MPH	m/s
	<12.3	<5.5
	12.3-13.4	5.5-6.0
	13.4-14.5	6.0-6.5
	14.5-15.7	6.5-7.0
	15.7-16.8	7.0-7.5
	16.8-17.9	7.5-8.0
	17.9-19.0	8.0-8.5
	19.0-20.1	8.5-9.0
	20.1-21.3	9.0-9.5
	>21.3	>9.5

advantage of new federal and regional incentives for alternative-energy production. Some of those incentives could be "sold" to investors; other incentives could generate cash from the sale of Renewable Energy Certificates (RECs), while the remaining financing might be packaged as a new loan from the Rural Utilities Service, a federal program left over from rural electrification programs.

Throughout the summer of 2008, Baker presented his findings to the board of the Fox Islands Electric Co-op. With the help of the Island Institute, he sent out periodic updates to all ratepayers, and stuffed answers to their most "Frequently Asked Questions" into ratepayers' monthly bills. Baker also gave

presentations to year-round islander forums on North Haven and Vinalhaven, and then to packed events for summer people on both islands.

During these community discussions, Baker said *we* a lot, as in, "We're all in this together." For most resident ratepayers, Baker's presentations were like attending a Harvard Business School lecture—chock-full of interesting technical details, but with an over-arching clarity that everyone could understand. He proposed to scale this first-ever island project to erect three 1.5-megawatt turbines to produce enough power so the two islands could achieve energy independence on an annual basis. His financial analysis suggested that the islanders could achieve long-term stability in

their rates for the expected 20-year life of the turbines, with a 10 to 20 percent reduction in electric power costs.

The result was that at the end of July, the ratepayers on both islands, summer and year-round alike, voted 382 to 5 to authorize the co-op to pursue the wind-power financing plan that Baker had outlined. As one island wit remarked, "You couldn't get a 98 percent vote on the American flag out here."

Throughout the fall and winter of 2008–2009, Baker was a whirlwind of activity focused on moving the Fox Island plan forward. He negotiated with manufacturers for turbines, met with regulators to understand their permitting requirements, worked out the structure of financial agreements, negoti-

ated bids from contractors, and kept the co-op board and ratepayers informed.

As with all plans, Baker has had to contend with the devil that crawls out from between the slightest cracks in the details. Baker met with Vinalhaven's Planning Commission to add a section to Vinalhaven's wind-power ordinance, to modify some of the requirements for a medium-sized wind farm—including the set-back requirements, which the town voted to approve in January. The avian monitoring conducted by ornithologists Richard Podolsky and Norm Famous recorded a significant number of eagles over the site during the fall migration period, which triggered additional studies to estimate impacts.

Then partway into the regulatory process with state and federal authorities, the turbine manufacturer, General Electric, insisted on new 770-foot set-back requirements from the public road that fronts the proposed 73-acre turbine site. Relocating the three turbines meant moving the turbine locations closer to other property lines of abutters. This meant recalculating the analyses for noise and shadow flicker (the momentary shadow cast when light from a rising or setting sun intersects with the turbine blades). Baker's goal continues to be to work through all these issues to receive the necessary local, state and federal permits in order to erect the turbines at the end of the summer of 2009. There is a narrow window for construction that closes quickly at the end of September, when autumn winds begin to blow and the huge crane necessary for the installation cannot operate; if the construction is not completed within that time frame, the turbines will have to wait for 2010.

In the meantime, Baker has given presentations to standing-room-only crowds on Peaks Island, and at a meeting of the Camden Energy Committee, currently studying wind-power potential on Ragged Mountain. He has provided guidance to a committee studying wind-power potential on Chebeague Island, and has been hired by Monhegan to develop a plan to install a 100-kilowatt turbine there. Monhegan's situation is both acute and unique. This past fall and winter, Monhegan islanders were paying 70 cents per kilowatt hour for the cost of their diesel-generated power—and they were threatened with a cutoff of their diesel delivery unless they could pay for a $16,000 load of fuel, in cash.

During most of the past year, Baker has functioned not only as the CEO of Fox Islands Wind LLC, an entity charged by the co-op to implement the wind-power plan, but also as a professor at the Harvard Business School. In addition, in the fall of 2008, Baker was appointed to the Governor's Task Force on Ocean Energy. The Task Force has been charged with making recommendations to the governor and legislature of changes in state policy that would facilitate the development of ocean energy, specifically plans that would include the use of offshore wind.

Baker believes that if the approach he has pursued for siting island wind-energy projects continues to be embraced at the local level, island projects may provide a model for how offshore wind projects could unfold. That is because, with or without legal justification, islanders treat their nearshore waters as extensions of their community and a key to their survival. Before

developers pursue big offshore wind projects with governmental backing, nearshore island projects that have benefited from extensive local input from islanders, fishermen and other coastal residents may be the most sensible strategy to pursue. And the key to gaining local support may be Baker's Fox Islands plan that seeks to co-locate environmental costs with community energy benefits. This approach means that the people who absorb most of the aesthetic and environmental costs also receive substantial economic benefits in the form of reduced power cost. This is essentially the same strategy that Søren Hermansen and Samsø islanders successfully pursued on the other side of the North Atlantic. As Hermansen put it succinctly, "We are not trying to save the polar bear—we are trying to save our community."

Islands *are* models of community; they are also acutely threatened by inexorably rising energy costs. Although costs have providentially declined with the economic downturn, no one seriously believes that vulnerable communities should plan on a decade or two of historically low energy prices.

Hermansen closed his talk to islanders last November with a stirring call to action: "As islanders, we have the possibility of creating history. We can make small communities look like small nations. We are the exhibition places of new ideas [because] we are responsible for our own future. We can test out how something works full-scale for real because we live this life all the time."

2009

To follow the progress of wind development on Maine's islands, visit www.islandinstitute.org/wind.

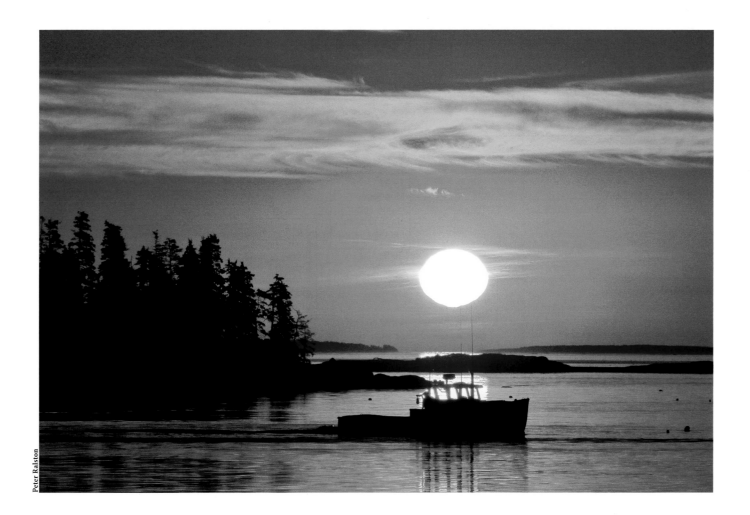

Peter Ralston

A Climate of Change

Fishermen's observations on a dynamic fishery

ANNE HAYDEN & GILLIAN GARRATT-REED

The Gulf of Maine is warming and it is extremely likely that greenhouse gas emissions are the cause. It is even more certain that the warming trend will continue. Due to the lag effect in the earth's climate system, warming due to existing levels of CO_2 in the atmosphere will continue for decades, if not longer.

In Maine, fishermen and scientists alike are concerned about the possible effects of climate change on the Gulf's flora and fauna. The Island Institute is bringing fishermen and scientists together in a collaborative process that will expand, if not transform, our ability to respond to the effects of climate change. Fishermen from up and down the coast and a panel of highly respected marine scientists have joined this excit-

ing enterprise in mutual learning and exploration.

Scientists are now confident that models of atmospheric warming at a global scale are reliable. They are less sure about what such warming means for the oceans or for regional ecosystems such as the Gulf of Maine, to say nothing of the local impacts in Casco Bay, Penobscot Bay or Downeast

Nevertheless, current research identifies sea-level rise, shifts in plant and animal populations, changes in nutrient cycles, and an increase in ocean acidity as possible consequences. Fishermen have much to offer such investigations. Their knowledge of ecosystem change is local and richly detailed. Unlike scientists' measurements, which are relatively recent, their knowledge

incorporates historical information. By bringing the two sources of know-how together, we may be able to predict what climate change will mean for Maine's lobster-fishing communities. The findings described are not sufficient to identify any current effects of climate change on Maine's lobster fishery; much more work needs to be done before it would be possible to determine if any such impacts are currently in play. These findings, however, represent an important source of environmental information that should be incorporated in future climate assessments.

Are lobster fishermen like the canary in the coal mine? Hardly. Unlike the helpless bird, they are exceptionally resilient. Lobster fishermen have adapted to a great many changes over

Timeline of significant events in the lobster fishery

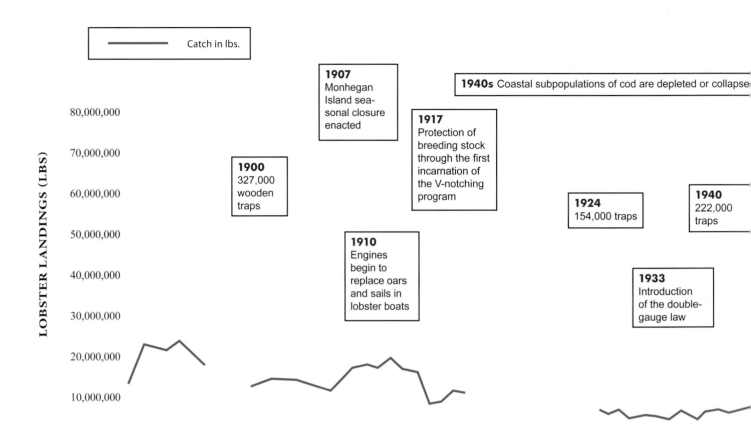

Catch in lbs.

1907 Monhegan Island seasonal closure enacted

1940s Coastal subpopulations of cod are depleted or collapse

1900 327,000 wooden traps

1917 Protection of breeding stock through the first incarnation of the V-notching program

1924 154,000 traps

1940 222,000 traps

1910 Engines begin to replace oars and sails in lobster boats

1933 Introduction of the double-gauge law

80,000,000
70,000,000
60,000,000
50,000,000
40,000,000
30,000,000
20,000,000
10,000,000

LOBSTER LANDINGS (LBS)

the 100-plus years of the industry. They constantly monitor their environment in order to adjust to changes they detect. The success of the fishery, in stark contrast to other fisheries worldwide, is due in no small part to the collective efforts of Maine's lobstermen to ensure the sustainability of their resource. In addition to gaining valuable data about the Gulf of Maine's response to global warming, working with fishermen holds many lessons for the rest of society regarding how best to prepare for the effects of climate change.

A century of lobstermen's observations

A key objective is to identify trends observed by fishermen—trends that might be related to increases in temperature and other climate factors. Maine's lobster fishery provides a rich context for examining the perceptions of fishermen regarding climate change.

Established over 100 years ago, the fishery has been dominated by the passing on of entry rights, local knowledge, and a concern for sustainability in the fishery from one generation to the next. As a result, the local knowledge of fishermen shared from one generation to the next has built a collective understanding of the fishery as one that follows natural cycles. Fishermen are keen observers of trends in the fishery and have historically adjusted their behavior to make it through the downtimes. At the same time, fishermen have devised rules to restrain overharvesting of the lobster population so that it may provide a livelihood for their descendants. The history of the fishery is one of continual adjustment of fishing behavior. The establishment of informal fishing territories that restricted access to the fishery was followed by the V-notching of egg-bearing females to protect those animals known to be breeders. In following years, the use of a "double gauge" began to limit

the harvest to lobsters within a narrow size range, protecting juveniles and oversized, reproductive lobsters, and a requirement for escape vents on traps allowed many undersized lobster out of traps before they were ever caught. The fishery was limited to owner-operators to ensure that knowledge of the rules stayed with the boat, and dragging for lobsters was banned. Most recently, the establishment of seven zones along the coast has enabled trap limits, suited to the local ecology of each zone, to be applied by zone councils. While each new rule benefited some fishermen at the expense of others, the overall effect has been to sustain the fishery.

Despite having already established many of these precautionary measures, in the 1920s a bust occurred in the fishery when landings dropped significantly for several years. Contemporary fishermen are well aware of the event and they ascribe it to natural cycles in the fishery, among other causes. Some fishermen,

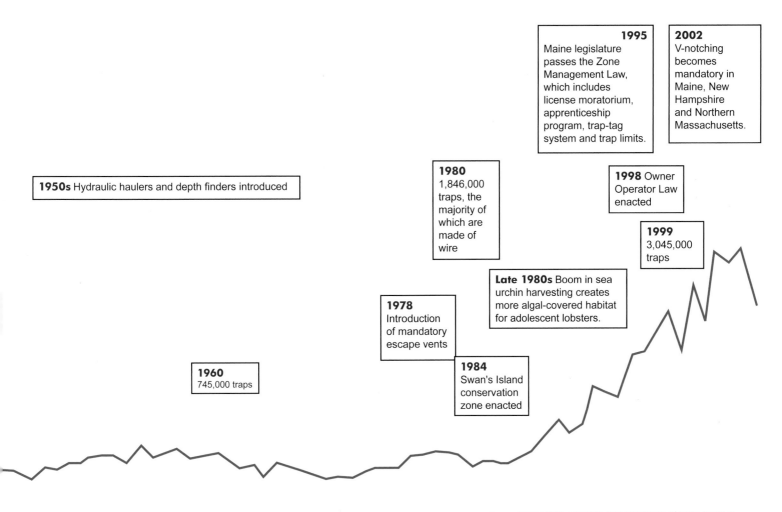

including Walter Day of Vinalhaven, wonder whether changes in climate contributed to the decline. Although the reasons for the bust are not clear, it appears to have contributed to the incentive to conserve: fishermen do not take lobster abundance for granted. Without stock assessments or limits on landings, the fishery sustained a harvest of roughly 20,000,000 pounds annually from the 1930s until the late 1980s. At that point, landings began to climb, only recently reaching an apparent peak of over 70,000,000 pounds. The causes of this tremendous increase are the subject of ongoing debate. Scientists do agree that a convergence of a variety of factors most likely explains the increase. The elimination of nearshore stocks of groundfish removed a major predator of the lobster. The overharvesting of urchins allowed kelp forests, a favorite nursery habitat for juvenile lobsters, to flourish. Water temperatures increased, promoting lobster growth and develop-

ment. Fishing effort increased dramatically during this time, as huge landings convinced many part-timers to join the fishery full time. Fishermen added many more traps, switching from wood to wire construction, which can be fished longer and harder. Boats and engines got bigger, and hydraulic haulers became common, allowing more area to be fished, particularly areas vacated by groundfishermen. Certainly, the efforts of the fishermen to sustain their fishery have also contributed to the increase in landings. However, recently, this trend has changed and the fishery can now be characterized by unstable landings and excess effort.

Capturing local knowledge

We have employed a variety of methods to capture the observations of fishermen. Trained facilitators convened roundtable discussions in February of 2007 and 2008. Fisher-

men expressed their thoughts regarding the seasonal cycle of the fishery: When do the lobsters start crawling in the spring, when does the shed occur, when do landings peak and when does the fishery dry up in the fall? Has this cycle changed from any historical norm? Have they observed any unusual creatures in their traps? How have storms affected fishing? Do they have any observations regarding sea-level rise?

Information from the roundtables was synthesized and presented at the Maine Fishermen's Forum in 2007 and 2008 and additional input was solicited from fishermen. As a follow-up to comments made by Walter Day of Vinalhaven, who compared current conditions to those of the 1950s, we also conducted an in-depth interview with Walter in order to capture his perspective, based on over five decades of fishing.

During the 2007 fishing year, Island Institute staff surveyed additional fish-

ermen by telephone regarding the impact of the Patriots Day storm as well as northeasters that hit the region later in early fall. In 2008, we developed a survey to expand the reach of the project, distributed it at the Fishermen's Forum and the Canadian-American Lobster Town Meeting, held in Portland, Maine in March, and then mailed it to all 5,677 commercial license holders in July 2008.

Findings

The findings of the project to date provide insights into the current and potential effects of climate change on the lobster fishery. Perhaps just as important, the project has shed light on how the fishery functions—and how it has evolved to be highly adaptive. The information provided by fishermen is complementary to data collected by scientists. Researchers have measured surface-water temperature for over 100 years at Boothbay Harbor, and they have measured temperatures at the surface and at depth off of Grand Manan

for over 80 years. Fishermen, on the other hand, have information on water temperature that describes the dynamics of a bay or cove in great detail. In some cases, it also stretches back several decades.

According to fishermen, patterns in the fishery are changing. Fishermen from Schoodic Point west, who shift their gear during the season to follow the seasonal shed of the lobsters, are shifting gear to deeper water earlier in the season than they used to. "The places I fish in August are the places we used to fish in October—and now everyone is starting to do it," said Jim Wotton of Friendship. Whether this phenomenon is related to changing oceanographic factors—or to the fact that inshore populations are being fished down by all the gear in the water—is unclear. Other factors could also be at work to further complicate analysis of patterns in the seasonal movement of gear. For example, the cost of fuel may influence some fishermen to delay moving their traps offshore. On the other hand, fishermen from areas popular with recreational

boaters often like to move their gear offshore to avoid congestion and the likely loss of traps due to entanglement in propellers.

Fishermen also agree that the pattern of molting by lobsters, known as "the shed," is changing. Lobsters molt as they grow, shedding a shell that is too small in order to grow a larger one. The rate of molting depends on the age and growth rate of the lobster, but the majority of legal-sized lobsters molt once or twice during the warmer months of the year. Lobsters with new shells appear in lobstermen's traps in a wave, or series of waves, each summer. Until a few years ago, the timing of sheds was very predictable. While following a different schedule in different parts of the coast, the arrival of shedders was something that fishermen could count on. In the past six to eight years, however, the timing of sheds has become much more variable, with an apparent shift earlier in the season. Jim Wotton remarked that he thinks the warmer temperatures are "making them shed a little earlier than usual." He, like some fish-

ELLIOT THOMAS, YARMOUTH

"Whenever a group of fishermen get together and talk, you always learn something because lobstermen tend to be keen observers of what is happening in their area. When asked to attend the first session of the project, I jumped at the chance to see if others had noticed trends similar to those I had observed. Although the two sessions I have attended can only be the start of observations of a long-term process like climate change, similar observations of change along the Maine coast by other fishermen seem to suggest that something is happening. As more observations are collected from other fishermen, we will be able to see more clearly how trends are changing over time, and we will be better prepared to adapt to any resulting changes in the fishery. My hope is that our observations can and will be used by scientists to help document these trends."

ermen, tracks water temperature carefully when planning his fishing. "I've got temperature on my fathometer. I like to see 58 degrees when I start up the river. When I get 56, 57, 58 degrees, it's time to start setting shedder pots." Sometimes, the shed seems to occur hardly at all; at other times, it stretches over several weeks rather than coming in what the fishermen call a "spurt." Landings data, which reflect increased feeding activity of post-shed lobsters, demonstrate changes in the nature of sheds. Distinct peaks in the shed occurred in most years; in 2003 and 2004, the shed took the form of a large plateau. Fishermen also noted that the point of highest landings along the coast has been gradually shifting to the east over the past few years. Sonny Sprague of Swan's Island attributes the shift to warming temperatures: "I do believe global warming is happening, because this year Hancock County supposedly was the top dog in lobsters and the top dog most of the time has been Spruce Head and Vinalhaven. Now it's shifted a little bit eastwards. Before long they're going to be by us; they'll be in Nova Scotia." The shift eastward follows a similar shift, several years earlier, in the settlement of larval lobsters. If climate change is behind the shift in landings, then its effect is most likely on the larval rather than the adult stage of the lobster.

Reactions to climate change

Concerns regarding climate change include fears for future generations of lobstermen rather than impacts on this generation. Fishermen have questions regarding an increase in invasive species, the possibility of freshwater run-off shutting off the fishing, and the trend in peak landings moving into Canada. For the most part, however, fishermen see the effects of climate change as just another thing they'll have to deal with; they are confident that they can adapt, just as they have adapted to trap limits, gauge increases, bait shortages, seal predation, etc. This view comes from the fact that fishermen have always had to be adaptive; even under the best of circumstances, when landings were growing and the shed occurred at the same time every year, lobsters have been unpredictable. Even during the times when, according to John Drouin of Cutler, you "could set your clock" by the timing of the shed, fishermen still did not know exactly where the lobsters would be. Adaptive by nature, fishermen plan to adjust to climate impacts by working harder. During the boom years of the 1990s, it was easier to catch lobsters when, as Jim Alwin of Biddeford Pool said, "you could do no wrong." However, with the changes in the fisheries he believes that "we need to go back to fishing and not just trap-hauling."

Fishermen who have participated in our project are very enthusiastic about the opportunity to work with other fishermen in making sense of what they see on the water day in and day out, year after year. As Jim Wotton of Friendship commented, "I liked it; I learned a few things, and I like hearing how things are different yet the same for all of us." While the fishery is comprised of individuals owning their own boats and

ANDREW PERSHING, PhD

Andy Pershing, an oceanographer at Gulf of Maine Research Institute, uses computer models to explore the potential effects of climate change on the Gulf of Maine. He and other scientists are in the early stages of determining what precise changes will result in the Gulf from warming water, increased ice melt, and more intense storms. Because of the limits in predicting marine response to warming conditions, Pershing says that "climate change is a form of uncertainty that must be factored in the lobster industry." Andy notes that there has been a shift in climate research away from the possible range of global temperature increases and toward thinking about local- and regional-scale impacts. Pershing sees a positive shift towards ecosystem-based research, but warns that "our management structures do not incorporate ecosystem climate changes yet."

WALTER DAY, VINALHAVEN

Walter remembers fishing in the 1950s, when his mother would take him out to haul his 10 traps; he brought his catch back in a peach basket and sold shedders for 35 cents. He notes that the bulk of the landings came later in the year—just as it does now. According to Walter, "the fishermen are always blamed"—unfairly—for the bust of the 1920s. He says that the decline was part of a natural cycle, but wonders if a change in climate might have played a role. Walter has noticed other changes in the fishery. Beginning in the late 1980s, lobsters could be caught on mud as well as hard bottom, expanding the availability of productive fishing area. More recently, Walter has seen the fishing improve in deeper waters. Now, "it's not worth the aggravation" to fish in shoal water thick with gear. Walter has temperature probes in two traps and watches bottom temperature closely by checking the Gulf of Maine Ocean Observing System website.

working their gear on their own or with a sternman, the fishermen still trade information regularly. By these means, they keep track of trends in landings along the coast, follow ups and downs in the market, and learn about innovations such as alternative bait or fuel-saving techniques. The roundtable discussions were particularly beneficial, according to fishermen who participated, because they were able to trade information with fishermen from other areas of the coast. Compliance with V-notch regulations, dynamics of the shed, strategies for getting the most out of gear and keeping costs down, tactics for finding hot spots, and the relative numbers of juveniles, V-notched, berried and over-sized lobsters were common themes among roundtable participants.

Scientists also appreciated the opportunity to learn about the information that fishermen collect. They were quick to identify ways in which this information complemented their own knowledge. They also made suggestions for structuring input from fishermen so that it could be more easily linked with more traditional forms of scientific data. In particular, the panel recommended that, in addition to participating in roundtable discussions, fishermen be surveyed to collect quantitative as well as qualitative information regarding their observations on the dynamics of the marine environment.

Fishermen have important information regarding fine-scale changes in their environment and in lobster population dynamics. This information can be linked with larger-scale climate data and scientific forecasts to provide a much fuller picture of the potential impacts of climate change on lobsters and the Gulf of Maine ecosystem. Our goal in launching this project was to take the first step in developing real-world recommendations for the lobster fishery and for all of the coastal and island communities that depend on it for their continued survival. Our hope is that, with this initial research and the work to follow, we will not only create a model for adapting to climate change along Maine's coast, but also one that proves useful for natural resource–based communities around the world.

2009

To view the full report of Climate of Change go to www.islandinstitute.org/climateofchange.

In the Lair of the Ice King

PHILIP CONKLING

PHOTOGRAPHS BY GARY COMER

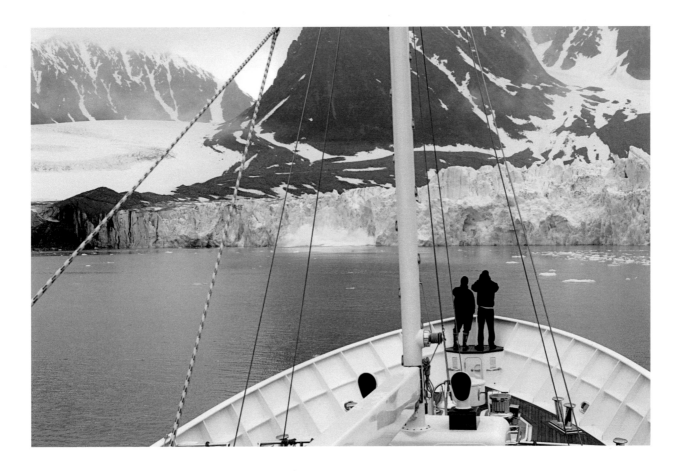

CROSSING THE GREENLAND SEA
July 13–15, 2000

A s our vessel cruises north from Iceland, it is hard to keep track of time when there's no difference between day and night. Most of us sleep throughout the night with the portholes covered to block out the white light while our highly competent crew moves TURMOIL, a 151-foot-long cruising vessel, through the Greenland Sea around the clock. It has been overcast and cool for most of the week since leaving Reykjavik, Iceland's largest port, where we met Gary Comer, TURMOIL's owner, and the crew. We are on an adventure of a lifetime—a voyage that will traverse the remote western coast of Iceland, then cross the Greenland and Norwegian Seas for a landfall at Spitsbergen, one of the most remote islands in the northern seas. Our intentions are to explore the fringes of the known world where few are able to go and to record our impressions of the life of the sea north of the Arctic Circle.

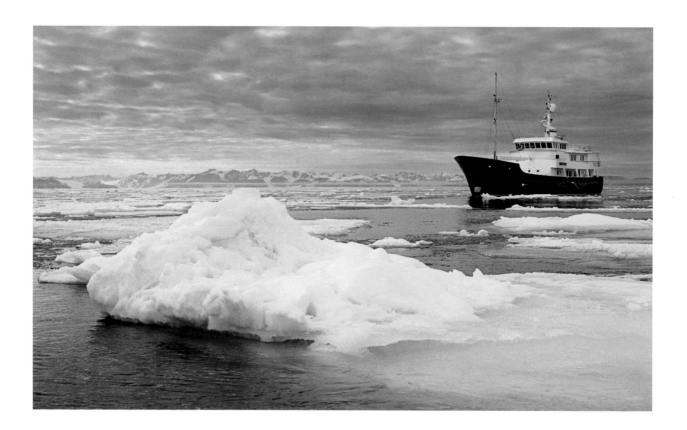

Throughout the day, the ship's routine goes on smoothly and unceasingly. TURMOIL's four passengers find little corners in the library, main salon or up on the bridge to catch up on reading or to send e-mails back home. The satellite coverage for regular telecommunications gets patchy north of 70 degrees latitude, so today may be our last contact with our offices and families back in Maine. It is truly amazing, of course, that we can communicate so effortlessly through written messages from the middle of the Greenland Sea, and perhaps a little frightening how emotionally dependent you can get on the technology if it is available.

The weather reports also come in via electronic telecommunication, either on the fax or e-mail server. The service is called Fleet Weather, based in New York. Philip Walsh sends them our position, the visibility, sea condition, and barometric pressure and gets back a 36-hour forecast each day. The weather continues to improve throughout the afternoon and we all gather on the stern deck before dinner. There is a moderately thick cloud cover overhead, although the horizon is clear all the way around the compass. Soon even the clouds overhead begin to dissipate. Suddenly, just off the stern quarter, is a massive spout and then the long dark back of an enormous creature from the underworld emerges from the toughs in the waves. It can only be a blue whale. It surfaces once more fur-

ther off and then is lost in our wake as we continue our northerly course. Shortly afterward the captain spots a tall straight silhouette many miles out that he at first mistakes for a sailboat mast. We alter course by 30 degrees to investigate. It takes us a quarter of an hour to get in the vicinity and suddenly we are surrounded by whale spouts exploding off to port and starboard.

As we angle closer in, a pair of finbacks, identified by white chevrons on their starboard sides, surfaces right off our beam. They are feeding on fish that have come to the surface. Soon two other finbacks join them as we steam side by side at 10 knots, approximating their speed. Every minute or so they burst to the surface in an explosion of spume and foam that cascades off their glistening dark backs. Then the most remarkable spectacle unfolds as three of the whales burst to surface almost touching each other, their torsos silver in the spray. One whale's mouth is so wide open its baleen plates are plainly visible. They lunge after a shoal of invisible fish, probably herring, then twist on their sides, extending flippers vertically in the air. Seconds later the tip of one of the flukes trails by like an enormous shark fin knifing through the water. The "lunge feeding" goes on and on as they chase the fish and feed. The noise of the spouts is deep and otherworldly, a cross between a shout of exuberance and a moan of despair. Although it is nearly 11:00 p.m. when

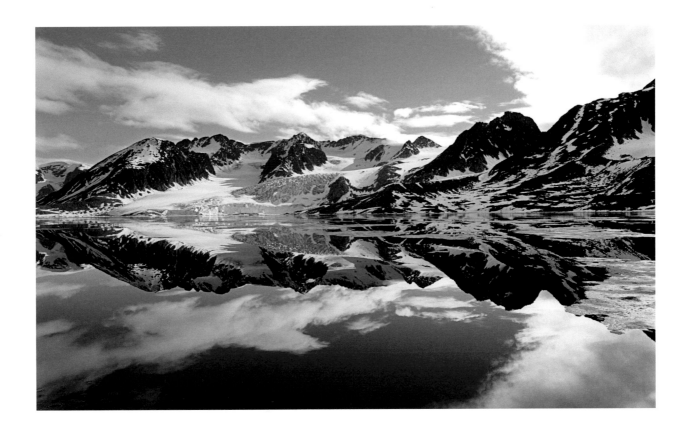

we break off from the whales, the sun is still several points above the horizon. Tonight the sun will not dip below the horizon at all, but will roll around the rim like a giant yellow marble balanced on the lip of an enormous saucer until it slowly begins to ascend on the other side of due north.

POLAR ICE AT THE 80th PARALLEL
July 19, 2000

After a quiet night in a fjord at the northern end of Spitsbergen we awake to gradually clearing skies. TURMOIL heads north from her anchorage with the intention of exploring the edge of the sea ice where we might see polar bears hunting for seals. As the clouds continue to lift in the shimmering morning sunlight, we begin to see mirages of ice off to starboard. A fata morgana, a mirage that appears in polar regions caused by air temperature and density differences, now fills the entire eastern horizon, looming up like a vertical wall through the binoculars. This can only be the edge of the pack ice, although it looks like the edge of an ice escarpment—a barrier we will never be able to cross.

Soon we are nosing through what the captain calls a field of "bergy bits," little pieces of ice dotting the surface. A mile further ahead we swivel into the edge of pack ice. When we arrive, Gary calls for the jet boat so we can maneuver through the floating bergs and get a closer look at the ice field swaying on gentle arctic swells. Meanwhile puffins careen by overheard, seemingly flying through the rigging of TURMOIL. The sun glints silver off the shifting ice pack. The sound of the

pack ice is like a rushing wind off in the distance, as the heave and surge of the sea lifts and lowers a thousand square miles of restless ice that shifts uneasily against itself like a huge moaning diaphone. It is the dull roar from the lair of the ice king.

A short while later back aboard TURMOIL in the pilothouse, there is a brief celebration at the GPS station as we cross the 80th parallel. Only 600 miles to the North Pole! For one mad moment, the same thought flashes across all our minds: Maybe we will get lucky and find a long-enough lead through the ice pack to make a dash for the Pole and get to the top of the world! Only for a moment, though. Who in his right mind would risk this boat for such an ice-crazed dream? But still . . .

POLAR ICE AT THE 80TH PARALLEL
JULY 23, 2000

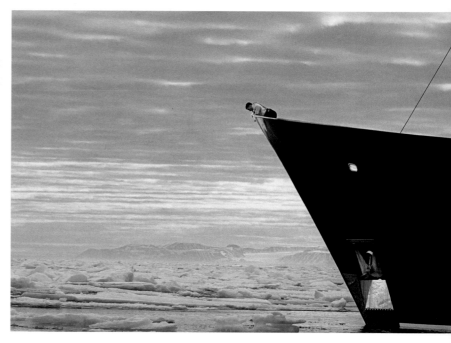

Our voyage ended, Turmoil puts into the port of Longyearbyen on Spitsbergen's western coast where we will meet the plane that will take us back to the temperate world. It is a clear morning as we take off and re-cross the empty expanse of the Greenland Sea we had traversed in Turmoil a week earlier. In less than half an hour the plane is over the eastern edge of Greenland, a half continent-sized island almost completely obscured by an immense blanket of ice and snow. The morning sun pools in pockets of golden glow over the frigid waters at the white edge of the land. This eastern edge of Greenland is seemingly discharging bits of its frozen surface into the southerly trending currents that carry this flotilla of icebergs south like an endless stream of packing bits loosed in the wind.

THE VIEW BACK HOME

Several weeks after returning from the Turmoil voyage we were stunned, like many others to read a front-page story in the *New York Times* reporting that a Russian icebreaker, Yamal, had left Spitsbergen with a group of tourists in mid-August headed for the Pole. When they got there a week later, instead of ice, they discover nothing but open water at the North Pole. There were several American scientists leading the tourist expedition aboard the Yamal, including Dr. James McCarthy, an oceanographer, and director of the Museum of Comparative Zoology at Harvard University. McCarthy said that he had been at the Pole six years earlier and had encountered a completely frozen sheet of ice and reported he had never seen so much open water in the polar region. The captain of the Yamal said he had been making this passage for the past decade and generally had to cut through an ice sheet six to nine feet thick. (Other reports from prominent polar scientists published a few weeks later point out that approximately 10 percent of the polar Arctic region is open water since the ice pack constantly shifts in winds and currents to create pockets of open ocean, and that open water will appear from time to time at the Pole.)

Despite such disagreements, the evidence is mounting that an unusual amount of melting is occurring in the polar regions of the North Atlantic. What effects this might have on the rest of the ocean, including our small window on the world from the edge of the Gulf of Maine, is anyone's guess.

What we do know is that the earth's surface temperature, including the temperature of the sea's surface, has increased by about one degree since the late 19th century, and the 1990s have been the warmest decade on record. The difference in average global temperatures between a full-fledged ice age and our present inter-

glacial climate is only about five degrees, so this global temperature increase is cause for concern, if not alarm. We also know from detailed recent measurements that the southern half of the Greenland ice sheet, the second-largest ice sheet in the world after Antarctica, has shrunk substantially in the last five years. Greenland is losing ice at a rate comparable to the size of Maryland covered by a foot of ice melting per year.

Closer to home, a story from last summer is a reminder of how interconnected life in the ocean can be. As a part of the Penobscot Bay Marine Collaborative, the Island Institute administers an interdisciplinary team of scientists, fishermen and managers trying to understand the dynamics of lobsters in the bay. Part of the project is to place college graduate "Island Fellows" and interns aboard lobster boats to collect information from cooperating fishermen. Lobstermen know that every year the habits of the world's most favored crustacean will be somewhat different than the previous year. Since anyone can remember, lobstermen in the spring have begun to set traps close to shore to intercept lobsters as they crawl into shallower, warmer waters to shed their old shells and breed. But last year was dramatically different. Fishermen set their gear as always, but catches in April, May and early June were not just low, especially in the Midcoast—they were almost nonexistent. Already nervous because of the collapse of the lobster population in Long Island Sound, N.Y., Maine fishermen feared the worst.

Then, beginning in early June, a strange thing happened. Lobstermen began catching shedders, very large numbers of them, between three or four weeks earlier than normal, in deeper waters than usual. The evidence

is anecdotal and therefore "unscientific," but a picture emerges: the early part of the lobster season was dramatically different from what many established fishermen had ever observed.

Informal observations from many sources also suggest that the deeper bottom waters along the eastern and midcoast sections of Maine were unusually warm early in the season, a state of affairs that led to an unusually early shed. Assuming that these observations prove to be accurate, the question is why warm bottom waters entered the bays of Eastern and Midcoast Maine, and what this change may be telling us about circulation patterns in the Gulf of Maine and beyond.

GLOBAL OCEAN CURRENTS AND CIRCULATION

Mariners have been studying ocean currents for centuries, but systematic observations of global ocean circulation features began in the mid-19th century when the United States Navy began to collect comprehensive current observations from fishing and commercial fleets operating throughout the world's oceans. These observations were painstakingly compiled to provide ship captains with estimates of the speed and direction of major ocean currents. Captains contributed information because no one could even begin to see the whole picture of the North Atlantic, for instance.

One of the most important ocean currents is the Gulf Stream that trends northerly off eastern North America to the region south of the Grand Banks of Newfoundland. From there it flows eastward across the North Atlantic. The significance of the Gulf Stream was not lost on commercial shippers, who laid their courses to take advantage of or reduce the disadvantage of this huge river-like current.

The Gulf Stream can be viewed as a vital piece of a global thermostat that transports heat trapped in equatorial oceans northward toward the poles where it cools as it goes north. Because so much of the rainfall over the North American continent is intercepted by mountains and falls on land, the saltiness of the Gulf Stream is high relative to other ocean surface waters. As this salty, and therefore heavy, seawater is carried north and cools, it meets cold polar currents in the region south of Iceland, and it sinks. Although tongues of the Gulf Stream continue to flicker north (including along the western coast of Spitsbergen), most of this dense, cold water sinks to the abyssal depths of the North Atlantic. There it sets up a giant, deepwater conveyor belt that flows along the bottom of the Atlantic basin beyond the tip of Africa, all the way to the edge of the Antarctic shelf.

Off Antarctica, North Atlantic bottom water, called the North Atlantic Conveyor, meets sinking cold surface water trapped between the sea ice to form a deep raceway around the Antarctic continent. The cold

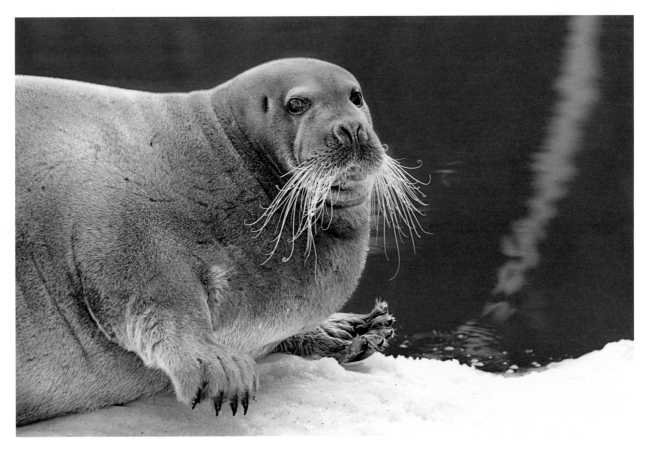

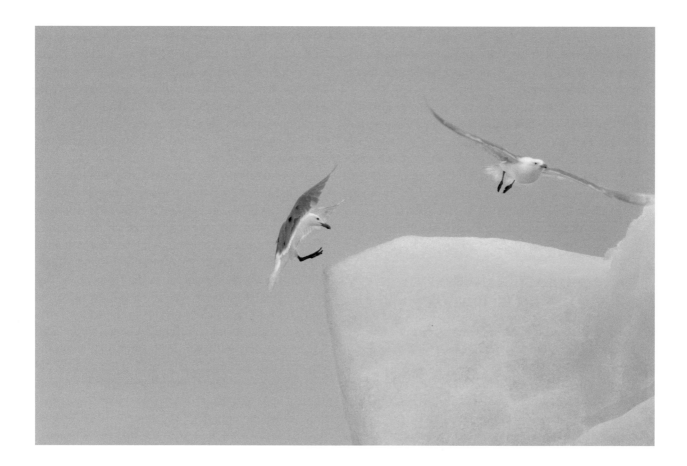

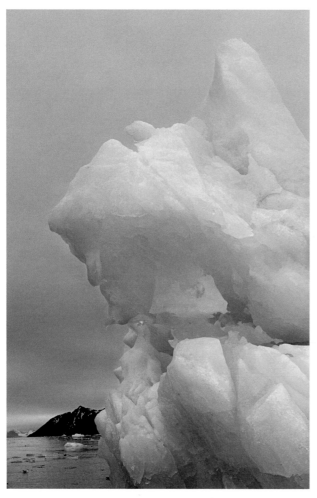

bottom waters of the North Atlantic Conveyor vie for dominance with the bottom waters that descend from underneath the Antarctic ice sheet. Currently, the North Atlantic Conveyor is slightly dominant and forms the source of salty bottom currents that flow through deep topographic passages to drive the circulation systems of both the Pacific and Indian oceans.

But what happens if the North Atlantic Conveyor loses its dominance? Perhaps no one has given this question as much thought as the dean of American oceanographers, Wallace Broecker, of Columbia University. Referring to the analysis of Greenland ice cores ,where a detailed record of the earth's climate during the past 60,000 years has been unraveled, Broecker points to clear evidence that the earth's climate has switched back and forth between two modes of operation. The difference in time between interglacial epochs of moderate climate, and periods of intense cold, is measured on a scale of a few decades to a few years. How can such gigantic shifts in the earth's climate occur on such short notice? Scientists like Broecker do not know for sure, but the most sophisticated climate model suggests the "trigger" is a shift in ocean circulation.

Broecker reasons that slight changes in the relative strength of the two major sources of bottom water in the North Atlantic or the Antarctic shelf can trigger a rapid reorganization of global ocean circulation. This analysis suggests the only physical mechanism that can

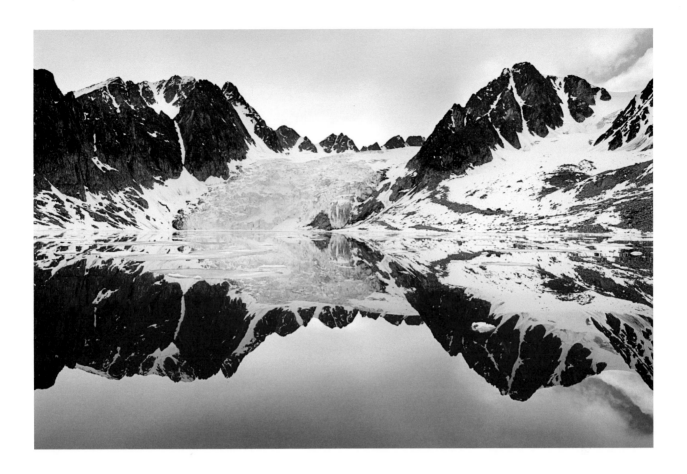

explain a decrease in the rate of North Atlantic bottom water production results from a reduction in saltiness, and hence density, of its surface waters. Thus, if rapid increases in the rate of melting of Greenland ice cap and the Arctic pack ice were to occur, the resulting freshwater increase in the eastern North Atlantic would reduce the dominance of the North Atlantic Conveyor. With even a moderate weakening, the deep ocean circulation patterns can flip into their other mode of operation, where the Antarctic bottom waters are dominant. The resulting ocean circulation alters global weather patterns, including the strength and direction of the Gulf Stream. The Gulf Stream no longer flickers as far to the north in the eastern North Atlantic, quickly plunging northern Europe into a much colder climate. The resulting change in atmospheric circulation leads to new storm centers that transport more water vapor to the poles. As water vapor builds up at the poles, ice sheets begin to creep outward, but the persistent storms also reduce the saltiness and density of the waters that previously drove the North Atlantic Conveyor.

While we do not know whether the North Atlantic Conveyor is slowing enough to risk major changes in global ocean circulation and global climate, major ice melting in the eastern North Atlantic is an observed fact. The changes in bottom water temperatures in the Gulf of Maine can (and will be) documented as either a trend or an anomaly.

No one has definitely linked the melting of ice in the high Arctic to the production of greenhouse gases released by the burning of fossil fuels, but it is worth asking what kind of worldwide experiment is now ineluctably under way. Global warming scientists used to model a doubling of greenhouse gases in the earth's atmosphere and try to interpret the results. Newer projections make a tripling of the volume of greenhouse gases ever more likely during the 21st century.

Those with their hands on the levers of government, at least on this side of the North Atlantic, have taken a "wait and see" approach to the debate over whether global warming is real and a cause for concern. Because scientists are unable to predict with any certainty the timing and magnitude of global climate change, nor even whether it will produce new deserts or new ice ages, some might think this strategy has the prudence of Solomon. But if you view the doubling or tripling of heat-trapping gases in the atmosphere to a global game of Russian roulette, especially when the outcome is so unpredictable, the strategy looks less like Solomon's and more like Nero's.

2001

See more images from Greenland and points north at www.islandinstitute.org/iceking.

Marine Communities

Under water, the connections are everywhere

TED AMES

For centuries the fisheries of the Gulf of Maine have produced a magnificent bounty of seafood. Fish and shellfish once seemed so abundant that the stocks were thought to be inexhaustible. Unfortunately, we have found otherwise, and in recent years we have so overwhelmed the Gulf's natural productivity that a number of species have been virtually eliminated from large areas of the coast. Others are seriously depleted.

Though biological diversity has been reduced, the Gulf of Maine continues to be very productive. At the same time, some species are abundant and continue to provide robust fisheries. Exactly how and why it responds to man's intrusion in the way it does is only now becoming clear.

A most peculiar combination

The Gulf of Maine owes much of its biological productivity to the peculiar combination of geology, tides and currents, and seasons. It is a leftover from the last ice age, with drowned mountains and rivers surrounding deep marine basins to form a very irregularly shaped basin.

When tides and currents encounter these barriers, they are forced from their paths and create numerous expanses of upwelling and eddy. Deeper currents draw nutrient-rich water upward to the surface to host an abundance of marine life.

Other nutrients come from the land. Rivers and streams along the Gulf's northern rim pour their contents into its bays, diluting its salinity and enriching it with runoff to form an inner body of water that becomes sandwiched between the land and 50 fathoms by the Maine Coastal Current.

During their seasons, plankton multiply to create enormous populations which become a feast for all marine creatures equipped to eat them or those who come to eat.

Fishing communities

Fringing the shores of the Gulf of Maine are coastal towns and villages that have depended on harvesting the sea for centuries. Fishing is the natural business of these places and fishermen have lived there, pursuing cod and a multitude of other seafood. The perennial song of the bay has been, "the fish're in!"

And like the species they pursue, fishermen have adjusted to the complex marine world that surrounds them, responded to the secret inner rhythm of the sea, changing their fisheries and scale of effort to match changing markets and the abundance of particular stocks.

Community infrastructure reflects this. Different vessel types and support facilities appear as fisheries change, and like the biological communities they depend on, these shoreside niches have adjusted to accommodate a changing ecosystem.

At first, the changes occurring in the ecosystem seemed to be the result of natural variations. But as fishing technology improved, the changes seen in the marine environment have often been attributed to overfishing.

Many who fish for a living challenge this conclusion and insist that these are only natural variations in the system. A peek at how marine ecosystems work lets us see if that could be true.

Benthic communities

If you examined a tidal pool along the edge of the Gulf of Maine, you would see abundance and variety in the creatures living there. They are not found everywhere; different kinds of marine organisms exist in mudflats and other habitats.

Each locale hosts its own unique community of species that are better adapted to its conditions. Stationary species are lifelong residents of their communities and include seaweeds, barnacles, worms, etc. Others are transient or seasonal and stay there only as long as local conditions are acceptable.

If you looked closely, you would find that wherever the habitat changes, the mix of species within a community also changes.

That difference reveals the preference and tolerance of a species for a particular type of bottom, current strength, salinity, etc. Such preferences include the available food supply, shelter and the presence of predators and competitors.

This creates a patchwork of different communities abutting each other, reflecting the changing habitat. Ultimately, these form a vast mosaic of communities that cover nearly every square inch of bottom throughout the gulf of Maine. But these are not the only biological communities present.

Pelagic communities

Creatures living within the water column form pelagic communities, many of which overlap with bottom communities. Pelagic communities are usually separated by indistinct boundaries between bodies of water that vary with time; the interface at the edge of a current, the temperature gradient, or the depth that light can penetrate.

Many key members are tiny and include plankton, whose abundance depends on the season (light intensity) and the concentration of dissolved nutrients. The eggs of most benthic and pelagic community members are released into the water column, their larvae feeding on plankton and each other until they metamorphose and become part of some other community.

Species grazing on this living potpourri include creatures from the benthic community like barnacles and scallops, others from the pelagic community that range in size from zooplankton to herring to whales. Still others eat the grazers; the cod, pollock, hake, seals, whales, etc. Many of those feeding were themselves recent survivors of earlier plankton stages and are now grown.

Unlike the patchwork segregation existing below them, the mixture and abundance of species in pelagic communities are in a state of constant change. This creates a tenuous, almost ephemeral collection of species that migrate seasonally to areas where the essential plankton abundance is occurring. While somewhat predictable, the actual times of arrival,

locations, and character of the pelagic community are inherently variable.

Changing communities

A tidal pool visited each summer over a long period of time would appear to change but little. The kinds of creatures found there one summer would probably still be found there during the next, indicating a remarkably stable biological community living in a remarkably stable place.

But this is misleading. Only those who can best accommodate the stresses of a habitat will inhabit it. Tidal pool creatures are there because they can tolerate living under those conditions better than others competing for the same niche.

Those species may visit and even stay for a period of time, but when conditions become too severe, they must move to more agreeable locations. Those left behind must endure the new conditions or die.

Such changes occur each season in the Gulf of Maine. To the uninitiated, whole populations seem to mysteriously appear in one area, remain for a period of time, and then disappear once again. Those more intimately connected to the marine environment realize this nearly continuous movement of species is the normal condition.

Change is, in fact, the most obvious constant in the sea. Its inhabitants are attuned to its timeless rhythm, and have orchestrated their life cycles to coincide with it. This ensures that proper conditions occur at each life stage, and in turn, insures the collective survival of each community in a delightfully complex series of events.

Linkage between communities

Stepping back, it becomes apparent that the life found in a tidal pool is not only a community of interdependent creatures living together, but the tidal pool community itself is dependent on a larger, more complex community for its maintenance and survival. The converse is also true, for the sum of community interactions describes the well-being of the Gulf of Maine.

Some interactions between biological communities, for example, involve species that belong to different communities during different stages of their lives. In fact, the developing stages of marine life often demand a whole series of different communities for critical habitat.

Cod, scallops, lobsters and a host of other commercial species have life histories of this type. Such species have synchronized their spawning to coincide with seasonal plankton blooms. Timing is critical, for successful reproduction depends on the eggs hatching when the plankton are still small enough to eat. If the larvae arrive too early, they starve; too large, and they are eaten.

Survivors of pelagic stages then occupy a sequence of critical subtidal habitats in nursery areas of the Gulf of Maine. These different biological communities must be close enough together for the juveniles to shift to, for as they grow larger, different prey are needed for food and different shelter becomes necessary for protection from predators.

If one of these critical biological communities is too far away, or is too damaged to support them, a bottleneck forms that makes it difficult for the species to maintain itself in that area.

The bottleneck need not be absolute. But when it occurs, there will be fewer of that species to eat the available prey. Over time this shift in "who eats whom" redirects the flow of energy through the food web to competing species, making it more difficult for the restricted species to hold onto its niche.

At some point, when too few survive, the local population will collapse. In turn, this induces a chain reaction where each of the several habitats once lived in would have vacant niches. If the missing species were a critical food source in some of those communities, other species would disappear, too.

The loss of cod, for example, would not just affect the herring, crabs and lobsters being eaten by adult cod. The spring and summer pelagic communities, and a host of benthic communities in which the cod live while growing from inch-long, post-metamorphic juveniles to adults, have to find a substitute prey for the missing cod if they are to survive. Cod eggs and larvae are eaten by herring, mackerel, scallops, etc., and when they become juveniles, are eaten by many different fish, shellfish, marine birds and mammals.

Having these interrelationships linked through a series of biological communities moderates the effect a species may have on others within the system. Unfortunately, we have succeeded in bypassing these restraints with potentially disas-

trous effect.

The fisherman's dilemma

When a successful year-class of cod appears in a natural system, many survive because predators can't eat them all. The number of predators will increase, but because it takes time for them to reproduce and grow, and because other factors affect how many survive to become adults, they increase more slowly.

This creates a living surplus and a cushion for the ecosystem against poor year-classes of cod in the future. Eventually the system adjusts to a new balance between cod, their food supply, and predators.

Fishermen are ultimately bound by the same limits as natural predators; but unlike predators catching food, they are motivated by the price of cod in the market. If the price is up, large numbers of fishermen will enter the fishery. This increases the number of predators much faster than would occur naturally and the number of cod is quickly reduced. This eliminates the cushion, and makes the stock susceptible to further declines in abundance.

New technology has had a more subtle effect on abundance. Not only does it seem to be a natural proclivity of humans, but in the short term, it lets fishermen catch more fish, more easily.

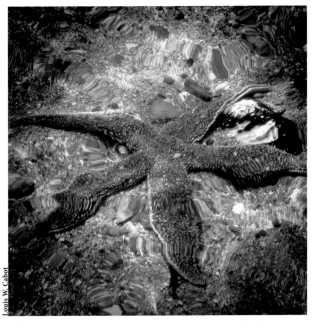

Louis W. Cabot

But there aren't more codfish, even though there appear to be. Instead, the cod that were previously inaccessible could now be caught. New technology has made the fisherman a more efficient predator.

With each new device, fishermen have been able to reduce stocks to ever lower levels. With fewer fish remaining, they again have to work harder to catch them. Fishermen using the old gear have usually been starved out. They had become less efficient predators.

In fact, landings continue to drop until the increased efficiency of the new gear is offset by the ability of the remaining cod to sustain their population. In the past, a new balance formed, but with a smaller stock of cod more susceptible to decline and collapse.

Until recently this allowed both fishermen and cod populations to maintain themselves in uneasy balance, for fishermen, you see, were still functioning as part of the ecosystem. It is this balance that needs to be recaptured.

Empty boots
"The fish're all gone, so I gotta go, too."

Looking over the abandoned fish plants and neglected groundfishing boats along the coast, it seems obvious that the submerged hangouts of cod are not the only habitats that were emptied. A surfeit of ex-fishermen are blunt testimony to what happens to predators when the prey's all gone . . . The niche they once occupied has also been abandoned.

The bustling factories and busy coastal towns were, in the final analysis, only an artifact of the ecosystem, and fishermen, too, are ultimately bound by the same natural laws as were the cod.

Too many commercial species have disappeared from our coastal waters to ignore the obvious. The combination of modern electronics with large fishing vessels has created a technology too powerful for stocks to withstand. The balance no longer exists.

The atrophy of groundfishing along Maine's coast is a stark reminder of how fragile our marine ecosystem is. While the loss of cod, haddock, herring and winter flounder from our bays is tragic enough, we have far more to lose if we fail to protect the web of biological communities that sustains all our fisheries.

Our losses have been local. Catching too many haddock on Georges Bank didn't cause the collapse of haddock in Penobscot Bay. It was caused by damaging critical nursery habitats while catching up the fish around Perry's Ledge, Sunken Seal Island, and Bay Ledge. If fishermen want to see haddock back in Penobscot Bay, those are the areas they have to start protecting.

To advise "you are catching too many" simply doesn't provide fishermen with a constructive course of action. Realizing how important local events are, could. Protecting local spawning habitats and nursery areas provide the key to using the Gulf of Maine's productivity more effectively. We need to fish smarter.

1997

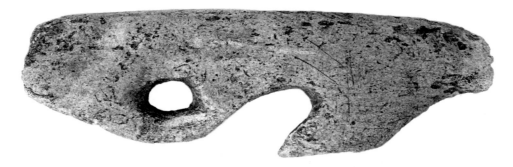

Who Were They?

From prehistoric times, the native people of the Gulf of Maine have been responding to its changing climate

ARTHUR E. SPIESS

When we prehistoric archaeologists present ourselves to the public, we are usually asked two very basic questions. The first is, "Who were they?"—these people whose actions made all the stone tool fragments and left all those piles of shellfish and animal bones. Second, we are often asked in much more subtle and variant forms, "What good is archaeology?" Besides being entertaining and putting some time-depth into our view of the world, does archaeology have any practical use in solving today's problems? Certainly it does along the coast of Maine, where prehistoric archaeology is particularly interrelated with environmental study. The last two decades of doing archaeology along the coast and among the islands have taught us much about the past Native American life, the ecology of coastal Maine, and how both have changed over the last 10,000 years. Our understanding of how our distant forebears adapted to that changing ecology provides a deeper baseline of information than we can get from modern ecological studies alone. And at the same time, we can flesh out the old bones and reconstruct something of the human lives as well as the environment in which they lived.

A fortunate circumstance of coastal Native American life was periodic collecting of shellfish and subsequent discard of the shells (along with the rest of the garbage) around the place of residence, forming what archaeologists call shell middens. These shells neutralize the usually acid Maine soil and consequently preserve food animal bone, bone tools, and an occasional human and dog skeleton that would otherwise have rotted away within a century. The presence of thousands of food animal bone fragments in shell middens allows us to reconstruct the hunting and fishing economy and seasonal movements of the Native Americans. In addition, it allows us to monitor changes in fish and game frequency over time scales of millennia.

As Maine coastal archaeologists learn about environmental changes in the past, we can also make contributions to the study of future environmental changes. We know that the coast of Maine is sinking rapidly, at least in geological terms. The Penobscot Bay region is sinking at a rate of about one millimeter per year, while the area around Eastport is sinking about nine millimeters per year. If this rate were constant over the past thousand years, a campsite on the central coast of Maine built at the high-tide line 1,000 years ago would now be under more than three feet of water (or would likely have been destroyed in the process of submergence). In fact, the oldest intact Indian site yet recovered from the coast of Maine is only 5,000 years old. There are very few coastal sites with components older than 4,000 years of age. But there are several places where scallop draggers have repeatedly recovered stone tools dating from 6,000–9,000 years old from gravelly bottom between 5 and 20 fathoms of water. So the older coastal archaeological sites survive only a scattering of stone tools on the inshore bottom. This environmental-archaeological connection is an important one, but let's first take a look at "Who were they?"

Ten years ago we began three short seasons of work on a small shell midden on Allen Island, at the request of the Island Institute and the island's owner, Betsy Wyeth. Primarily we were there to determine whether the site was significant, and secondarily to test for evidence of George Waymouth's visit in 1605. We found instead a wigwam and fire hearth floor containing European clay tobacco pipes dating from about AD 1675, overlying a second wigwam floor of about AD 800 Both wigwams have been occupied during the summer, and both groups had been making a living the same way: catching fish, hunting birds and trapping the now extinct sea mink (*Mustela macrondon*). This site showed that there was some basic continuity in life along the Maine coast, which had remained stable for millennia, until even after the initial European contact suggested by the clay pipes.

There were few European trading voyages into the Gulf of Maine during the 1500s except perhaps a few by Basques. Sustained European presence, and with it direct and indirect interference in Native American affairs in the Gulf of Maine,

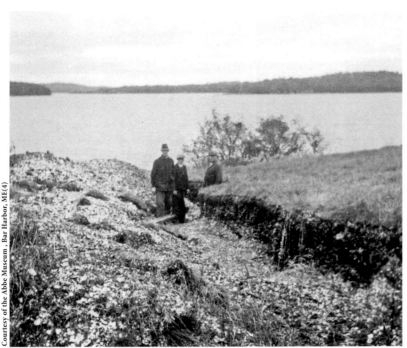

Tranquility Farm Site, Gouldsboro, excavated by the Abbe Museum in 1930-1931 under the direction of Walter B. Smith

began only with Samuel de Champlain and George Waymouth, around 1605.

Between 1605, when Champlain's account first specifically mentions Maine ethnic groups, and 1676 when the Indian wars brought drastic change, three ethnic groups (tribes) inhabited the peninsula that is today Maine and the Canadian Maritime Provinces. From northward to southward these are the Souriquois, Etchemin, and Abenaki. Farther south along the coast were a series of Massachusett-speaking groups. The Souriquois are (primarily) the ancestors of the modern Micmac; they inhabit what is now Nova Scotia, New Brunswick, and possibly northeastern Aroostook County, Maine. The Etchemin were the primary ancestors of the Maliseet and Passamaquoddy. In the early 17th century, they lived on tidal rivers and the coast between the Kennebec River and the Saint John drainages. The Etchemin inhabited a village near the mouth of the Kennebec of the east side, while upstream another group had a village at Norridgewock.

Souriquois and Etchemin were hunters, fishermen, and gatherers of wild plant foods. The inhabitants of Casco Bay and the Saco River mouth were agricultural, growing corn and beans. Champlain originally called them Armouchiquois in his 1604 account. By 1629 he refers to an agricultural group living at Norridgewock as Abenacquiouit, now "Abenaki." We assume that the Abenaki and the Armouchiquois were one people, and that Champlain had learned that latter name was an epithet. It was a Souriquois word related to "dog."

After the Indian wars began, these names changed. Between 1676 and 1692,

two terms were used for Native Americans living east of the Kennebec: "Canada," referring to expatriates from the Kennebec River who had joined people already living on the Penobscot in 1676; and "Maliseet." "Etchemin" disappears. Also beginning about 1650, French colonial authors increasingly used the term "Abenaki" to refer to a greater and greater proportion of the Indians in Maine and the Maritime province. The Penobscot tribe descended primarily from people living in the Penobscot after 1700. Following the American Revolution, the Maliseets were split by the new border between the United States and Canada into Maliseet and Passamaquoddy.

So answering the question "Who were they?" gets a bit complex. Tracing these ethnic groups backward into prehistory more than a few centuries involves major assumptions about the correspondence between certain styles of making ceramics or arrowheads and linguistic or ethnic groups, assumptions that most archaeologists are not willing to make. The answer for prehistoric inhabitants of most Maine archaeological sites is "They were Native Americans," and their language was probably related to modern Algonkian languages such as Penobscot or Maliseet.

The focal points of early-17th-century Indian life were a series of villages occupied for geographic name and one or more sagamore (chief or headman). The inhabitants of each village often dispersed to smaller, seasonal campsites for one or a few families. In 1614 John Smith found Penobscot River and Bay "well inhabited with many people, but they were from their habitations, either fishing among the Iles, or hunting the lakes and woods . . . [O]ver all the land, iles or other impediments, you may well see them sixteene or eighteene leagues from their situation"—that is, up to 50 miles from their home village during the season of dispersal.

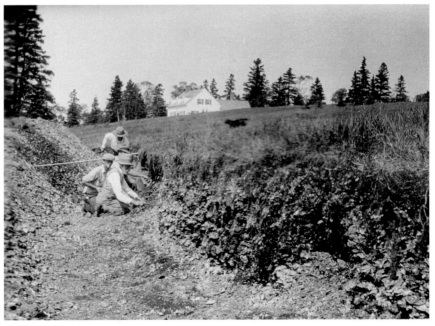

Tranquility Farm Site, Gouldsboro, excavated by the Abbe Museum in 1930-1931 under the direction of Walter B. Smith

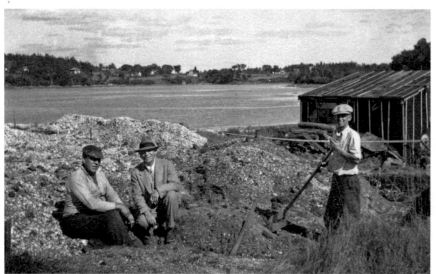

Taft Point Site, West Gouldsboro, excavated by the Abbe Museum in 1939, under the direction of Wendell S. Hadlock

All settlements were located on some sort of water shoreline (island, coastal, river or lake). The large multiseasonal villages were located in estuaries along the coast and along the middle and lower reaches of major rivers. The furthest village inland on the Kennebec was at Norridgewock.

In 1605 George Waymouth kidnapped five Native Americans from the vicinity of Allen Island and brought them to England, where they were taught English. A census of sorts, apparently derived from these captives' recollections, was published in 1625 by Samuel Purchas. Twenty-two villages were reported on the drainages from the Union River (Mount Desert Island area) westward to the Saco, each with between 30 and 160 households and between 90 and 400 men (except one small one with eight households and 40 men). Making some assumptions about proportions of men, women and children, the largest villages may have been home to 1,000 souls. Asticou's village, on Mount Desert Island, was reported by Purchas to have 50 houses and 150 men (400–500 persons). In the summer of 1613 the village was described as an area of 20 to 25 acres cleared of trees, with grass in some places to the height of a man.

The total population of tidewater Maine from Mount Desert Island to the Saco, inclusive, was probably about 12,000 people. Perhaps 20,000 to 25,000 people lived in what is now all of Maine. This population began to decline drastically in 1617–1619 with the first major epidemic of a European disease to sweep along the coast.

On May 12, 1605, Waymouth anchored in the Georges Islands (now Allen, Burnt, and Benner), and found evidence of hearths and food animal bones lying on the surface of an unused campsite. At 5 p.m. on May 30 three canoe-loads of men, women and children arrived, started fires and made camp. The account of the voyage records the delivery of a major oration by one of the arriving men, probably the senior member of the group. Perhaps it was a welcoming speech, but it could just as easily have been an expression of indignation and request for the English to depart. Since Waymouth's ship had been in the islands for two weeks, and the English had explored thoroughly, these Etchemin (we now know) had just arrived from the St. George estuary for their summer season stay. Archaeological work on several islands off the coast confirmed that "outer" islands were used during the summer only. The shell heaps in inner islands (including North Haven and Vinalhaven in Penobscot Bay) and in the estuaries, indicate multiseasonal or year-round use. Some Native Americans lived year-round on the coast of the Gulf of Maine, as implied by Purchas' census. Thus, at least some of the larger shell middens on inshore islands and in estuaries were the "home base" villages, each probably with a name and sagamore.

The archaeological evidence for political and social changes is sketchy, but we have a much more solid database for reconstructing past environmental changes, their effects on human subsistence and economy, and vice versa.

We have now located about 1,530 shell midden archaeological sites along the Maine coast. Most are located on inshore islands and estuaries. A study of shell midden site locations in the Boothbay and Muscongus Bay areas by Douglas Kellogg revealed the primary factors in the decision to use a particular coastal spot as a village campsite. A major consideration was all-tide access for a birch-bark canoe: the vast majority of shell middens are located adjacent to a (large or small) cobble, gravel, or sand beach which extends from high to low tide.

Ecological change has affected many aspects of the coastal environment during Native American habitation of Maine. As described earlier, the coast of Maine has been slowly sinking relative to sea level for at least 10,000 years. Radiocarbon dates on shells show that the 9000-year-old shoreline near Seguin Island is now under 65 feet of water. I have already mentioned stone tools from an eroded campsite underwater

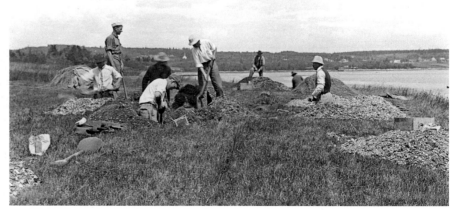

Warren K. Moorehead's excavation of the Boynton shell heap in Lamoine in 1913

near Deer Isle. The campsite is associated with an underwater channel (drowned estuary) that preserves patches of large oyster shells. A radiocarbon date of the oyster shells proves that the 6,000-year-old shoreline near Deer Isle is now under about 30 feet of water.

Oysters prefer brackish and relatively warm water compared with soft-shelled clams. So, while clams may not have been as common several millennia ago, oysters or some other species of shellfish were available. The oyster shell heaps at Damariscotta represent a localized survival of the estuarine conditions necessary to maintain major oyster populations. Deposition of these oyster shell middens by human harvesting began about 2,000 years ago and ended with European contact. Most of the rest of the shell middens along the coast are composed of soft-shelled clams and mussel.

The Gulf of Maine is a unique body of water where some extreme tides are caused by thegeometry of the water body. While the Gulf has become deeper and larger as the land has subsided, the tidal mixing in the Gulf has increased. Before about 6,000 years ago, tidal range was much lower than it is today. Because tidal mixing pulls cold water off the bottom of the Gulf and mixes it upward in a large upwelling off the eastern Washington County coast, the Gulf has also become colder and foggier.

We know that until about 3,800 years ago the summer surface waters of the Gulf of Maine, and Penobscot Bay in particular, were warm enough to support large numbers of swordfish. This species is now largely confined to the warm, offshore Gulf Stream. But the people of the Red Paint (or Moorehead Phase) culture around 4,200 to 3,800 years ago, and their predecessors at least as early as 5,000 years ago, successfully hunted them. One axiom of archaeology is that people butcher large animals near the kill site, and don't haul bones and viscera around unnecessarily. If swordfish were being hunted offshore, then outer island sites of this age would be the only ones full of swordfish bone. However, several sites at the inland end of Frenchman's Bay are packed with swordfish bones, including backbones and ribs. We therefore conclude that swordfish swam inshore among the inner islands and bays. Sometime about 3,800 years ago, the cool upwelling water became strong enough to affect inshore coastal ecology along the central and western Maine coast. The change was rapid, but not instantaneous. Swordfish hunting, and the Red Paint people with it, disappear to be replaced by other, immigrant folk. The coastal subsistence of even later people, after 2,000 years ago, including the ancestors of the Etchemin, was based on high inshore and nearshore biological productivity maintained by the high tidal range and cool surface waters. Sturgeon, flounder, sculpin, and juvenile cod became the most important fish, most probably taken in shallow water with the aid of tidal nets and weirs or fish spears. The proportion of shorebirds, ducks and geese in the food supply increases, which must reflect larger bird populations. And the number of seals in the food bone samples grown continuously until European contact, another indicator of increasing inshore productivity.

These ecological changes are reflected in coastal terrestrial ecology, too. The coastal spruce forest strip appears to have

Peter Ralston

Sifting for objects at a 1984 dig on Allen Island, led by Arthur E. Spiess.

widened and extended westward to its present western limit in eastern Casco Bay over the last few thousand years. Moose and caribou would be favored by such forest cover and white-tailed deer would be reduced by the decrease of hardwood-dominated forests. If we look at the 4,000-plus-year sequence of occupations at the Turner Farm shell midden on North Haven there is a ten-fold increase in the number of moose killed for each 100 deer killed (two for 100 became 20 for 100) at this one spot, beginning 4,200 years ago and ending with the last sample about 800 years ago. Caribou, that supposed denizen of northern Maine which was extirpated by sporting hunting about 100 years ago, shows up in coastal shell middens along the Washington and Hancock county coast after about 2,000 years ago, but not farther westward.

Archaeological data accumulate slowly. Archaeology is not an experimental science in the sense that repetition of a laboratory experiment constitutes "proof." Instead, the total accumulation of facts over decades and centuries of archaeological research allows us to advance our understanding of the past. Perhaps in the next decade we will be able to see more clearly backward from about AD 1600 into the more distant past, and understand more fully how people have responded to the changing ecology of the coast of the Gulf of Maine.

1993

Fisheries

ROBERT SNYDER

Let us reclaim our oceans by generating opportunities to reconnect—to fresh fish; to fishermen; to innovators in the marine realm who give a damn. A process of reclaiming will rebuild our oceans with or without the institutions of management that have brought us to the brink.

Over the past 25 years, the central debate about how to save our oceans has been one of scale: Should management institutions be constructed as "top-down" schemes, or "community-based" bottom-up strategies? Should management focus on single species or ecosystems? Should we privilege scientific or local knowledge?

Ironically, these debates have progressed without full participation from fishermen, and with almost no recognition that the oceans are a public trust. These debates have played out—enclosure and exclusion have been their hallmark. Depletion ensued. The general public does not think about the ocean's fish as their fish. Despite current trends toward localvore consumption, the majority of the populace doesn't yet choose what fish to eat based on the face, place and taste. Take the test, similar to the one suggested by Russell Libby of Maine Organic Farmers and Gar-

deners Association: Do we know who caught our fish, where our fish is from, and what fresh fish really tastes like? By and large, we don't.

We are now glimpsing new ideas that will push the debate over the future of our oceans into the hands of the people. In Maine, we are increasingly able to buy shares of fresh fish from our local fishermen through Community Supported Fisheries (CSFs). This movement includes marketing and branding efforts that tell the stories of local fishermen who value conservation and quality, which distinguishes them as responsible stewards of the resource.

As the demand for local fish increases, appropriately scaled, value-added processing will return to our fishing villages. The enthusiasm for fresh fish, a genuine caring by consumers for fishermen's livelihoods, and the sense of ownership of the ocean that is evolving through this fishermen-driven innovation suggests that it won't be long before thousands of "shareholders" make their voices heard in this debate.

People who have a taste for fresh fish, particularly in Maine, will be disheartened to learn that fishing permits, which represent access to the fish right off our shores, are quickly consolidating

to southwesterly ports. Furthermore, our nation's fish stocks are being privatized through allocation to the few people who still have permits. Those who gave up permits in the past, or those who don't currently have permits but would like to fish in the future, will have to purchase permits on the open market. This will likely be prohibitively expensive. In less than two decades, Maine could lose all access to local fish.

Community-minded fishermen are thinking about ways to entrust their fishing permits to their communities in perpetuity. The innovative concept of "permit banking"—buying permits and placing a form of conservation easement on them—is perhaps the boldest and most urgent solution to this crisis. The Island Institute, The Nature Conservancy and Penobscot East Resource Center are investigating methods for banking future access in Maine for research, leasing, and retiring fishing effort while stocks rebuild. As partial owners of the resource—in partnership with fishermen and our community-supported fisheries shareholders—we will have a greater say in how this resource is cared for going forward.

This reconnected and secured "community" will be able to engage more thoughtfully in some very hard but necessary discussions: Should additional areas of the Gulf of Maine be claimed for seasonal fishing? Should we request that particular areas of the Gulf of Maine allow only certain types of gear?

We have the data and the technology to answer these questions, but we need fishing communities to drive the decision-making. "Eco-regional assessments" and Marxan geographic information mapping systems (GIS) were developed to enable large-scale conservation planning. Up until now, these tools have been the purview of scientists and technicians. We know very little about how closely the maps generated by these tools actually reflect the priorities of fishermen and shareholders, who should be part of this process

These alternative economic, environmental and community-based actions mark a new approach to managing our oceans. With these innovative methods, we will enact a new set of priorities and decisions, including grounded management; strengthened responsibility to one another and future generations; and accountability for stewardship—what Dr. Jane Lubchenco, President Obama's newly appointed head of the National Oceanic and Atmospheric Administration (NOAA), refers to as the "New Ocean Ethic." Our new ocean ethic will hopefully make it possible for us to reclaim the ocean during this era of depletion.

Why do I think we have a shot at this? For starters, none of what I have spoken about here requires action by managers, even though their acknowledgment of these forces would be wise. Perhaps because we don't need the managers to begin shaping this alternative future, this movement toward a new ocean ethic is not only possible, but even probable.

Creating a Fishery for the Future

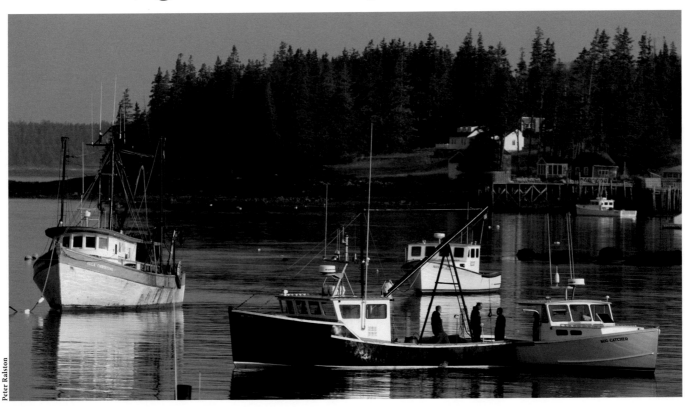

Peter Ralston

If you drive to the very tip of the St. George peninsula in midcoast Maine you will find the small village of Port Clyde.

Best known to the outside world for its ferry service to Monhegan Island, and as the setting for many paintings by the Wyeths, Port Clyde is—for those who live there year-round—all about fishing. It sits at the confluence of Muscongus and Penobscot bays, and provides key access to myriad fishing grounds.

The village is steeped in the fishing industry, going back some 200 years, and was originally named Herring Gut after the area's plentiful herring runs. When the fish were running, the church bells would ring, calling all the women in the community to the fish factory where they would clean and package the fresh catch.

On a much smaller scale, this heritage continues today with lobster as well as groundfish such as haddock, flounder, cod, pollock and hake. Port Clyde's small fleet of roughly a dozen groundfishing vessels makes it—next to Portland—the state's second-largest groundfishing port, and its fishermen have formed a unique alliance bridging

the gap between the lobster and groundfish fisheries. Working together, the fishermen of Port Clyde are determined to preserve their heritage, their community and the resources they depend on.

In 2006, the Port Clyde groundfishing fleet formed the Midcoast Fishermen's Association (MFA) as a nonprofit advocacy group for area fishermen. Their intent was to communicate more effectively with regulatory entities, participate in collaborative research, raise pubic awareness, convene discussions, create strategic alliances and find positive solutions for the fishery.

A year later, MFA members launched the Midcoast Fishermen's Cooperative to market their catch and to provide a direct link between the fishermen and the consumer. With the help of a Senior Island Fellow on loan from the Island Institute, co-op members developed an innovative way to market their seafood: the state's first Community Supported Fishery, based on the nationally known, highly successful Community Supported Agriculture concept. The cooperative also created a business model that gives the fishermen the most value for their catch while connecting local con-

sumers with fresh, high-quality seafood that is sustainably caught. The result is a win/win: financial stability for the fishermen combined with a meaningful (and delicious) way for people throughout midcoast Maine to help protect the fishery and sustain the region's traditional fishing communities.

At the core of all these efforts is the fishermen's strong conservation ethic, placing the protection of the ocean's resources at the forefront. And it is this sense of environmental responsibility that brought about the collaboration between the MFA and the Island Institute.

The Sustainable Fisheries Act of 1996 is a federal mandate that recognizes the importance of fishing communities and the need for their participation in the fisheries-management process. Centered in a tiny fishing village at the end of a remote Maine peninsula, there is already an effective, replicable model of fishermen, researchers, and conservation organizations working together to rebuild a fishery that will last for generations to come.

Jennifer Litteral

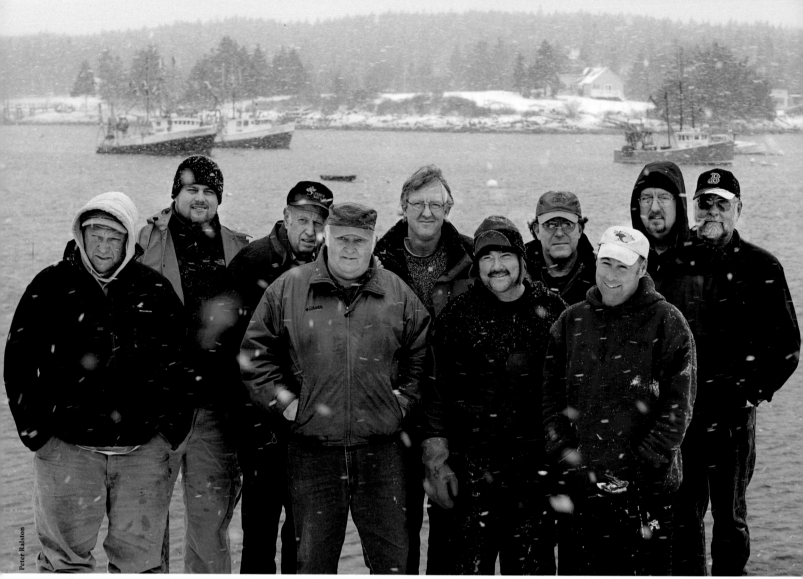

Peter Ralston

"The Boys" of Port Clyde, from left: Mathew Thomson, Justin Libby, Roger Libby, Edward Thorbjornson Sr., Gary Libby, Randy Cushman, Jim Frank, Gerry Cushman, Glen Libby and Glenn Hall

Port Clyde fishermen are developing a sustainable fisheries model

New England's economy was built on cod, yet today, marine fisheries in New England are among the most depleted and poorly managed fisheries in the nation. Over-fishing continues annually on 13 depleted fish stocks, including signature species such as Atlantic cod and all flounders, a restaurant favorite. For 15 years the National Marine Fisheries Service has tried to manage the groundfish fishery based on how much time the fishermen can spend at sea, called Days at Sea. Unfortunately, this has led to fewer fish, fewer fishermen and less revenue.

There is one boat left that is actively fishing between Port Clyde and the Canadian border, where at one time there were hundreds. According to the Maine Department of Marine Resources, only 70 boats actually landed their catch in Maine in 2007. Maine fishermen cannot continue to lose access to this industry or they may never regain the rights to fish off their own coast. It is essential that we keep this critical food source and industry here now and for future generations.

We, the groundfish fishermen in Port Clyde, were not alone in our view that the Days at Sea management system was broken and has fallen short of its original intent to meet the requirements of the Magnuson-Stevens Act. Over the past decade, there has been a steady decline of fish in the near-shore areas along the coast of Maine. This decline has led to a loss of fishing opportunity and continual cuts in Days at Sea that fail to restore the resource.

This landscape, coupled with historically low prices for wholesale fish, and the continued increasing costs of running a business, is a recipe for disaster to an industry that has been integral to this state long before the country was founded. In the face of this adversity the Midcoast Fishermen's Association (MFA) was formed.

Those with a vested interest in healthy stocks and sustainable fishing communities saw an opportunity to attain this vision with new alternatives to New England's fisheries management. An unprecedented event occurred: fishermen, non-governmental organizations, conservation and fishing advocacy groups forged collaborations in support of a new form of fisheries management. Moving to a system based on catch limits set to sustainable levels—that rebuild fish stocks—will ultimately restore profitability to fishermen and maintain our traditional New England fishing communities.

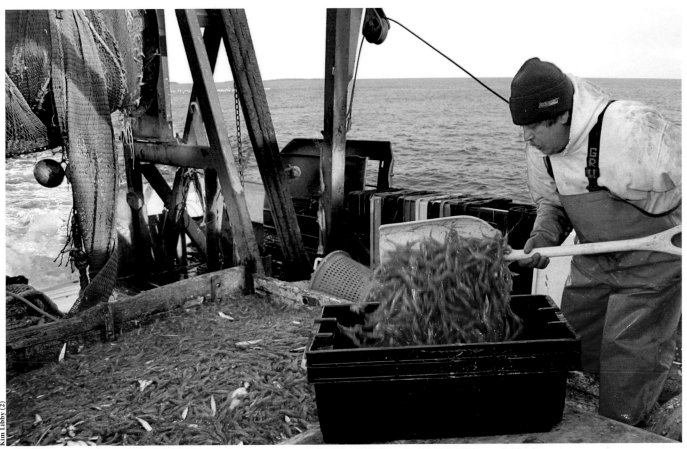

The ability of these guys to laugh when their backs are against the wall is awe-inspiring if not a little disconcerting.

The Midcoast Fishermen's Association is a forward-thinking commercial groundfishing organization made up of active fishermen. Our mission, based on conservation, is to identify and foster ways to restore groundfish stocks and sustain fishing communities. And our policy agenda is based on the following principles: the desire to have this fishery return to a viable state; the need to sustain fishing communities; a vision to have access to this fishery for generations; a commitment to building a coalition of like-minded fishermen; and, the recognition that a local food supply was a missing link in policy.

We're advancing these principles along a two-pronged track. One track is within the federal process in which the MFA is a collective voice advocating for policies that support conservation of the resource and viability of fishing communities.

In our second track, we've created a business-marketing model, through the fishing cooperative, that allows the public to participate in the recovery and sustainability of this fundamental public resource.

Through the federal track, the MFA supports two alternative management systems: area- or community-based management, and sectors. *Area management* assigns fishing opportunity to fishermen as well as allocating a portion of fish to a specific area. Each area is recognized as unique and is managed accordingly. This form of management also advocates for changes in fishing technology that reduce bycatch and impact to habitats. This concept is radically different from the way that the groundfish fishery has been managed in the northern Gulf of Maine, but is strikingly similar to how Maine's lobster fishery is managed.

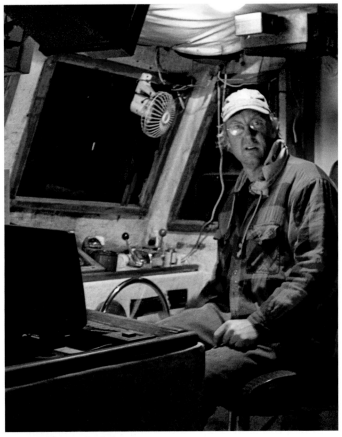

Gary Libby at the helm

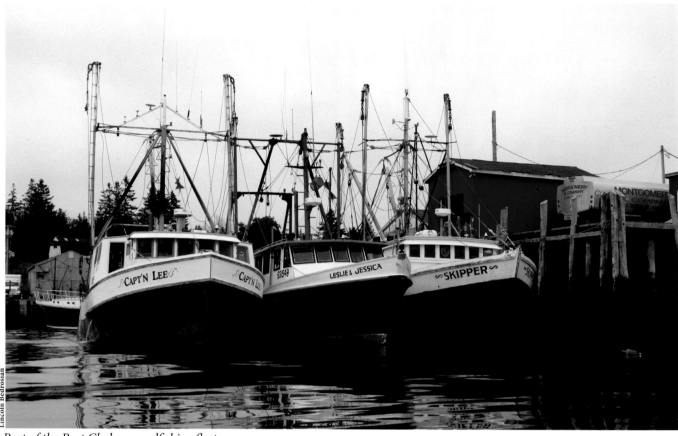

Part of the Port Clyde groundfishing fleet

The second management alternative, called *sectors*, consists of a self-selecting group of fishermen that form harvesting cooperatives. They are given an allocation of fish, and in exchange for staying within annual catch limits, fishermen are given more flexibility to make their business profitable. Sectors is a management tool with strong accountability measures and holds great promise as a way to get away from the failing Days at Sea system. Both of these management systems are essential to the health of the stocks and to the viability of the communities that depend on them.

We created the Midcoast Fishermen's Cooperative (MFC) to address marketing and branding of Port Clyde Fresh Catch™ products. Through the business-marketing track, the MFC fishermen are changing the current marketing structure. The MFC's goal is to enhance the ecological and financial sustainability of Maine's groundfish fishery and the coastal businesses that support it. We have voluntarily adopted stricter gear restrictions than federally mandated. These changes are backed by scientific research that was found to significantly reduce bycatch of untargeted species. These gear changes were coupled with an innovative marketing structure to move from the antiquated model of catching high volumes of low-quality fish for a low price to their model, in which they catch low volumes of high-quality fish for a price that reflects a more accurate cost of doing business. By increasing profits, this model achieves conservation of the resource by reducing the fishing effort.

Our fishermen have been pioneers by starting the first Community Supported Fishery (CSF) in New England. This was modeled after the highly successful Community Sup-

ported Agriculture concept. Using this model, we have established a way to keep Maine's fishermen fishing as well as creating a connection with our customers. MFC's customers are helping to preserve one of Maine's last remaining traditional fishing communities while supporting sustainable fishing that will restore the resource and strengthen Maine's local economy. Putting control back in the hands of the consumer in this participatory manner provides a fundamental base to advocate on behalf of our mutual principles.

MFA fishermen acknowledge that there have been mistakes in managing this fishery in the past and do not hold themselves blameless. We willingly take responsibly for our mistakes and we now consider ourselves stewards of the resource. The MFA fishermen are emerging as leaders, working in partnership with other fishing and conservation groups that share our vision of a future where there is balance of thriving resources and prosperous fishing communities.

While the MFA fishermen are trying to be innovative in the face of adversity, we fear that we will not be able to keep this model successful while operating under the Days at Sea system. We continue to work within the federal arena, advocating for policies and management systems that rely on science-based annual catch limits to end overfishing and allow the fishing fleet to remain solvent. Moving to a system that limits catch to sustainable levels and rebuilds fish stocks will ultimately restore profitability to fishermen and maintain the traditional New England fishing communities.

Glen Libby

Learn more about the Midcoast Fishermen's Association at www.islandinstitute.org/mfa.

Developing the Port Clyde brand helps fishermen and the fishery

One year after the Midcoast Fishermen's Association was created, the Midcoast Fishermen's Cooperative (MFC) was started to address marketing and branding of its fish.

Since its conception, the MFC has been leading the way in innovative marketing models. The current marketing structure dominating this fishery is based exclusively on volume. The MFC is moving away from this antiquated model of catching high volumes of low-quality fish for a low price. Instead, its model focuses on catching low volumes of high-quality fish, which is then sold for a premium price directly to local markets.

The MFC has also voluntarily adopted stricter gear restrictions than federally mandated and implemented rigorous quality assurance standards. These factors, along with the distinctiveness of the Port Clyde fishing community, provided the foundation to create the unique brand, Port Clyde Fresh Catch™ for the MFC.

Using the Port Clyde Fresh Catch™ name in marketing and branding raises consumer awareness of the Port Clyde fishermen's work and creates a demand for their fresh, wild-caught seafood. As consumers enthusiastically seek out Port Clyde Fresh Catch™ seafood, the cooperative's fishermen have strong incentives to adhere to the innovative gear changes and the rigorous quality assurance standards, as well as stewardship over the resources. Customers then know they are getting a premium-quality product that is harvested in a manner that conserves the fishery.

While the Midcoast Fishermen's Cooperative may harvest fewer fish than other fishermen, they are paid more for their harvest because it is sold as a high-quality, branded product that customers value. This is a cycle in which the customer,

PRODUCT OF PORT CLYDE, MAINE
WWW.PORTCLYDEFRESHCATCH.COM
207.372.8065

the fishermen and the resource benefit. The consumer creates the demand for access to local, fresh, high-quality fish; the fishermen are paid a premium price so they supply only that demand, which achieves conservation of the resource by reducing fishing; this in turn allows the public to participate in the recovery and sustainability of this fundamental resource.

Purchasers of Port Clyde Fresh Catch™ seafood also know that they are helping preserve one of Maine's few remaining traditional fishing communities, supporting environmentally sustainable fishing, and strengthening the local economy.

Research that quantifies the effects of the fishermen's gear modifications is one of the tools that make this cycle successful. It provides clear, scientific evidence as to how these changes reduce impacts. Identifying new markets using the Port Clyde Fresh Catch™ branded name is the other tool that is fundamental to sustaining this cycle. These markets provide fishermen with the economic incentives to leave the archaic, high-volume marketing model behind and will ultimately sustain the traditional fishing community of Port Clyde for future generations.

Most seafood consumed in the United States travels up to 1,800 miles and changes hands several times. Because the Port Clyde Fresh Catch™ brand centers on quality, it raises the value of the product in the eyes of consumers. Customers know exactly where their seafood comes from—the icy waters off the coast of Maine. The locally harvested, wild-caught

Laura Kramar

Gary Libby, a member of the Midcoast Fishermen's Cooperative, delivers a fish to Steve Cartwright, left, at a CSF program pick-up in Rockland.

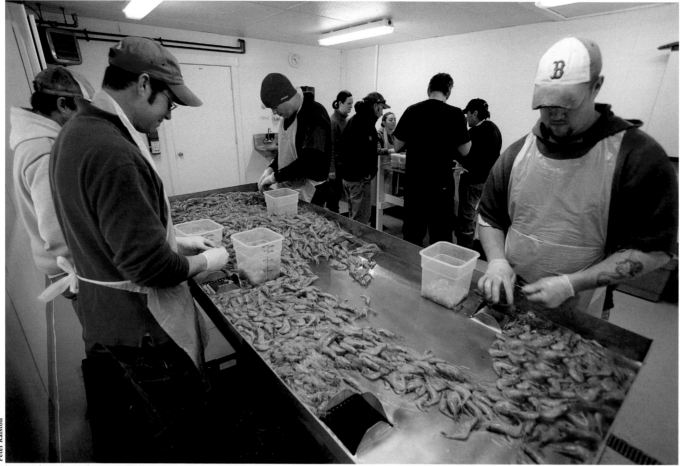

Peter Ralston

The Midcoast Fishermen's Cooperative opened a fish and shrimp processing facility in Port Clyde in March of 2009.

fish they purchase has traveled only a few miles before reaching area restaurants and other outlets. It's a fresh, preservative-free product of the highest quality, caught in an environmentally conscious manner and handled with extreme care.

One novel and highly successful market that was created by the MFC was the Community Supported Fishery (CSF). This was the first of its kind in New England and was modeled after the highly successful Community Supported Agriculture (CSA) movement.

In both the CSA and CSF, members pay in advance for shares of produce or fish and then pick them up at a specific time and place each week. Consumer demand for the CSF generated considerable press coverage, which has spurred the creation of a rapidly growing mail-order business through which Port Clyde Fresh Catch™ will be sold through the website and shipped by mail. This program also gives back to the community by donating fish to "Share to Spare," a program through which CSF shares are donated weekly to the local Meals on Wheels and Food Pantry programs.

Consumer demand for fresh, local, environmentally harvested fish is strong. Innovative marketing allows the MFC to harness this demand to help sustain the fisheries and fishing communities that depend on this resource. The next steps are to expand the CSF and restaurant markets. In addition, other alternative marketing channels will be developed with distributors and food retailers, and the volume of seafood will be expanded and sold through these channels. A processing facility opened in Port Clyde in March 2009. This now allows products to be tailored to the customer's needs.

Laura Kramar

Learn more about Port Clyde Fresh Catch at www.islandinstitute.org/mfa.

Gear research validates conservation efforts

In the summer of 2008 the Gulf of Maine Research Institute (GMRI), the Island Institute and the Midcoast Fishermen's Association (MFA) set out to verify that gear modifications adopted by the MFA fleet reduces the capture of noncommercial or non-targeted species as well as juvenile commercial species.

The mission of the MFA is one based on conservation. Its members have set out to identify and foster ways to restore groundfish stocks and to sustain their fishing community. Their goal is to enhance the ecological and financial sustainability of Maine's groundfish fishery and the coastal businesses that support it. These fishermen have voluntarily adopted stricter gear restrictions than what is federally mandated. These changes had yet to be scientifically validated and quantified. The parameters tested within this research were the first of their kind to be studied within the New England Groundfish Fishery. These gear changes are coupled with the MFA's innovative marketing structure and business plan to restore groundfish stocks, reduce environmental impact and sell high-quality seafood to local consumers, and this research was the foundation needed to articulate these goals.

Two weeks of at-sea research was conducted on board the fishing vessel SKIPPER, owned and operated by Glen Libby, chairman of the MFA. The 54-foot-long SKIPPER is traditionally rigged to trawl for groundfish, such as haddock, flounder, codfish, hake, monkfish, sole, halibut and pollock. The common trawl net used to catch groundfish typically has a codend or netting bag to retain fish that enter the trawl. The codend is usually made with diamond-mesh netting with a 6½-inch opening, which is a minimum size mandated in the fishery. A problem with these codends is that the meshes collapse at the front and impede juvenile and noncommercial fish from escaping.

Square-mesh netting, while used in other fisheries around the world, has not been widely tested in New England in the trawl fishery. The conservation effects of square-mesh netting dates as far back as the late 1800s. Square-mesh netting does not collapse at the front under the full weight of the catch so juvenile and noncommercial fish are able to escape.

Square-mesh codend. The meshes of this codend remain open even under the full weight of the catch, and small, non-targeted species and juvenile fish are able to more easily escape.

During the at-sea trials both a diamond-mesh codend (6½-inch) and two square-mesh codends (6 ½-inch and a larger 7-inch) were tested.

Overall, the standard 6½-inch diamond mesh codend allowed the escapement of at least 43 percent of fish and other animals that entered the net. This is an important result given that claims by various interest groups regarding the poor selectivity of this type of commercial fishing gear. However, the square-mesh codends not only retained more legal-sized targeted species but they also allowed more non-targeted species and juvenile fish to escape; in fact the 7-inch square-mesh codends allowed more than 50 percent of these animals to escape compared to the diamond-mesh codend. Many fishermen from Port Clyde are already using square mesh, and the results of this study confirm that it is the right choice.

The Midcoast Fishermen's Association is planning further research, where modifications to the front of the trawl net are planned, as well as changes to lighter, more modern netting overall, which will further reduce the non-targeted catch but will also reduce the amount of fuel required to tow the trawl, which will additionally reduce the impact on habitat. The goal of the MFA is to move to being the greenest and most conservation-oriented trawl-fishing group in the region backed by collaborative scientific research.

Steve Eayrs

2009

Diamond-mesh codend with collapsed meshes due to the full weight of the catch. Small, non-targeted species and juvenile fish are unable to escape through the collapsed meshes, and can only escape through a narrow band of meshes immediately ahead of the catch.

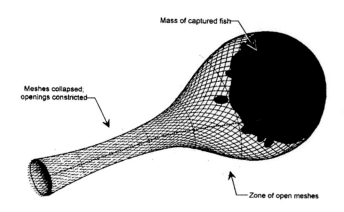

Mass of captured fish

Meshes collapsed; openings constricted

Zone of open meshes

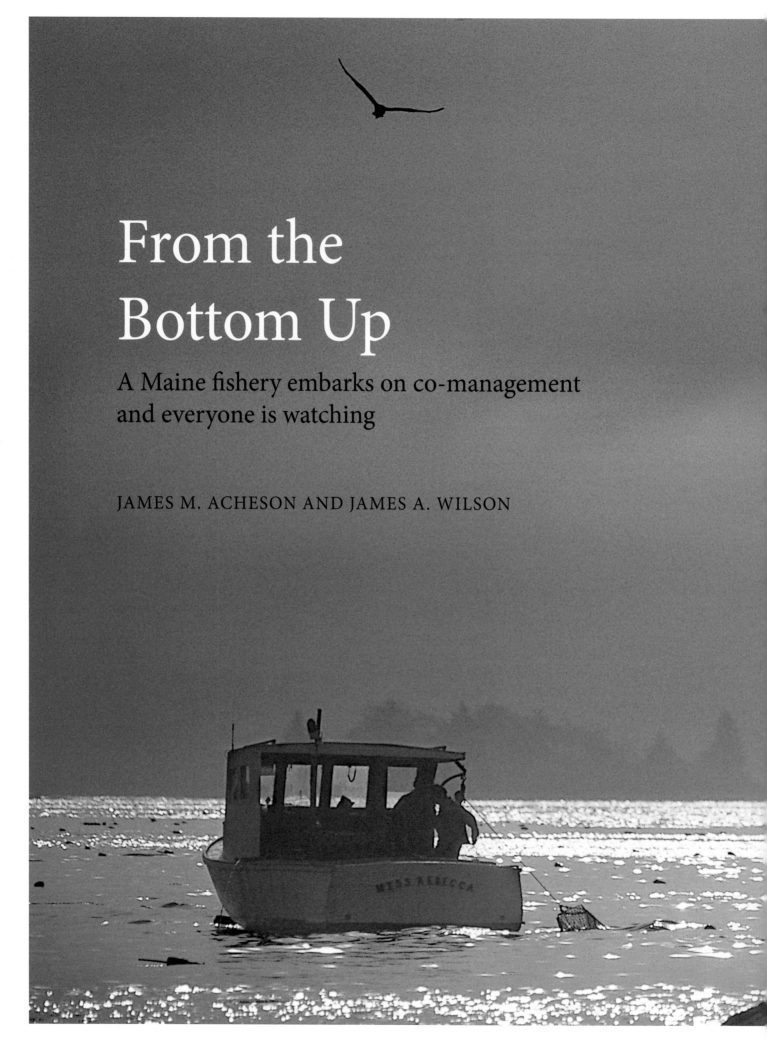

From the Bottom Up

A Maine fishery embarks on co-management and everyone is watching

JAMES M. ACHESON AND JAMES A. WILSON

Peter Ralston (4)

In the winter of 1995, hundreds of Maine lobster fishermen turned out for meetings in nine coastal and island towns, from Cape Porpoise to Jonesport. The occasion was unprecedented: For the first time in the history of their fishery, the independent-minded Maine citizens who earn their livings catching lobsters assembled, at the call of the State Legislature, the Department of Marine Resources and their own industry associations, to take part in an experiment in self-governance.

Legislation passed last year stipulated that the coast would be divided into zones, and that each zone would be managed by an elected council of lobster-fishing license holders. The commissioner of marine resources was to establish the zones, the councils and the procedures for their operation by July 1, 1996.

This approach to fisheries management is variously called "bottom-up," "co-management" or "self-governance." It means allowing fishermen to manage aspects of their own industry in coordination with the state. If it works well in the case of the lobster zones, it is quite likely that the legislature will extend the responsibilities of the councils to include broader authority in the lobster fishery, and possibly authority over other fisheries.

Fishermen, more than any other group in society, have a strong interest in the long-term conservation of the resource, because their livelihoods depend on its health. In the past, fishermen have not often been in a position to reach and enforce agreements about the kind of restraint necessary for long-term conservation; the institutions, the places to meet and discuss and decide have not been there. More than anything else, the formal, legal authority to make and enforce such agreements has not been present.

Co-management is an attempt to create the formal institutions that will allow fishermen to legally make and enforce agreements about mutual restraint.

Maine's zone management law came about because of long-standing interest in a coast-wide trap limit. For 20 years, many individuals have believed that too many fishermen were using too many traps, and that the solution is to set a maximum allowable number of traps per license holder. But fishing practices in different parts of the coast are very different, and there has been no agreement on the number of traps that should be allowed in Washington County, for example, many fishermen assert that 600 traps is more than ample; in Casco Bay large numbers of people claim they can't make a living with fewer than 2,000 traps.

The new zone management law sidesteps these differences of opinion, allowing fishermen in various parts of the coast to establish different trap limits, taking into account traditional fishing practices and local conditions.

Traditions in the lobster-fishing industry should make it relatively easy to undertake co-management. Each harbor's group of lobster fishermen tends to form themselves into a group or "gang," and face-to-face communication allows them to reach consensus. Many activities are coordinated. Fishermen from each harbor have established traditional territory where they fish. They are able to coordinate the "defense" of these territories by sanctioning those from other harbors who violate their fishing territory.

The territorial system and the illegal practices involved in maintaining it have given the entire fishery a good deal of notoriety. But what is frequently overlooked is that the system has beneficial effects on the lobster stocks, and that the territorial rules are well understood and obeyed by everyone in the industry. There is surprisingly little trouble.

More important, within these harbor groups there is consensus on proper fishing practices, a set of rules to be obeyed. If someone wishes to continue fishing in an area it is impor-

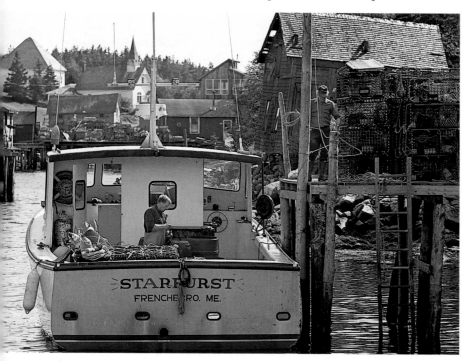

tant that his behavior conform to that found acceptable by the other fishermen. Taking and selling short lobsters, "scrubbing" the eggs off gravid females and molesting other people's traps are universally condemned. Any number of subtle to not-so-subtle sanctions can and will be applied to the individual who violates the rules.

Harbor gangs have the capacity to generate new rules for themselves. When a problem arises, fishermen in a harbor will typically talk it over—sometimes for a period of years—before deciding on a course of action. They may approach the legislature for a special law they believe will be in their interest. If there is little opposition, the legislature will usually pass the law requested. (Over the past 120 years, a very high percentage of all conservation regulations in the lobster industry have been the result of lobbying activity by various groups of fishermen. The Zone Management Bill and the idea of bottom-up management were strongly supported by the leaders of the Maine Lobstermen's Association and the Downeast Lobstermen's Association.)

In other instances, harbor gangs decide to develop a rule informally and rely on voluntary compliance or enforcement at the local level. There are harbors in which fishermen have agreed on ways to place traps to avoid congestion and entanglements, harbors where they have agreed on voluntary trap limits.

Inshore, lobster fishermen are already involved in a good deal of self-governance. In the Maine lobster industry, co-management is not new, but merely an extension or continuation of a well-established tradition.

In Japan, co-management is a tradition that stretches back to the 18th century, when ocean areas near shore were considered part of fiefs owned by local lords who controlled fishing technology and seasons, and established sanctuaries where fishing was not allowed. In the 1880s, the Japanese government established cooperatives; after World War II the U.S. occupation authorities changed the rules for cooperatives to make them the primary fishery management unit that would equalize access to the resource. Each fisheries cooperative association was made the owner of a section of coast, and the right to fish in these territories is held jointly by cooperative members.

Over time, a strong sense of stewardship has evolved. Association members establish fishing practices, and disputes about gear conflict and rule violations are handled at general meetings that can be fairly raucous. The associations are divided into smaller units of fishermen who cooperate on a local level. The associations are also part of a larger bureaucratic structure. Legal authority for resource management in inshore waters belongs to the prefecture governor, who allocates power to prefecture fisheries agencies.

In the Lofoten Islands of Norway, local control by fishermen dates to the 19th century. Today the system operates under the authority of the Norwegian Salt Water Act of June 3, 1983, and is administered by the Norwegian ministry of fishery. The ocean area surrounding the Lofoten Islands has been divided into 15 districts, each of which is administered by a superintendent and eight "control assistants" who enforce the rules. The fishermen of each district are divided into groups according to gear type, and are allowed to elect their own inspectors.

Fishing rules for each district are determined by a regulatory committee. The chairman of the committee is appointed by the Norwegian government; the rest of the members are fishermen selected by the inspectors. These committees specify the locations where various types of gear can be fished, generate rules concerning how fishing will take place, and specify the times of day that fishing is allowed.

Both the Japanese coastal fisheries and the Lofoten fishery are doing well today, as they have for decades.

The primary advantage of bottom-up or co-management is that the regulations are apt to be relatively easy to enforce. Rules promulgated by groups of fishermen are not likely to conflict with local practices or norms, and they are apt to be crafted to minimize the problems of making a liv-

ing. They tend to be relatively flexible and to permit people to craft agreements that take into account local conditions. Most important, fishermen will generate rules that they believe are in their own in the long-run.

A number of observers have pointed out those fishermen's views of the ocean and the factors that determine fish populations are often different from those of biologists. Fishermen may see biologists' prescriptions as simplistic, ineffective, unrealistic and not likely to conserve the stocks of fish. If management is going to be effective, conservation rules must be obeyed—a state of affairs that's not likely to exist as long as fishermen see the rules as silly and ineffective.

Fishermen are likely to generate the sort of rules that we see in the Maine lobster fishery, and they are very different from the rules fisheries biologists and administrators generally favor, such as quotas derived from stock/recruitment models. Concerned with the size of populations of fish, these models are based on the presupposition that marine ecological systems tend toward equilibrium, that fish populations tend toward equilibrium, and the long-term abundance of a species is strongly linked to the amount of exploitive "effort" on that stock.

The relationships between stock size and fishing effort can be described mathematically. The theory assumes that when stocks are overfished, the larger the parent stock, the larger the number of future additions to the population (i.e., recruitment). Such a model leads unerringly to politics designed to regulate the quantity of fish that can be taken, usually through quotas of some kind.

Fishermen have a very different conception: to them, the ocean is constantly in flux. Fish populations vary drastically in ways that are very hard to predict. For fishermen, the idea that oceans are in equilibrium and that populations can be controlled by curtailing effort are laughable. This is not to say that fishermen do not believe there are ways that fisheries can be managed. Their ideas about proper managerial techniques almost always emphasize what we would call the preservation of basic biological processes.

Recent efforts to model fisheries do suggest that fisheries are very complex and possibly chaotic. If this is true, management by controlling fishing effort may be impossible, since that requires a huge amount of fine grained information that must be constantly updated. If fisheries are chaotic, or simply very complex and very difficult to measure, we need to focus on maintaining those regular biological processes on which the long-term well-being of the stock depends. We need to protect the breeding grounds, nursery grounds, migration routes, and fish in critical parts of their life cycle. This can be done by rules that affect how, when and where fishing is done. We must control technology, time, season and place; we must avoid taking fish in certain age ranges. Such rules may not allow us to control population size (especially if those popu-

lations are chaotic), but they will prevent the disastrous stock crashes we have seen.

These are exactly the kinds of rules that already exist in the lobster fishery, where the most important regulations are the double gauge (which protects both the large breeding stock and the juvenile lobsters), the V-notch law (which protects the proven brood females), the escape vent law (which requires traps to be constructed to allow small lobsters to escape), and the requirement that traps, which do little to the bottom, are the only technology that may be used in the fishery.

There has never been a quota—a law in the fishery limiting the number of lobsters that could be caught. The consistent performance of this fishery since World War II suggests that the rules in place have worked.

Rules on how, when and where to fish are known as "parametric management." Lobster fishermen in Maine, when they have generated rules for their fishery, have chosen parametric

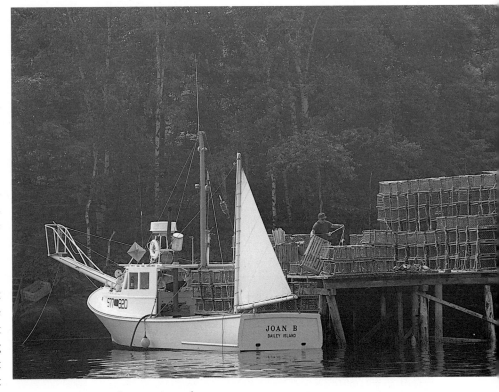

rules consistently.

The new zone management law gives fishermen the right to administer some of these parametric rules (a trap limit, the numbers of traps on a warp, time of day). If the past is any indicator, the rules that zone councils and members are apt to adopt will also be parametric in nature.

During last winter's round of meetings on the zone management law, most fishermen expressed support for the concept of co-management. Those who opposed it seemed to be saying that fishermen couldn't govern themselves. But 200 years of town meetings, we believe, have given Maine people a lot of practice with direct democracy. Given a chance, co-management will work in the Maine lobster fishery, and it could prove to be the salvation of other fisheries as well.

1996

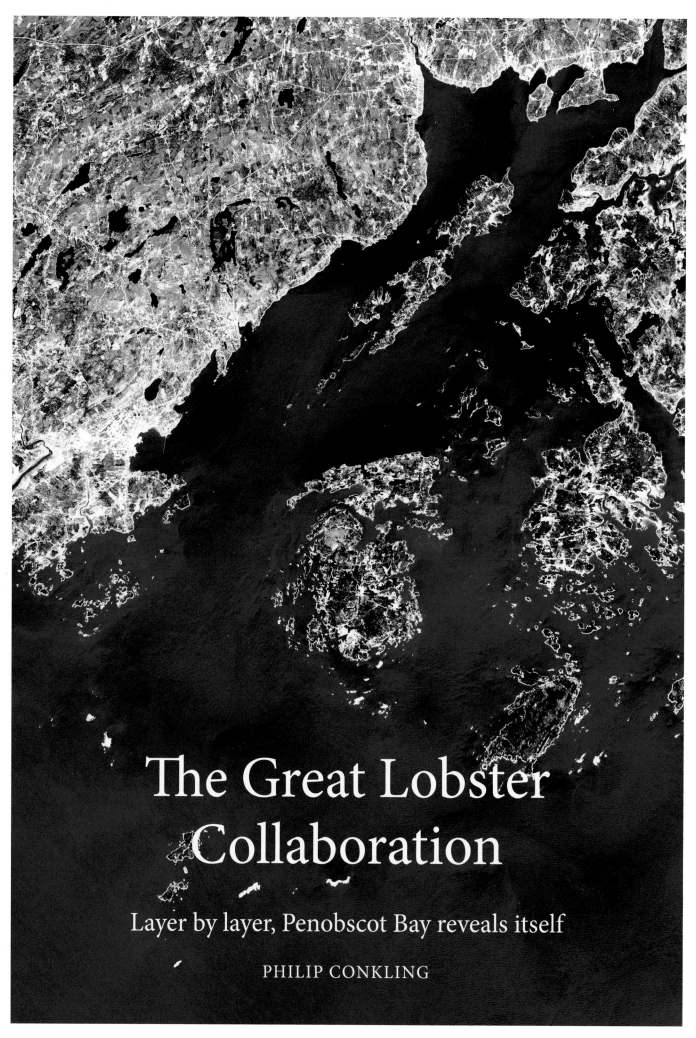

The Great Lobster Collaboration

Layer by layer, Penobscot Bay reveals itself

PHILIP CONKLING

For the past three years, Penobscot Bay, the largest embayment on the country's Atlantic Coast north of the Chesapeake, has been the focus of a great scientific collaboration. Its purpose is to decipher how the bay's complex ecosystem affects the patterns of abundance and scarcity for the region's lobster fishery. The project, which involves more than 100 fishermen, scientists and managers, is sponsored by a federal agency, the National Oceanic and Atmospheric Administration's National Environmental Satellite Data and Information Service (NOAA-NESDIS). This agency's mission is to collect, process and distribute vast quantities of information from the nation's orbiting satellites.

This collaboration marks the first time that the United States' enormous national investment in remote sensing technology—not just sensors on satellites, but also underwater sonar imaging capabilities and, more recently, ocean buoys that telemeter real-time data back ashore—has been focused on the problems of managing inshore waters. The significance of such work to a place like the Gulf of Maine, home to important fisheries and prone to human impacts, is huge.

The Penobscot Bay project's origins lie in the Magnuson-Stevens Reauthorization Act, federal legislation that, among other things, called for deep reforms in the way this country manages its fisheries. Here in the Gulf of Maine and on neighboring Georges Bank, it has been painfully obvious for some time that efforts to manage fisheries have failed. The Magnuson-Stevens amendments (also known as the Sustainable Fisheries Act) require the National Marine Fisheries Service to apply "ecosystem" management principles to the nation's fisheries.

Oceanic dynamics are difficult to see at the ocean's surface. They change from year to year, season to season and sometimes day to day after storms or floods. We have tried for half a century, but we haven't been able to keep track of fish populations in the ocean. Today that is changing: near-instantaneous, high-quality, remotely sensed information has the potential to revolutionize the ways to approach fisheries management. Such information enables us, among other things, to focus on the details—where and when fish gather, or the characteristics of spawning and juvenile populations.

Different questions

So what could be done differently to manage Penobscot Bay based on its ecological dynamics? With respect to the lobster fishery, for example, wouldn't the location or habitat of the broodstock—those large female lobsters that carry most of the eggs—be important? Similarly, where do these females' tiny young, the larvae that spend their first month and a half of life floating in the water, get carried on coastal currents?

The side scanning sonar at ALICE SIEGMUND's *stern*

New assumptions need to be made. For example, broodstock females might not necessarily be distributed uniformly across their range, which from the point of view of federal fisheries managers extends from Long Island Sound to Eastport, Maine. Also, perhaps not all eggs are created equal. Larger, older females carry a much higher number of eggs that are more likely to survive than eggs from young females. So, it is important to find out if large egg-bearing females live in disproportionately higher numbers in certain parts of the lobsters' range.

New priorities need to be set. Breeding mothers must be protected. Fisheries managers and scientists need to know how and where the young of the year are "recruited"—in other words, find the location of their nursery and juvenile grounds. Questions about how these little lobsters become residents of an area or bay, and whether the pattern varies when conditions are different, need to be answered.

Money should be spent to study and understand the lobster's life cycle. And because lobstermen have been an inseparable part of the system for most of the past two centuries, the differences in the way these fishermen fish—with traps or trawls—must be considered to see how each method affects lobster mortality. And because lobstermen have been protecting females for a half-century, the help of fishermen who can efficiently collect real-time data on ecological conditions must be respected and eagerly recruited. Finally, awareness of how land-based contaminants might affect the productivity of inshore nursery grounds must be expanded and promoted.

Developing partnerships to seek answers to our questions became the central purpose behind the NOAA-NESDIS Penobscot Bay project, an intensive feasibility study of how decision-makers might manage a marine fishery using ecosystem principles and techniques.

Peter Ralston (7)

Egg-bearing female lobster

August 14, 1995

warmer cooler

Sea-surface temperature

	Gravel
	Mud
	Rock
	Sand

SEAFLOOR GEOLOGY: *This map highlights the work of geologists Joseph Kelley and Stephen Dickson, who used bottom sampling and sidescan sonar to map the geology along the floor of Penobscot Bay.*

Pieces of the puzzle

The Gulf of Maine's scientific community is large and experienced, but widely dispersed. In Maine, the Penobscot Bay project recruited an interdisciplinary team of two dozen scientists to create a "virtual" marine research institute, each member of which would be responsible for contributing data on pieces of the bay's marine ecosystem. Woven into the fabric of this investigation was the data being collected by a larger group of more than 75 fishermen whose boats cover all corners of the bay. The fishermen would contribute information on what they caught and in some cases returned to the bay.

The scientists are from the University of Maine's Darling Center, the Bigelow Laboratory, the state Bureau of Geology and the Department of Marine Resources. They also come from the Island Institute, Maine Maritime Academy and the Lobster Conservancy.

Oceanographers think of the waters of the bay in layers. There's the top of the water with its tides and temperatures, the input from the Penobscot River and its associated estuaries. There's the bottom of the bay, once dry land but now an inland sea, with its different substrates and bottom communities. There's everything in between, including the way circulating water distributes nutrients, larvae, pollutants and benefits throughout this mini-system.

What the science is saying

Because lobsters spend most of their lives crawling around on different substrates of the bay's bottom, and because underwater photography has given us actual pictures of the ecological communities here, the bottom is a good place to begin constructing a detailed picture of the bay.

AUGUST 22, 1998: Joe Kelly and his wife, Alice, from the University of Maine, and their colleague, Steve Dickson from Maine's Bureau of Geology, are aboard the ALICE SIEGMUND. This 36-foot lobster boat has been converted to an efficient research vessel by her captain, Corrie Roberts of the Island Institute.

The team has spent about 50 days over two field seasons collecting side-scanning sonar images of the sea floor. They do so by towing a torpedo-like instrument behind the boat that "sees" ("images," oceanographers might say) wide swaths of the bay's bottom and records a picture based on reflected sound. (Hard ledge gives a very different sonic profile than soft mud.) Sonar can also distinguish sand from gravel and can locate boulder fields—important habitat for juvenile lobsters. Today Kelly, Roberts and their team will deploy an ROV (remotely operated vehicle) equipped with underwater video cameras to "ground truth" some of the coarser sonar data they have collected on earlier voyages.

After two seasons of field work, Kelly has directly imaged about 30 percent of the bay. He has found several features of particular interest, including extensive pockets of mixed boulders, cobble and gravel in a large area south of Vinalhaven that have never been mapped before—ideal habitat for the frequently immense populations of juveniles and adults that are found here, year after year. Kelly has also found extensive

Marine scientist Lew Incze

Captain Corrie Roberts and scientist Rick Wahle

gravel beds southwest of Vinalhaven, as well as a deep valley running down west Penobscot Bay. The valley, which corresponds to historic spawning grounds of cod and haddock in that area, consists of very hard gravel bottom scoured by strong currents.

Lobster biologists

It is not surprising that Maine is blessed with a strong contingent of lobster biologists. The fishery, after all, is the state's largest and most valuable. The most visible and outspoken of these biologists is red-haired Bob Steneck, who teaches at the University of Maine's School of Marine Sciences. He

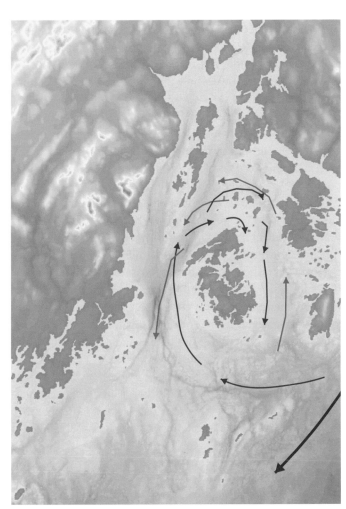

CIRCULATION: *The purple arrow represents the Eastern Maine Coastal Current. The blue arrows represent circulation near the surface and the red arrows indicate patterns nearer the seafloor.*

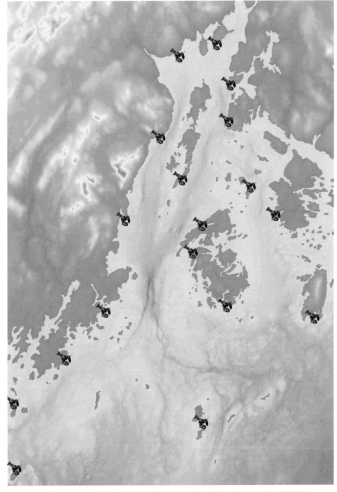

INTERTIDAL AND SUBTIDAL JUVENILE LOBSTER SAMPLING LOCATIONS

Marine scientist Bob Steneck

currents where young larvae are floating.

Rounding out the lobster team is Diane Cowan, who founded the Lobster Conservancy a few years ago in Harpswell, Maine. She has been working at the edge of intertidal habitats, where no one has looked for young lobsters before. Cowan has found a remarkable abundance of lobsters, ranging from recent settlers to nearly mature lobsters. Working with trained volunteers in a handful of coves at the lowest lows, or "moon" tides, Cowan has captured and tagged thousands of lobsters to discern patterns. Cowan has built a picture remarkable in its novelty, a convincing hypothesis that the nursery grounds of larval lobster extend upward from 30 feet to the edge of the normal low-tide mark.

Now Maine's chief lobster biologist, Cowan believes it is possible to use the sons and daughters and wives of fishermen, as well as others, to generate a predictive index of juvenile lobster abundance from year to year.

Fishermen as Scientists

Walter Day has fished from Carver's Harbor, Vinalhaven, for 35 years, ever since his father helped him set off in a skiff to trap lobsters on short warps. In recent years, Day has fished a large area to the west and south of Vinalhaven alongside roughly 175 others from the island whose territory extends out to the far edge of Penobscot Bay. Under Maine's new lobster zone management system, Walter Day has been elected from his island district to represent the views of fellow fishermen on the region's Lobster Zone Council, which is intensely concerned with how the lobster resource of Penobscot Bay is managed.

Day became interested in the Penobscot Bay project when he was approached about helping to assemble a picture of lobster distribution and population structure in the bay, based on fishermen's records. An engaging and cheerful man, Day points out that in all his years of lobster fishing, he had never before been asked to contribute data to a scientific project. He was eager to cooperate. Day worked with Carl Wilson, a graduate student of Bob Steneck's now employed by the Island Institute, and a team of interns aboard lobster boats to record not just what fishermen landed at the dock, but also the number of the larger and smaller lobsters and "V-notched" females that had been marked by a cut in their center tailfin at some point during the past three years. These females were all carrying eggs when they were originally caught and marked, and at least in Maine, must legally be returned to the water after getting a free lunch at the bait bag.

Day helped Wilson contact other fishermen on Vinalhaven who might want to participate. David Cousens, who is the president of the Maine Lobstermen's Association, and who fishes the Muscle Ridge Channel on the west side of the bay, helped contact fishermen in his area. Leroy Bridges from Deer Isle did the same thing on the east side of the bay, and soon scores of fishermen began to pool their data.

This remarkable display of industry support is indicative of the sea change that is under way between fishermen and scientists. Amazingly, this information has never before been collected on such a scale.

conducts his research from the Darling Marine Center on the Damariscotta River. For more than a decade Steneck has fielded teams of divers to sample lobster populations in situ, underwater, by counting and measuring all lobsters in small sample areas. Together with colleague Rick Wahle, now at the Bigelow Laboratory in Boothbay Harbor, Steneck has pioneered a suction-sampling technique to collect tiny lobsters and determine where they spend the first several years of their lives.

Wahle and Steneck have come to a startling conclusion: Along most of the Maine coast, the greatest number of very small lobsters live in one relatively rare kind of habitat, subtidal cobble and boulder fields in fairly shallow water. Most such areas lie around the islands and along the rocky shorelines of midcoast Maine.

Wahle and his colleague Lew Incze, also of Bigelow Lab, have discovered another important pattern. Near Damariscove Island off Boothbay Harbor, they consistently found many more newborn lobsters off the east-facing shorelines than off corresponding west-facing shorelines a quarter-mile away. To Wahle and Incze, this finding suggests that nearshore ocean currents are the lobsters' larval delivery mechanism. Incze has proposed an intensive larval sampling program coupled with a study of how surface currents interact with local sea breezes, the "smoky sou'westers" and onshore breezes of summer days, to influence the direction of surface

Getting the big picture

The hub of the Penobscot Bay collaboration is the treasure trove of satellite imagery that NOAA has made accessible to the project. To begin with, Andy Thomas of the University of Maine established a link with NOAA's enormous AVHRR (Advanced Very High Resolution Radiometer) data archive, showing sea surface temperatures at a scale of about a square kilometer per data point.

As part of the Pen Bay project, Thomas analyzed the NOAA archive of AVHRR images collected four times a day between 1988 and 1995 to understand the changes in the location of surface currents over time. Using approximately 8,000 of NOAA's images, Thomas derived seasonal synopses, clearly showing the variations in the distinctive cold-water surface currents that drive the ecology of the inner edge of the Gulf of Maine.

Because AVHRR data is meant to sample ocean surface features on a large scale, finer-scale satellite information must be examined to see how currents trending past the outer edge of the bay interact with Penobscot Bay itself. At the Island Institute, Dierdre Byrne and Chris Brehme researched the archive of NASA's Landsat imagery, which has much finer resolution—approximately 10 times the detail of the AVHRR pictures—looking particularly for patterns of persistent temperature features that might be correlated to lobster movements and distribution.

Seasonal patterns

Until now, no one has definitively ascertained whether the Penobscot River plume of freshwater flows into east or west Penobscot Bay or whether, indeed, the pattern of river flow varies from season to season. Stream measurements show that during the spring freshet (March–May), the river's flow is more than twice what it is during the remainder of the year. It peaks at over five times its average flow.

Data collected during hydrographic cruises and correlated with satellite image analysis begins to reveal important relationships. When river flow is high during the spring, cold freshwater rides over the denser salt water and empties into the upper portions of both east and west Penobscot Bays, freshening the upper surface waters by as much as five parts per thousand. In west Penobscot Bay, this fresh layer, which is confined to the top 15 feet or so, is discernible as far south as Gilkey Point on Islesboro and Northport on the mainland.

Despite the clearly detectable plume of cold river water between Sears Island and Islesboro, satellite image analysis of spring sea-surface temperatures shows that a temperature "front" forms across both east and west Penobscot Bays, separating the warmer upper bay from the colder outer bay.

There is also evidence of a clockwise "gyre" around Vinalhaven and North Haven. This surprising and previously unknown feature appears to dominate the circulation in

the outer bay and control the exchange between the Eastern Maine Coastal Current and Penobscot Bay.

During the summer, sea-surface temperature images show only a weak outflow from the Penobscot River. Along the western shore of the entire west bay, from Belfast Bay all the way south to Owls Head, relatively warm water is present in most images.

A temperature front between North Haven and Islesboro is a persistent feature in every summer image. It separates warmer waters to the northwest (around Islesboro) from cooler waters in the mid-bay off North Haven and Vinalhaven. During the entire summer, the colder waters of the Eastern Maine Coastal Current (the portion of the Gulf of Maine Gyre that runs along the eastern Maine coast from Grand Manan

Vinalhaven lobsterman Walter Day

as far west as the outer edge of Penobscot Bay) are persistently visible in sea-surface temperature images. This current flows past the outer shores of Isle au Haut, Matinicus and Monhegan, but also intrudes far up the western shore of Vinalhaven, all the way north to Crabtree Point off North Haven.

Early in the year, outer Penobscot Bay is warmer than the northern and inner reaches of Penobscot Bay. But when the bay warms up during the spring, there is a vigorous mixing of waters, undoubtedly augmented by tidal energy and bottom topography. Vertical mixing is significant because it stimulates intense biological activity. In summer satellite images for areas where cold waters in the bay reach the surface, patterns can be seen where cold, nutrient-enriched bottom waters of the Eastern Maine Coastal Current are moving vertically to the surface. These areas are probably of importance to such species as lobsters, as well as juvenile herring, cod, haddock and other species.

In autumn, images demonstrate, the Eastern Maine Coastal Current turns offshore in a southerly direction at the eastern edge of Penobscot Bay, rather than beyond the western edge of the bay as is characteristic in earlier summer images. Nev-

ertheless, colder waters are still found up against the shores of Vinalhaven and North Haven, and the characteristic front between the cold areas and the warmer, less saline waters of the western and northern portions of the bay is clearly present, though it is not as strong as in the summer season.

During the winter, a very distinct band of water flows along the southern or outer edge of Penobscot Bay. It is important to note that these waters are strongly differentiated from waters at the head of the bay, which are colder than the offshore waters at this season. During the winter, in other words, the estuary is the coldest part of the bay.

The circulation model

To round out the Pen Bay project, University of Maine oceanographer Neil Pettigrew has deployed temperature buoys at the outer edge of Penobscot Bay and then in a number of locations within the bay to understand how water is moving throughout the system. These "smart" buoys collect temperature, salinity and current measurements at different depths in the water column on a continuous basis, storing them in an onboard computer, which then calls a university computer from a cellular telephone mounted on top of the buoy. Using this information, Pettigrew can calculate water mass movements.

Working with university colleague Huijie Xue, Pettigrew is constructing a dynamic circulation model, based on buoy data, reflecting the bathymetry or profile of the bay's bottom. The model includes data from wind sensors at Matinicus Rock and Owls Head airport.

Penobscot Bay, Pettigrew has found, does not act like a typical estuary because the mean flow is into west Penobscot Bay, not out of it, as one might expect.

Pettigrew will launch additional buoys in the bay during 1999 to get a clearer picture of circulation patterns, but his preliminary findings are immediately suggestive of a mechanism where larvae floating in the Eastern Maine Coastal Cur-

rent get drawn into the western portions of Penobscot Bay.

For lobsters, which may be carried for more than 100 miles during their early life stages and then, responding to a temperature signal, drop out of the water column to prospect for hideouts, these current measurements suggest how and where things are likely to happen.

Pettigrew's findings also appear to correlate with Steneck's, Wilson's and fishermen's samples of subtidal lobster densities—highest at the outer edge of the bay near the border of the Eastern Maine Coastal Current, decreasing as one goes up the bay, lowest at the northern or inner edge of the bay. Lobster densities are also higher in western Penobscot Bay than in the east bay, again suggesting that westerly flowing currents are driving their larval ecology.

A comprehensive picture

The Penobscot Bay project enters its third field season with a great deal of momentum. The project set out to deliver what may now be within our grasp: a comprehensive picture of how the complex oceanic dynamics interact with a regional embayment in the Gulf of Maine system. This picture might explain and perhaps predict the patterns of abundance for a commercially important species. This work is based on unique collaborations, not just within the scientific community, but in the fishing community, which needs this information to manage itself more effectively and predictably in the future.

Important as they are, lobsters are admittedly only one of the species that interact constantly with one another, and with the particular marine environments in which they are found, in Penobscot Bay. But by focusing on a single species, researchers believe they will uncover not just compelling new information on how the lobster moves through its environment over time, but also assemble the many pieces of a puzzle in order to produce the ecologically based predictive science that has always eluded fisheries management.

1999

Learn more about the Pen Bay project at www.islandinstitute.org/penbaycollaborative.

In Cod We Trusted DAVID CONOVER

"When a problem is so big that everybody can see it, it's almost too late to do anything about it," comments Lloyd Dickie in his article, "The System in the Sea" in the 1993 *Island Journal*. Last summer in Newfoundland the inconceivable happened—the government moved in forcefully to close down a dying fishery, throwing thousands of Newfoundlanders out of work and effectively destroying not only a livelihood, but also a way of life. Could anything have been done to prevent it? Could it happen elsewhere?

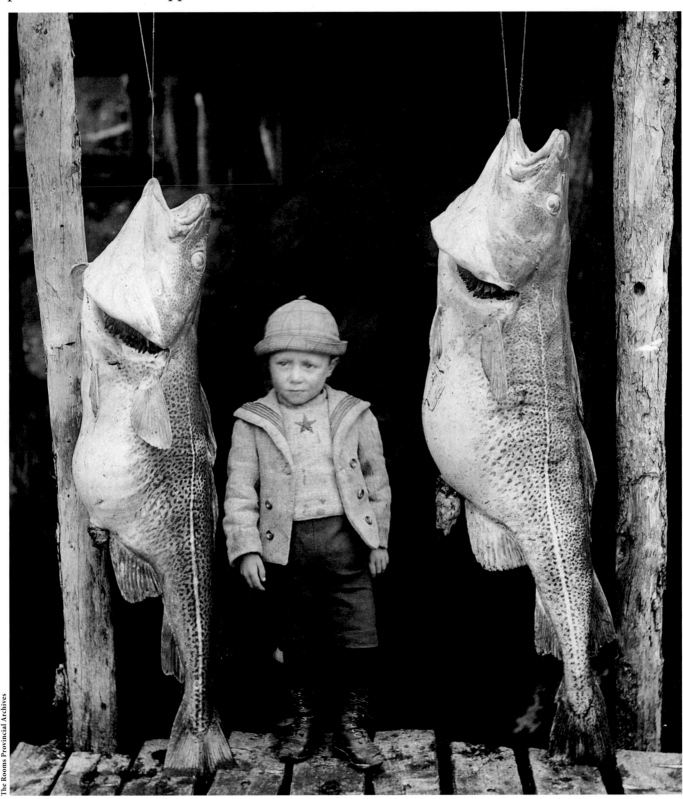

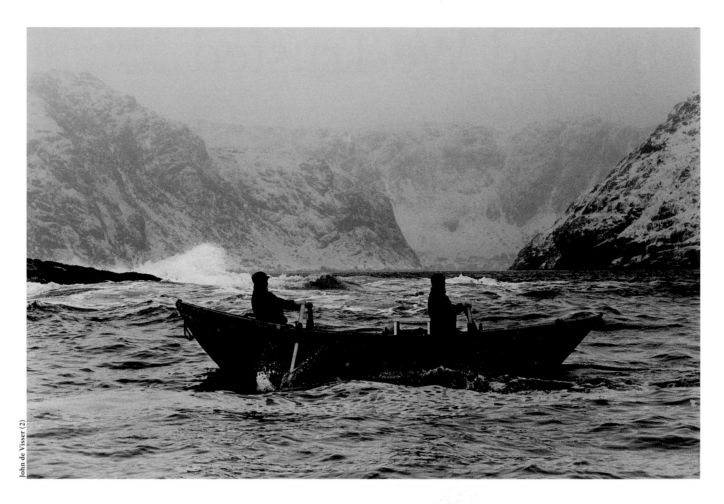

On July 3, 1992, in a back room at the Radisson Hotel in St. Johns Newfoundland, Canadian fishery minister John Crosbie announced to an assembled group of press that the Grand Banks was closed to the taking of northern codfish, known here simply as "fish." A 500-year-old fishery, by far the largest in the Northwest Atlantic, had collapsed and was now commercially extinct. Twenty thousand Newfoundland fishermen and plant workers were out of work. The Grand Banks had been fished out.

Here in New England the news was but a whisper. Our cod fishery is already a receding memory. Once the codfish were as plentiful as on the Grand Banks, but they were fished out 30 years ago. The cod have never come back. No one knows if they ever will.

Barred from the press room that night, a group of concerned fishermen watched the proceedings on a large-screen TV in an adjacent room. Included in this group were Sam Lee, an inshore fisherman with whom I had spent a good deal of time that previous week while exploring the fisheries for a PBS *Nova* documentary, and Cabot Martin, president of the Newfoundland Inshore Fishermen's Association and a champion of the fishermen's cause. The fishermen were angry, frustrated and depressed. The news was expected, but the words cut cruelly nonetheless. Sam rushed out of the room and began to pound on the door of the press conference room to "have a word with the minister." His pounding echoed throughout the hotel and was felt in the bones of all who heard, or who watched on TV. I saw Cabot reluctantly stand between Sam and the door, hold up his hand, and say, "Stop, boy, stop . . . It's doing no good."

For a New Englander like myself, the scene witnessed at the Radisson that night stirred something far down inside me, a memory of a promise and a trust inherited from a time long, long ago—and now almost entirely betrayed. "How has it come to pass that we would put at risk the mighty cod—our past, our future, our essence?" That is Cabot Martin's question, and he asks it unfailingly of all who will listen: himself, Sam Lee, the Newfoundland government, its fisheries scientists. His struggle to find a response ripples far beyond our Maine islands, too, with the fish that still remain.

Cabot Martin is a zealot for cod. Son of a Protestant minister, born and raised in a Newfoundland outport, he became a lawyer and eventually a United Nations delegate during the framing of the Law of the Sea treaty in the mid-1970s. His mind is sharp and wide-ranging as evidenced in his weekly newspaper column and his recent soulful book, *No Fish & Our Lives*. Books about the fishery from every angle cram his home: the history, art, science and politics of fish. During the season, the phone rings off the hook as fishermen friends call in with the latest news. And as for historical perspective, Cabot's stories of the great days of cod paint a wrenching picture of what has been lost: not just livelihood, but a cultural identity.

In the beginning, there was the fish. Cabot Martin's forebear John Cabot may have been looking for the northern spice route in 1497, but it was his fish stories that encouraged most of the trips that followed. And did the Europeans go for that fish! By 1504 the outer Grand Banks were being fished by the French and the Portuguese who had plenty of salt and were able to cure their enormous catch at sea and carry it

back "wet" to market. Records show that on one day in 1542, 60 vessels left Rouen, France, for Newfoundland. Soon afterwards the English arrived, fishing closer to shore.

Eventually, the summer drying stations became year-round communities. Word of the fabulous fishing grounds and the land beyond was also attracting other kinds of settlers: Disaffected religious pilgrims sailed farther south, landing near Cape Cod, in Plymouth. In God—and cod—they trusted. As the centuries passed, communities diversified and spread inland, eventually becoming the communities and cities of New England and Nova Scotia that we know today. But back in Newfoundland, the close tie to the sea persisted—almost as if, having survived the long sea passage, the settlers were unwilling to fully step off their boats. With so many fish there was no need to.

Now Sam Lee's boat drifts uselessly in the twilight years of a once-great fishery that only knew a bountiful harvest. The story of what led up to this point is complex within its specific Canadian context, but the highlights are disconcertingly simple and familiar. In the 1970s and 1980s the fishing was very good. Too good to last. Advances in technology and in the number of boats in the offshore fishery had stripped the outer banks of cod, where they congregate to spawn. In Sam's own inshore fishery, advances in fish-finding equipment and in the efficiency of traps set took what

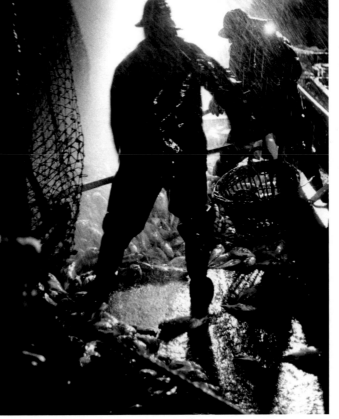

was left over when the fish came in to feed. No one put on the brakes—not the fishermen, not the government and not the fishery scientists. The fishermen wanted fish. The government wanted short-term economic growth. Fishery science was in its infancy and unable to say forcefully "we don't know." A fishery that had lasted 18 generations disappeared in one.

Cabot Martin acknowledges that the waters that John Cabot discovered in 1497 are gone, long gone. He has tried to chart new directions to save what may remain of the fishermen's way of life. And even on the rocky island of Newfoundland, new grass can grow around the sternest of tombstones, and there is hope of learning from mistakes. Sam Lee, for example, has learned what a new direction for living with the ocean means.

In former days, a Newfoundland inshore fisherman like Sam sets his nets a few miles from his home and tended them day after day, year after year, with a small boat. His traditional fishing grounds, or "berths," inherited from his father, had telling names like "the Minister," "the Front Door," and "the Pulpit." His brother and a friend helped him haul. His knowledge is mediated by stories of fear, hope, disaster and bounty; knowledge born from being in one place for a very long time, trying to catch as many fish as possible. Perhaps the deepest-set characteristic of this knowledge has been trust: trust there will always be more fish, and that the vastness of the resource will never be diminished to the point of not recovering. Words and ideas like *environment* have been foreign thinking for Sam: he lives mainly with the rock, and the sea, and until recently the fish.

With the northern codfish gone, however, so is the trust. The resulting shock has forced Newfoundland fishermen to see things differently and to form an alliance with an unlikely party: the environmental community. This was not a small leap for both these groups, despite what may appear to be common goals. Many fishermen resented the intrusions of the save-the-seal crowd in the 1980s. The environmentalists were seen as publicists with an outside agenda unconnected to the traditions and integrity of Newfoundland life. They never seemed to fully grasp the wonder and importance of fish and fishermen as integral parts of the ecosystem, focusing instead on the icons of warm, fuzzy mammals and seabirds. A gap exists, Cabot often adds, because the environmentalists are not themselves directly tied to the sea, the rock, the fish.

Yet, by being outsiders, environmentalists could also see things in a larger world context: wide-term and long-term. Cabot Martin recognized this and, after holding out the olive branch to Farley Mowat, Newfoundland's well-known environmental writer, to Greenpeace, and to others, he worked hard to bring them into the fishermen's world. He has invited environmentalists to meetings with fishermen and urged fishermen to expand their understanding of the whole ecosystem, and to adopt a longer view. Many, like Sam Lee, are coming to see sense in this view.

The result of this is a promise of a new environmental fishing community in Newfoundland. At present it is only a promise, however—a whisper at the edge meeting with many skeptics and naysayers. Whether that promise actually becomes a forward-thinking alliance is now on hold, awaiting an uncharted future when maybe, just maybe, cod and the fishermen will return to the Grand Banks.

1993

Working Waterfronts

DAVID A. TYLER

The working waterfront is the soul of the Maine coast. It is often noisy, smelly and chaotic. At any time of day or night you will find lobstermen, fishermen, clam diggers, shipbuilders, boatyard workers, ferry crew and longshoremen working here, as they have for generations. These men and women respond to the rhythm of the sea as they bring home fish and lobster, build boats, and keep the state's islands connected to the mainland.

Unlike lighthouses or summer islands, few poets write odes to the working waterfront. Although not seen as romantic, these working waterfronts are vital to the future of the Maine coast and the state's economy, supporting 35,000 jobs and providing more than $850 million in state revenue.

In order to keep our coast working, access to the waterfront must be preserved.

In 2003, the Maine Working Waterfront Coalition was formed to work statewide with a variety of partners to preserve access for businesses that depend on access to the water in order to survive.

A community mapping project begun in 2005 by the Island Institute and its partners revealed the threat to working waterfronts in stark terms: The Institute identified 1,555 points that provide saltwater access in the state's 142 coastal communities. Only 1,045 of those points support activities requiring water access, such as commercial fishing, boatbuilding, marinas, marine construction, etc.

Of Maine's 5,300-mile coast, all that is left for working waterfront is 20 miles, according to the Island Institute's report, "The Last 20 Miles: Mapping Maine's Working Waterfront," published in 2007. Of the 888 access points that support commercial fishing, two-thirds are privately owned and could be sold, which could halt the fishing access.

Faced with these grim statistics, those who want to preserve working waterfront access took action. The Working Waterfront Coalition was crucial in mobilizing support for two statewide ballot questions that were overwhelmingly approved by voters in 2005. Voters approved a change in the state constitution to allow waterfront land used for commercial fishing to be assessed based on its current use, rather than if the land was developed for vacation housing. Voters also approved a conservation bond that included money for working waterfront access. That conserva-

tion bond helped to create the Working Waterfront Access Pilot Program, which was co-managed by the Island Institute during the first round of grants.

Since 2006, that program has helped to permanently save 14 properties for fishing use that generates $35 million in income and support sover 700 fishing families.

This fund allows fishermen and communities to choose valuable waterfront land that needs to be preserved. Development rights are sold to the state in exchange for ensuring that the waterfront will forever be used for commercial fishing. The program bans conflicting uses, such as condos, but does allow a degree of mixed use, providing the property owner with the flexibility to successfully manage the property.

Since working waterfronts are often at the heart of an island or coastal community's commercial center, that flexibility is important. The Holbrook Community Foundation in Cundy's Harbor sold a covenant through this program for $300,000 to preserve property worth $1.15 million. The property includes a commercial fishing wharf, a snack bar, a historic house with two apartments, a general store, and a second dock with a float for recreational boating access.

Another success story is the new wharf in Port Clyde. The Port Clyde Fishermen's Co-op sold a covenant to the state for $345,000 for waterfront land in St. George valued at $845,000. The wharf is used by the 28 members of the lobster co-op and about a dozen groundfishing boats of the Midcoast Fishermen's Co-op.

The Port Clyde covenant sale helped pay for a $500,000 new wharf that opened in the summer of 2008. In addition to money from the fishermen, additional funds came from the Island Institute's Affordable Coast Fund, the 1772 Foundation and Up East, Inc., and an in-kind donation by Prock Marine Company of a percentage of the labor costs.

With this program, progress has been made toward saving access for commercial fishing. But to keep our coast working, that energy and creativity must continue. Other working uses of the coast need to valued and saved, from boatyards and marinas to terminals for merchant shipping, to access for clam diggers and urchin divers.

All of us who love the Maine coast should value the working waterfront the same way we treasure its pristine beaches and uninhabited islands. We must feel the same passion and outrage when a working waterfront is threatened as we do when pristine shore land is threatened by development. For without working waterfronts, the people who earn their livelihood from the sea will vanish, and the coast will become a sterile, lifeless place.

Preserving a Way of Life

After statewide victories, fishermen and communities have new tools to keep waterfronts working

DAVID A. TYLER

Peter Ralston (2)

In 2003, Holbrook Wharf in Cundy's Harbor was for sale. Like so much of the Maine coast, this crucial part of the waterfront in Harpswell could be lost, cutting off access for fishermen and the entire community.

Holbrook Wharf, as is the case for so many coastal communities, is more than just a pier. For over 150 years, it served as the center of this fishing village. The wharf was built in the mid-1800s and has been a landing spot for urchins, shrimp, lobsters, tuna and groundfish. There's also a general store, a magnificent Italianate home and a lobster restaurant. "I cannot imagine Holbrook Wharf not being available to the community," said Sue Hawkes, in a December 2004 *Working Waterfront* article. Hawkes is a member of the Holbrook Community Foundation and her family owns Hawkes' Lobster next to the wharf.

It is an all-too-familiar scenario for those struggling to preserve access to Maine's coast for fishing and other traditional uses. A strong real estate market for coastal property, higher waterfront taxes and the cost of maintaining piers means that industries dependent on the waterfront lose places they need to do business, as property is sold off for vacation homes and condos. But in the past few years, a grassroots effort has worked to fight the loss of essential waterfront. Coastal and island residents, working with nonprofits and legislators, have raised awareness about this statewide crisis. Action has been taken and waterfront is being preserved. When the Working Waterfront Coalition helped get two referendum questions passed in 2005, it meant, for the first time, that waterfront used for fishing could be protected forever, through a statewide program.

It was not easy winning these two ballot questions. The groundwork was laid with the formation of the Maine Working Waterfront Coalition in March 2003. This group was created to work statewide to preserve access to the coast for marine-dependent industries. It has grown from a dozen organizations, at its founding, to over 150.

Access preserved, one waterfront at a time

Working waterfronts are crucial to island and coastal towns. Many of the waterfronts used by fishermen are also essential to the entire community. On Isle au Haut, for example, the entire island uses the municipal pier: about 20 lobster boats, boats hauling freight, the island ferry and private boats. When it comes to access, often "there's only one place on an island," said Steve Schiffer, former Isle au Haut selectman. "As places get bought up and as waterfront gets more expensive, you don't have much of a choice of different places to come and go" from the island. Once that waterfront access is lost, it impacts everyone: fishermen, lobstermen, harvesters and community members.

Since January 2006, the Working Waterfront Access Pilot Program (WWAPP) has provided $3.6 million in state bond funds that have helped preserve 14 properties for commercial fishing use. More than $35 million in annual income is directly dependent on these properties, according to a press release from the state Department of Marine Resources (DMR). These waterfronts also support over 450 boats and over 650 fishing jobs.

Fishermen, businesses and communities submit projects to be considered. When a project receives funding, the development rights are sold to the state. The state then holds a covenant on the property to protect all current and future fisheries uses.

Applications are reviewed by the DMR, and the Land for Maine's Future Board makes the final decision on which projects receive funding. Factors that are considered include: whether the working waterfront is strategically important; whether the waterfront fully supports commercial fishing, including all-tides access, fuel, bait, sales and/ or parking; whether the waterfront is under threat to be developed and no longer usable by fishermen; whether the community has shown a clear desire to support commercial fishing; and whether the waterfront is a critical part of the local fishing infrastructure.

Here are some examples of projects that have already been funded, moving along the coast from west to east:

Pine Point Harbor Town Dock, Scarborough

The municipal pier at Pine Point will be renovated in the fall of 2009 using $400,000 from the Town of Scarborough, money from the sale of the covenant to the state, and a grant from the Maine Department of Transportation's Small Harbor Improvement Program (SHIP). The area of the pier will be tripled, all-tides access provided and direct vehicular loading by mechanical hoists is planned. The pier serves 25 lobstermen and 40 clam harvesters and recreational boaters who also share launch ramps and the pier. Lobstermen were limited to three hours each day at the pier to unload their catch and equipment. After the project is completed, fishermen will have 24-hour access to the water.

Pemaquid Fishermen's Cooperative, Bristol

In February 2009 the Pemaquid Fishermen's Cooperative was awarded $265,400 to purchase a covenant on a four-and-a-half-acre parcel valued at $1.3 million. The co-op plans to build a new shoreside building with a new chilled seawater system, and better lobster storage equipment on their boats. Some of the money will also go to better branding and marketing of their lobsters. This waterfront supports about 50 fishing and harvesting families.

Friendship Lobster Cooperative

The covenant in Friendship protects 0.6-acre of waterfront land with 110 feet of shore frontage, a wharf with 22,000 square feet of working area, berthing space for multiple boats, parking for all co-op members, and fuel and bait storage. The wharf serves 70 fishermen in 40 boats. The Friendship Lobster Cooperative sold a covenant to the state for $250,000 and plans to use the money to buy a nearby parcel for gear storage and renovate the wharf, according to Jim Wotton, co-op president.

Port Clyde Fishermen's Cooperative, St. George

In 2007, the Port Clyde Fishermen's Cooperative (the lobstermen of Port Clyde) received $250,000 from the access pilot program for the sale of a covenant to a 0.75 acre parcel in Port Clyde Harbor. The fishermen's co-op built a new, $500,000 wharf that also accommodates groundfishing boats from the Midcoast Fishermen's Cooperative. The wharf opened in September 2008. In addition to the investment by the fishermen, money also came from the Island Institute's Affordable Coast Fund, the 1772 Foundation, the Up East Foundation and an in-kind donation by Prock Marine, the project's contractor. The wharf is used by 28 lobster boats and about a dozen groundfishing boats.

Vinalhaven Fishermen's Cooperative

The Vinalhaven Fishermen's Cooperative sold a covenant to the state for $176,000 for waterfront that includes one acre of shoreside facilities, 320 feet of deepwater frontage, all-tides access and two piers. About 60 boats use this waterfront. The award, granted in March 2009, will help the co-op build a facility for the storage of both the frozen and refrigerated bait. "In addition, the funds from the sale of the covenant will allow us to build a bait cooler which we really need, but would not have done given the uncertainty of the economy and its effect on lobster prices," said co-op president, Ted Lazaro, in a press release.

Isle au Haut Municipal Pier

The Town of Isle au Haut received an award of $104,000 from the WWAPP for its town pier. On this island of 86 residents, the pier is the only public waterfront access. Isle au Haut will use the award to help pay for a new pier. The current structure is 50 years old and must be replaced, according to inspectors from the state Department of Transportation. The new pier will cost about $580,000; the rest of the money comes from a $350,000 federal Community Development Block Grant and a $150,000 SHIP grant, according to Steve Schiffer. Construction will begin in September 2009.

Perio Point Shellfish, Beals Island

In 2007, Carver Enterprises was awarded $261,250 for a covenant that will preserve permanent commercial fishing access to a 1.8-acre parcel that includes two tidal lobster pounds and serves 75 to 100 boats. These boats land lobster, crab, scallops, worms, urchins, cucumbers and quahogs. The waterfront also includes wharves and a service building.

David A. Tyler

Another important step was a community-mapping project begun in 2005 by the Island Institute and several partners to figure out exactly how much waterfront access was left. The results of this project, published by the Island Institute in the report, "The Last 20 Miles: Mapping Maine's Working Waterfront," were eye-opening. The Institute identified 1,555 points that provide saltwater access in the state's 142 coastal communities. Of that total, only 888 of these points support commercial fishing activities. And two-thirds of the 888 access points are privately owned and vulnerable to conversion to uses that would not allow fishing, according to the Institute report. An even smaller group, just 81 access points, are considered "prime working waterfront" with parking, all-tide access and fuel on-site.

The report's most disheartening conclusion has now become well known: of Maine's 5,300-mile coast, all that is left for working waterfront is 20 miles. If the current trend is not halted, a study by the Maine State Planning Office suggests that the majority of the state's coast will be classified as suburban/urban by 2050, according to the Institute report.

The problem had been clearly defined. But what could the solution be? If the state did not recognize working waterfront as having special qualities, how could it be protected?

In York Harbor, two lobstermen, community leaders, the York Land Trust, the Mt. Agamenticus to the Sea Conservation Initiative, and Coastal Enterprises Inc. came up with a pioneering answer to this question.

In 2003, a fishermen's dock and land near Sewall's Bridge was for sale for $710,000. Plans to develop homes at the site seemed imminent. York Harbor had already lost three commercial wharves to residential development, including one parcel that was converted into a home and sold for $2.3 million.

The land trust stepped forward to work with fishermen and community members. Trust officials felt that the pier was part of the historic and sce-

nic beauty of the river, and should be protected. The trust, the fishermen and residents worked hard to create a conservation easement that protected the dock for working waterfront uses. In the end, two lobstermen, Jeff Donnell and Mark Sewall, paid $300,000 and the York Land Trust raised $410,000 for the conservation easement. It was likely the first time a land trust played a role in preserving working waterfront.

"We were the pioneers," said Joey Donnelly, vice chairman of the York Harbor Board. "We did it because we wanted to preserve the dock." Rob Sny-

der, vice president of programs at the Island Institute, who worked on the 2005 ballot questions, agrees. "It was the York Harbor innovation that started the whole thing. York became the basis for the state working waterfront program."

It was not easy getting a statewide program passed. In 2000, a ballot question asking that voters change the state constitution to allow waterfront land used for commercial fishing to be assessed based on its current use, rather than if the land were developed for its highest and best use (usually vacation housing), failed by a very narrow margin, 49.6 percent to 50.5 percent.

In 2005, however, the constitutional amendment passed, 72 to 28 percent. And $2 million for a pilot working waterfront access program was included in the 2005 Land for Maine's Future bond issue, which passed 66 to 34 percent. The Working Waterfront Coalition

was crucial in mobilizing support for these two questions. The group worked for over a year, holding rallies across the state, lobbying legislators and bringing the message to the media and voters about how crucial working waterfronts are to the statewide economy.

Adopting these ballot measures was a huge step for the state voters, who had recognized farmland, open space and historical structures as having qualities that significantly benefit local communities, but had never considered working waterfront in the same way.

With the passage of the Land for Maine's Future Bond, the Working Waterfront Access Pilot Program (WWAPP) was created. For the first round of grants, the program was co-managed by Coastal Enterprises Inc. and the Island Institute. Since then, the program has been run by Coastal Enterprises Inc. and the state's Department of Marine Resources.

The access pilot program began in 2006. Fishermen and communities make proposals on which waterfront to save and the state evaluates the projects based on several factors (see "Access Preserved, One Waterfront at a Time," page 134). The state bond money is matched by private contributions, bank loans or grants—about $10 million so far.

Since 2006, the WWAPP has helped to permanently save 14 properties for fishing use with a fair market value of over $13 million, according to a release from the DMR. These waterfronts support more than 700 families and generate over $35 million in direct income and more than $70 million in additional money for local economies. "The challenges that these boats, businesses and families are facing today are unprecedented," said Hugh Cowperthwaite, fisheries project director at Coastal Enterprises Inc. "The program is achieving its goal of preserving this access forever at a time when some businesses are really struggling to stay viable." In 2007, voters again approved the Land for Maine's Future bond, which included $3 million for the working waterfront access program.

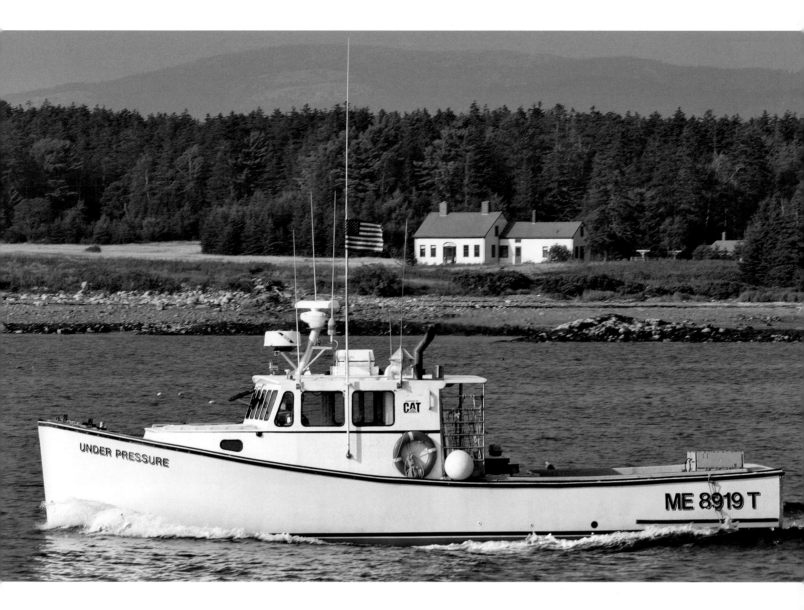

The nationwide collapse of the real estate market does not relieve the pressure on Maine's working waterfront, according to Snyder. Because of the economic collapse, there is "a hard year ahead for our lobster and ground fishermen. The Working Waterfront Access Pilot Program is only becoming more vital."

In Cundy's Harbor, a dedicated group of volunteers used this new program to help save Holbrook Wharf. The Holbrook Community Foundation raised money from over 500 donors, received a loan from the Genesis Foundation and a $300,000 award from the WWAPP to raise the money to purchase the property, valued at $1.2 million. The group also received a technical assistance grant from the Island Institute to help pay for the application process for the WWAPP award. In 2006, volunteers cleaned out the general store and the surrounding area and the store reopened in 2007. In the winter of 2007–2008, volunteers removed the unsafe dock behind the store, which was rebuilt, with five floats, by Ben Wallace of Redfish Marine Inc. in Harpswell.

In the winter of 2008–2009, a project to rebuild the wharf was undertaken. In the fall of 2008, all the buildings on the wharf and 6,000 square feet of the wharf were removed. Rideout Marine of Boothbay removed the wooden pilings, which had marine worms. Rideout installed new pilings, which were adapted from recycled utility truck poles. A new, metal commercial fishing building was built (which can house four to five marine businesses), along with a new building for the restaurant on the wharf. The snack bar and general store opened in May of 2009. So far, the foundation has spent between $600,000 and $700,000 on all the improvements, according to Bill Mangum, president of the foundation.

During the rebuilding, Mangum was at the wharf nearly every day, and watched a steady stream of cars drive by to check progress. "If we had a dollar for every person who stopped by to see what is happening, our fund-raising days would be over," he said.

Mangum reflected on all that the community has done, with donations of time, money and materials, to keep this wharf working. "Our dream was to preserve and revitalize this working waterfront," Mangum said. "As anyone who visits the site will see, that dream is coming true."

2009

Learn more about this topic at www.islandinstitute.org/waterfrontaccess.

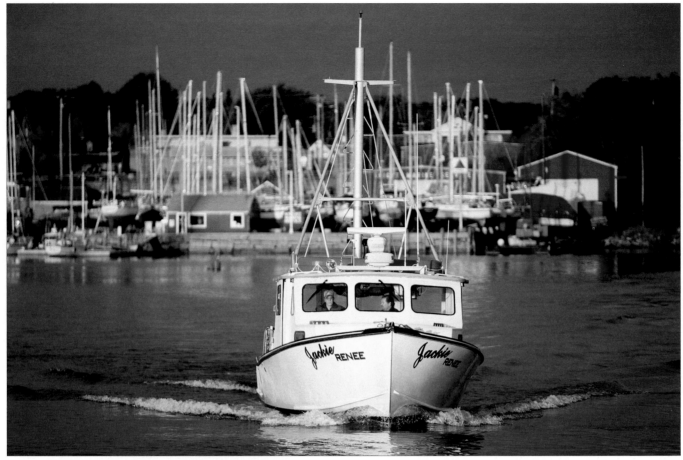

JACKIE RENEE

A Highway Home

A network of private ferries and mailboats connects islands to the mainland and each other

STEVE CARTWRIGHT

PHOTOGRAPHS BY PETER RALSTON

Ferries take us back—back to the islands that some of us call home or back to the mainland where most of us live. Independent ferries and mailboats along the coast are the island taxicabs, taking us where we want to go, at a pace where we have time to get acquainted, time to absorb the sightings of seals, lighthouses and seabirds; time to appreciate the passage we are making.

Sometimes, as with our lives, it's the journey that matters.

When you're headed for Peaks Island and you catch a whiff of the Casco Bay breeze, the effect can melt the stress of deadlines, phone calls and city traffic. The hubbub is replaced by blue water and blue sky and fishing boats; or just the solitude of fog. Long before cars took over our lives and before railways carried us from place to place, Native people ferried goods in their bark canoes and gathered eggs on islands; wooden boats brought the first white settlers to the islands and the mainland, and steamboats carried the first tourists downeast. The sea was and still is a highway, with exits to harbors and roads leading upriver to towns and cities that only

grew there because boats could reach them.

Josh Weed is a captain at 27. He skippers a ferry from Stonington on Deer Isle to Isle au Haut, a community of about 55 year-round people. He earned a teaching degree from St. Joseph's College, and still plans to teach in a classroom, but a deckhand job evolved into full-time work on the MISS LIZZIE and the MINK, the two ferries of the Isle au Haut Boat Company.

One of the best things about making the 40-minute trip to and from Isle au Haut is friendship. Passengers like to chat with their captain, and that's fine with Weed. "You not only know their names, you know their off-island family, too. The wheel isn't separated from the rest of the boat. People can come up and talk with me."

But he isn't distracted from piloting his 50-foot vessel. "One of the most important things is keeping the boat running, keeping an eye on kids to make sure they don't fall overboard from another boat's wake." He makes the run in all kinds of weather, from fog to 50 mph winds if he can find enough

shelter in the lee of islands. Rarely are runs canceled, and if they are, islanders get anxious.

Captain Larry Legere of Cape Elizabeth has put in 28 years with Casco Bay Lines, and daughter Alexandra has joined the business selling tickets for the ferries to Cliff, Peaks, Long, Chebeague, and Great and Little Diamond islands. The service runs 365 days per year, from 5 a.m. till 11:30 p.m. Casco Bay Lines has been carrying people and the mail to the islands since 1871. "It's a nice tradition," Legere said.

Over the years, the same passengers ride the same ferries and they become pretty familiar faces to captain, crew and each other. "It's a very small community. We're their lifeline. We have the opportunity to know a great many of them," said Legere. Peaks Island has by far the biggest year-round population in the bay at about 1,000; Chebeague is home to 350 people; Long Island is next with 200; Cliff and Great Diamond islands have about 75 year-rounders; Little Diamond has seasonal homes only. It's 17 minutes by ferry from downtown Portland to Peaks. The trip to Cliff Island takes an hour and 15 minutes.

Legere's father was the last captain of the SABINO, a coal-fired wooden ferry operated by Casco Bay Lines from the 1930s until 1959. The SABINO is now preserved at Mystic Seaport in Connecticut.

Legere "came ashore" after shipping out on oil tankers, and said he is happy to ply the bay by ferry, collect old ferry photos and other memorabilia and generally maintain reliable transportation to the inhabited islands. Casco Bay Lines, a nonprofit company, has five ferries in operation, including the 98-foot MAQUOIT II. Legere likes the Native American names, and has worked to keep them in circulation. "Maquoit" means salt marsh, he said. The rest of the fleet features the 110-foot AUCOCISCO III, new last April and named for a wooden steamer that served in Casco Bay from 1897 to 1942; the 122-foot MACHIGONNE II, a car ferry to Peaks Island; the 65-foot ISLAND ROMANCE; and the 85-foot BAY MIST, a charter vessel and party boat.

Monhegan Boat Line, owned for more than three decades by Judy and

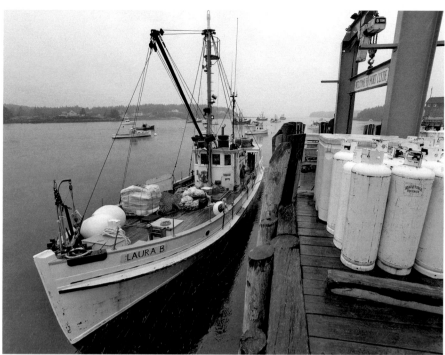

LAURA B., *Monhegan Boat Line*

QUICKSILVER, *Islesboro's water taxi*

Jim Barstow, has served Monhegan since 1914. The Barstows met on Monhegan, where both had summer jobs. Jim and his family had been spending part of the year on the island since Jim's childhood.

Now, the parents are selling the Monhegan Boat Line to daughter Karen McGonagle and her younger brother Andy Barstow, a graduate of Maine Maritime Academy and a merchant seaman. "I always wanted to work with my brother," said Karen, who joined the business as a deckhand on the LAURA B. at 14. Even if not related to the Barstows, "The people that come to work for the boat line are like family" she said.

Karen said the LAURA B., a 65-foot

wooden vessel used on the Monhegan run for half a century, was like a "fifth child' in the family of four kids. The old boat is the soul of the business, beloved by the Barstows and generations of Monhegan people. Built in 1943 as a World War II transport boat in the Pacific, the Laura B. now has been joined by the modern Elizabeth Ann, which has more comfort and less character than its older sister. The older boat, rebuilt in Rockland, has traditional sheer and the look of a fishing boat—it once carried lobsters from Vinalhaven to Boston — while the new boat has glassed-in decks and two bathrooms, known as "heads" at sea.

Monhegan, Mecca for artists and

MISS LIZZIE, *Isle au Haut*

tourists alike, is also served seasonally by Balmy Days Cruises of Boothbay Harbor, named for a former ferryboat much like the LAURA B., and by Hardy Boat Cruises of New Harbor. The average fee for the 10-mile trip from Port Clyde to Monhegan, or the 12-mile trip from Boothbay Harbor, is $18 one way.

Why is Monhegan so popular? "It's a step back in time to go there," said Karen McGonagle. "When people ask, we tell them to bring a flashlight and two pairs of shoes. And the island store closes at 6 p.m." She said the beauty of a ferry, particularly the LAURA B., is that it brings people together on an equal footing, at a slower pace. Passengers and crew are temporarily caught in the embrace of a small voyage, a small island village, a peaceful sense of place.

Tom and Sharon Daley visited Islesboro several years ago for the wedding of ferry and island boatyard owners Earl and Bonnie McKenzie. They loved Islesboro and immediately bought six acres there. Now they are the owners of QUICKSILVER, a South Shore 34 built in Northport.

Tom, originally from Boston and Cape Cod, said he has liked boats since riding with his uncles, who owned tugboats. As skipper of QUICKSILVER, he is on the water year-round, taking contractors, basketball teams and summer

EQUINOX

people to and from Lincolnville Beach. Unlike the state ferry that departs from the same mainland location, he can make the 15-minute run at all hours. Tom Daley believes there wouldn't be much of a sports program at the Islesboro school without his ferry.

Tom Daley can have his second boatload of contractors on-island by 7 a.m., he said, giving them a full day's work. Islesboro residents have set a limit of 10 building permits per year, but it hasn't slowed a boom in expensive houses. Three houses are under construction; a lot of remodeling is going on. Sometimes there is a wedding party aboard

QUICKSILVER. Sometimes Tom spreads the ashes of an islander on the waves.

Sharon Daley is a registered nurse aboard Maine Seacoast Mission's SUNBEAM, bringing "telemedicine" to island communities. "Her boat is bigger than mine," Tom said.

Navy veteran Jim Kalloch has served on an aircraft carrier in the Arabian Gulf, but he is finding operating his 38-foot Young Brothers ferry, named for daughter Jackie Renee, is enough of a challenge. After 30 years in the military, the Owls Head native figured he would "retire" to lobstering. But because he let his lobster license lapse for one year, he

KATHERINE, *Eagle Island*

lost a chance to renew and wasn't about to start over as an apprentice. He began fishing at 13.

So he bought a boat with a 450-horsepower diesel from Art Stanley of Owls Head, and he was off and running. "I'd been pushing water uphill for a long time," he joked. His Penobscot Ferry and Transport operates from Knight's Marine in Rockland, and serves North Haven, Vinalhaven, Matinicus and Criehaven at competitive rates.

Kalloch is a substitute teacher in the Rockland schools, an accomplishment for this Rockland High dropout who later earned an MBA. He owns a small house on Criehaven where, if his schedule permits, he can spend some quiet time. "It's a great life," he says. "I love what I do."

Two former Outward Bound instructors teamed up, not only to marry and have children, but also to start a flexible ferry service with their 40-foot, Clark Island lobster boat, the EQUINOX. Sometimes, John Morin and Sue Conover take their children, Simon, 6, and Lydia, 9, on boat trips. Licensed for 28 passengers, the Rockland-based boat makes runs as needed to Vinalhaven and just about any island where people want to go.

In the summertime they offer tours featuring a half-dozen lighthouses. Mostly, EQUINOX does charter work, including a partnership with the Maine Lighthouse Museum in Rockland. Rates vary, with the lowest prices for islanders "because they're the backbone of the business," John said. A one-way trip to Vinalhaven is $10.

EQUINOX was built for Monhegan lobster fisherman Zoë Zanadakis who acquired celebrity status when she appeared on the TV show "*Survivor.*" The boat is blue, considered bad luck by old-time fishermen, but John Morin noted it's also a color on the Greek flag, something Zanadakis wanted.

Dave Bunker was a deckhand as a teen and got his captain's papers at 18, when he graduated from high school. Now he runs the barge between Northeast Harbor and the Cranberry Isles for Beal & Bunker, the ferry company founded by his father, Wilfred Bunker, and business partner Clarence Beal.

The younger Bunker is busy throughout the year barging fuel, vehicles and heavy equipment to Great and Little Cranberry islands. Summer, of course, is the busy time for Beal & Bunker, as the year-round population of the two islands swells from 150 to several hundred seasonal residents. The company makes three round-trips per day off-season; six round-trips in the warmer weather. The trip from Northeast to Great Cranberry takes 15 minutes; it's another 10-minute ride to Little Cranberry. A one-way ticket is $8.

Beal & Bunker has three boats plus the barge, and the ferries carry the mail six days per week. "There's always something going on," Bunker said.

Helene and Bob Quinn are fifth-generation residents on Eagle Island in East Penobscot Bay, and they are the only people who live there year-round. Since taking over Sunset Bay Company from Bob's cousin—also Robert Quinn—in 1998, the couple has operated the boat service and mail run nonstop. In the off-season, from September to June, they make the mail run twice weekly from Sylvester's Cove on Deer Isle to Great Spruce Head and other islands. In the busy summer season, with passengers and sightseers along, it's a seven-day-per-week operation. They run the 38-foot KATHERINE in the summertime to Bear, Butter and Oak Islands, among others, and use Bob's smaller lobster boat, the TM II, during the off-season. Bob fishes, too, and is caretaker for summer places. His boat is named for grown daughter Trina Marie.

In the wintertime, when floats and ramps are hauled, the Quinns must row ashore to rocky island beaches.

A passage from Deer Isle to Eagle Island costs $12, but the fare may increase with rising fuel costs. The Quinns hold a year-round mail contract, but Helene acknowledged it's the summer people that keep the ferry service alive. "We're like other Mainers," Helene said. "You patch together a lot of different things to make a living."

Is it lonely, staying in their early-1800s home on Eagle? "We need it after the summer season. We kind of look forward to it," she said. A phone connects them with the outside world, and weather permitting they can head inshore when they want to go shopping or visit their grandson.

For Helene, living on Eagle Island and running the ferry isn't a lifestyle choice. "It's a continuity of what you've been handed. Not that we couldn't have chosen to do something else. But it's who we are. We can't separate ourselves from it.

"We have to know the weather, the tide," she said, "things other people don't have a clue about." As for crossing to Deer Isle, "Just think of it as a long driveway."

2006

A Family Tradition

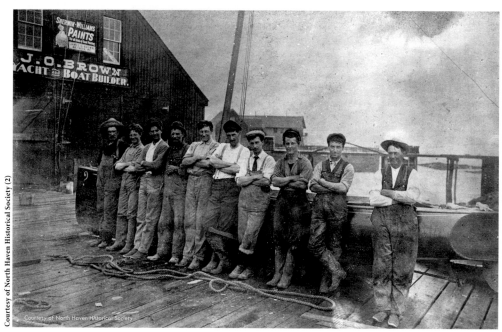

The crew, circa 1922

North Haven's J. O. Brown boatyard is launched on its second century

JANE DAY

For more than a hundred years now the J. O. Brown & Son boatyard of North Haven has weathered the pressures of national whim and welfare with the steadiness of its wooden boats riding the rise and fall of the tide.

Five generations of Browns have put heart and sweat into the boatbuilding and repair yard since the first James O. (Osman) Brown opened shop on the island in 1888. The yard's random assembly of buildings occupies much of the original site alongside the ferry terminal, its wharf and red frame boat shop a landmark on the Fox Islands Thorofare that threads its way between North Haven and Vinalhaven.

Although the yard crew may ferry people across the channel 100 times a day in the summer—"It takes longer to walk down the dock than go across in the outboard," says Foy Brown—the Thorofare separates a less tangible economic and social character of the two islands. North Haven's year-round population of several hundred triples with the annual return of a well-rooted summer colony, many of whose families date from the earliest settlers. Vinalhaven's greater year-round population is home to an active fishing community that supplies J. O. Brown with a good bit of work in general repairs and new boat construction.

Members of three generations of Browns now account for most of the regular crew, their first names known to fishermen and yachtsmen alike from Beals Island to Boston and beyond. James E. (Jim) Brown, 75, grandson of the founder and now patriarch of the family, lives in the house his grandfather built close by the yard. He took over from his father Foy W., in 1940, and ran the yard until recently with his sons Foy W., 45, who now heads the operation, and James O., 47, known to the family, as "Oz"; together with Foy's son, Foy E., 27. As the alternating succession of names might suggest, tradition runs

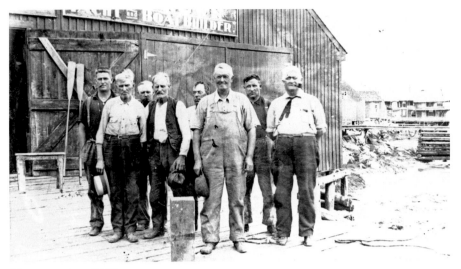

The crew, circa 1920s

and find a boatyard down the road." In many cases, the J. O. Brown boats themselves are their best advertisements. Foy's own 34-foot lobster boat CENTERFOLD—"a wicked good boat" by his own admission—led to a succession of orders from a Massachusetts fisherman who saw it in one of the Stonington lobsterboat races.

The years have brought a lot of changes in the boatbuilding and repair business, some more questionable than others. Take boat lumber, says Foy: "The price is up and the quality is down." He has noticed a steady decline in the quality of boat lumber, particularly in the past 15 years, but it still hasn't dampened his preference for wood as a building material. As for island delivery: "It doesn't make any difference whether you're here or there; you've still got to get it ordered special. Nobody has that kind of stuff lying around." Foy has a supplier who cuts the timber, mills it, and delivers by truck to the island. But now he prefers to pick it out himself. "We don't skimp on wood," he says, adding that the yard's outstanding feature is a "good heavy boat, built to last a long time."

Since its beginning in 1888, the J. O.

strong in the Brown family as well as in the quality of the boats they build.

A major asset in J. O. Brown's historic operation has been its ongoing ability to buck a tide that would have defeated many another boatyard. As a business, it has the dubious advantage of being located an hour's ferry run off the mainland. More remarkable still, the Browns build only in wood, traditional carvel-planked cedar over oak, one of the few boatyards on the coast that has held out successfully against fiberglass or epoxy construction.

The very nature of an island operation requires stocking a good supply of basic materials. Getting the unexpected replacement part involves phoning in the order, then depending on the mainland supplier—and more often a taxi—to deliver to the next ferry.

The yard's business traditionally comes by word of mouth. "It's nice out here," says Foy, "but if someone doesn't know about you, you're hard to find. On the mainland you can drive up the coast

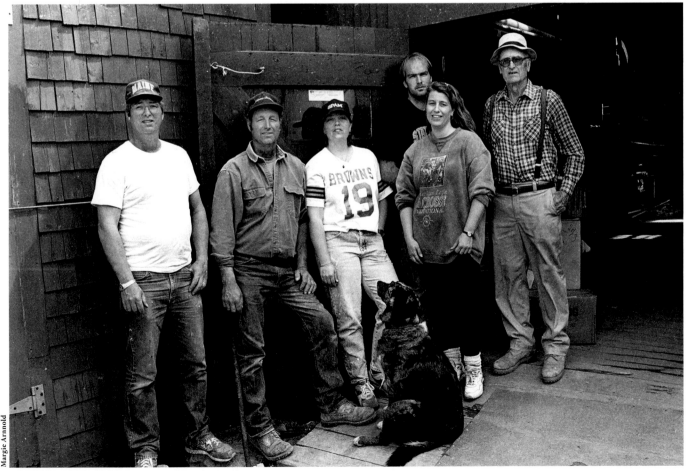

Margie Arnnold

The crew, circa 1980s

143

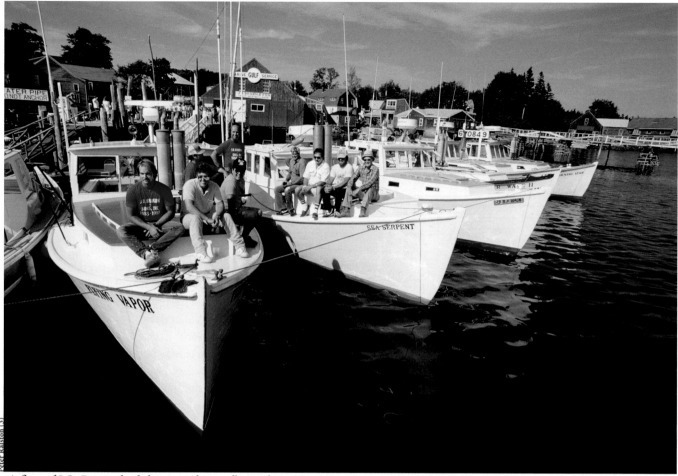

A fleet of J.O. Brown-built boats at the yard's 100th anniversary

Brown yard has shown a marked ability to roll with the changing demands of customers. At first the yard built boats for the local fishermen, and in the years before the gasoline engine, sailboats in the 30- to 40-foot range to meet the demand of the affluent summer population. It was not unusual in those days to have 12 or 15 men working—up to 20 some winters. With the advent of power, the yard built a number of sport-fishing boats as well as the sturdy vessels favored by area lobstermen and scallopers. And in deference to the proliferation of fiberglass boats, the yard not only stores and repairs them, but has finished off a number of fiberglass hulls.

The Browns design most of the boats they build. Jim starts with a half model—"My father built that way and my grandfather." He makes a distinction in the construction of what he terms the "Maine lobsterboat hull" between the "built-down" hulls he builds and the "deadwood" or skeg type favored by builders in Jonesport and Beals Island. "In a built-down boat, you plank clear down. They hold up better and they've got more buoyancy. But the deadwood boat will drive easy. And those fellas down Beals Island are after speed.

"We do the whole thing from start to finish—caulking, rigging. When I grew up it was powerboats. I don't sail. I've rigged 'em and hauled 'em and fixed 'em, but I never sailed 'em."

Most of the boats built in Jim's time were powerboats for fishing and yachting. One of the largest was the 43-foot Pow-Wow, which came off the ways about 30 years ago for use as a fishing party boat. She's had a couple owners since, but was still in good shape when she came by a couple years ago. The

yard has built boats for owners largely in New England and the Mid-Atlantic states, and once shipped a 22-foot sailboat to a customer in Puerto Rico.

But perhaps J. O. Brown is the best known for the 14-foot 4-inch gaff-rigged North Haven Dinghy, the racing-class sailboat built in the yard's first years, primarily for the island's summer colony. Demand for this round-bottomed, centerboard boat grew out of the island yacht skippers' hankering for a small racing-class boat to replace the yacht tenders they had been using. Every winter for decades, the Browns built several of these now-classic dinghies that marked their 100th anniversary a few years ago. But they are no longer built of wood. Dinghy racing members had molds made, and for the past 10 years or so, all the North Haven Dinghies have been built of fiberglass at another yard.

The major part of the present J. O. Brown operation is boat repairs and storage. Early this year, several small boats were in various stages of repair, including a 17-foot fiberglass Crowinshield knockabout. The main shop of the lofty 90-foot by 40-foot building—originally a canning factory—can handle a boat up to 45 feet. Rows of wooden and aluminum masts line the rafters overhead. A workbench along one wall, its deep drawers worn with decades of use, is laden with hand tools and the usual boat shop collection of parts and might-come-in handies. "The day after I get rid of something, I'll need it," says Foy.

It's usually December before all the boats are hauled and the Browns settle down to building. It was mid-January before they could get materials for a lobster boat for one

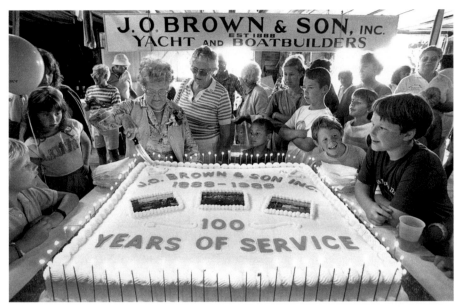

Celebrating the 100th anniversary

Vinalhaven fisherman—red oak for the keel, white oak for stem and timbers, cedar for planking. When she was launched seven months later, she was fully equipped, ready to go lobstering the next day. Boats are launched at high tide from the forward end of the shop which is located right over the ways.

Although the yard hasn't had a new boat to build this past winter, or the one before, its island location may have isolated the J. O. Brown yard from the brunt of the recession that has gripped the rest of the country. "North Haven has been fairly recession-proof," says Foy. "There'll be boats here. The Fox Islands Thorofare is Route One as far as boats are concerned. Anybody who leaves Boston headed east, 99 percent of 'em come through here. In the last few years, we see more boats, more boats, more boats. Go to Massachusetts in summertime—the harbors are full. There's no place else for 'em to go but this way. This past summer, they were fighting to get into our float, yelling at each other."

J. O. Brown is in the business of serving these people, pleasure boaters and working fishermen alike. But Foy acknowledges that many who come to the island to get away from it all aren't one bit happy about the "crazy madhouse" at the waterfront in the height of the summer. The yard supplies all the gas for boats and cars on the island. On Sunday mornings the dock swarms with boat owners buying ice and gassing up for the day's outing.

Jim Brown remembers that the first outboard he ever saw was in the late 1920s or early 30s. But the increased in the numbers of outboard engines in the last 10 to 15 years, he says, accounts for one of the most dramatic changes he has seen in the business. "We used to store a dozen motors; now we store 50 to 75, anywhere from 4 horsepower to 150 to 200 horsepower."

Boat storage has grown by leaps and bounds as well. Nowadays the yard handles 100 to 150 boats each winter, most of them fiberglass. The Browns have an upper yard a short distance from the wharf where they haul about 100 boats for winter storage on a 14-ton hydraulic trailer—a recent acquisition—pulled by an old army weapons carrier. Other boats are stored in and around buildings at the yard.

For years after the boatyard began

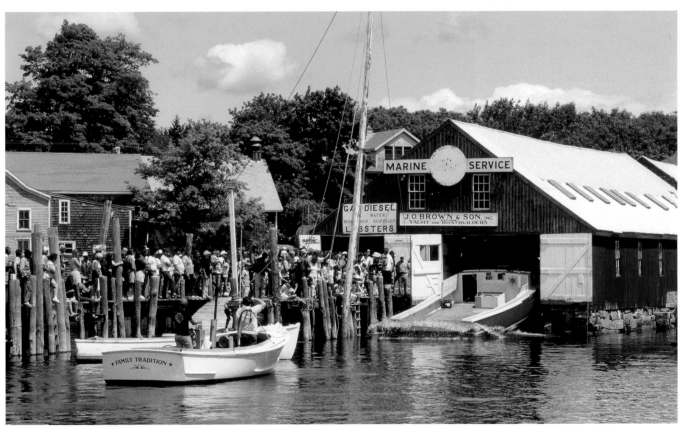

Another boat launched at J.O. Brown, 1990

the crew hauled all the boats with a windlass. Jim remembers it well. "We called it a crab. It usually took two men to haul a boat, but I've seen five or six men on it, if it was a heavy boat. The first thing I did when I got out of the service was put in a railway. We got the Travelift in '72 or'74. That made a big difference in time."

One day this past winter as Foy surveyed the array of boats in the upper yard, their blue plastic covers bright against the snow-covered field, his mind was on spring. "I hope they all don't want 'em by Memorial Day. In summer, by the time we get these boats overboard, it's time to haul 'em back. Plus set all the floats and moorings. And a lot of these cottages have boathouses and caretakers. We help them move their boats around and help move their moorings and floats. The main thing is to have something done when some body wants it. If they come down for two weeks' vacation and find their boat all ripped apart, they are not happy."

When he was little more than toddler, Foy would follow his father around the yard all summer long. He started working at the yard part time and during summer while he was in school, and full time after graduated in 1964. Labor has never been a serious problem at the Brown yard. Besides Foy, father Jim, brother Oz, young Foy—and two or three island boatbuilders—other family members round out the labor crew. Ivaloo Brown Patrick, Jim's sister, served as bookkeeper most of her life until 1988, when Foy's sister, Kim Alexander, took over the duty. In summer his daughter Karen helps in the yard. "She and young Foy can put varnish on better than I can." His brother's daughter Rachel also helps out in summer. Foy's wife Viola works at Brown's Coal Wharf, the restaurant the family opened in a build-

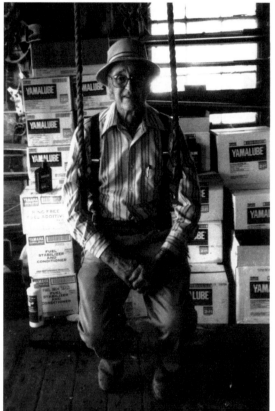

JIM BROWN 1917-2008

ing they bought a few years ago next to their property on the waterfront. The only restaurant on the island, it is open for dinner in the summer and seats 50.

The CENTERFOLD, a 34-foot lobsterboat with a 6-71 Detroit Diesel, which he built for himself and launched in 1982, is his chief source of pleasure and relaxation. He's won lobster boat races with her, and two years running he and young Foy took first in the trap-hauling contest, an exercise that begins with a race from the dock to boat to traps, hauling baiting and back. His best time: two and a half minutes. Foy regularly fishes about 100 traps as soon as he can get away from the shop in summer till dark. "You can be exhausted, but you get out there and just let all this stuff in your mind go. It's like starting fresh."

The first James O. Brown, known as Ozzie, was the son of a fisherman who died aboard a mackerel seiner off Prince Edward Island. When he was a young man, Ozzie went over to Camden and worked in the shop yard to learn the trade, then returned to the island and started the boatyard. At the urging of Dr. Charles G. Weld, forebear of the Pingree family, Ozzie rented a small fish house and began to build boats. It was in that fish house that the first North Haven Dinghies were built, having been designed and commissioned by Dr. Weld. Ozzie took apparent pleasure in his craft, and over a 15-year period built a planked-hull sailing model of a four-masted schooner, now housed in a glass case in the boat shop. When he died in 1927, the business fell to his son Foy W., Jim's father.

Jim started working at the yard summers during high school and went to work full time after he got though. He worked off-island just once. When the yard was slack one winter, he went to Massachusetts and worked for a house contractor. Soon after, his father died and Jim came home to take over. That was 1940. For the next 45 years or more, Jim ran the yard.

The only time work at J. O. Brown came to a halt in its century-long history was during World War II, when Jim was in the navy in the Pacific. All the men were away or at work in shipyards with defense contracts. But Carl Bunker, a longtime member of the yard crew, returned a year or so before the war ended and ran the shop along with Ivaloo, until Jim got home. He still puts in the 7 a.m. to 4 p.m. day with the rest of the crew, plus Saturdays, which is customary for family members.

Ask Jim if he favors a particular boat of all he's built and he names the one he built in 1952 for his own pleasure—the TWO SONS. "When I got out of the service we had the J. O. that we hauled passengers in, a 42-footer. If I wanted to go anywhere the boat was busy. I decided if I wanted to go somewhere, I'd build one for myself. Took me three years to get her overboard—nights, Saturdays, Sundays." She's a regular lobster-boat type, 36 feet long. Jim goes scalloping in her on winter weekends, "if we don't have too much to do," and on summer Sundays he likes to take the family to picnic on one of the islands.

Now into its second century, the family business spawned by Ozzie Brown has developed into a community-oriented service as well. "If someone on the island wants something," says Foy, "and they don't have a cent to their name, they can come down and get it anyway. If they want to come down and use the tools, they can. If they want to put their vehicle in here and work on it and we aren't using the space, they can. If somebody wants something in the middle of the night, we get it for them."

1992

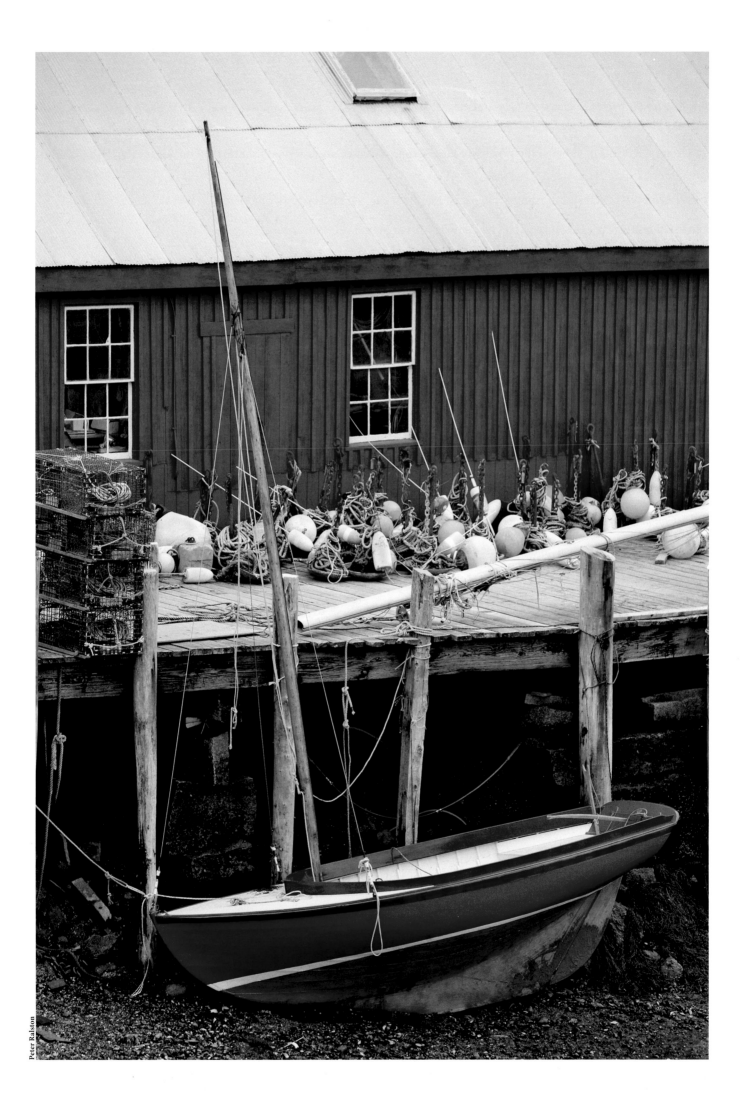

AUTHORS & CONTRIBUTORS

Jan Adkins has been associated with several magazines including *Air & Space, Smithsonian* and *WoodenBoat*. He also served for nine years as associate art director at *National Geographic*.

Ted Ames is a board member at the Penobscot East Resource Center, and a retired fisherman, who does research in historical fisheries ecology.

James Acheson is Professor of Anthropology and Marine science at the University of Maine.

Christopher Ayers is a freelance photographer who lives in Maine.

Lincoln Bedrosian is the senior editor at *National Fisherman* magazine.

Philip Booth published 10 collections of poetry. His work appeared in *The New Yorker, The Atlantic Monthly, The American Poetry Review* and *Poetry*. He spent childhood summers in Castine, where he and his wife had retired.

Louis W. Cabot is a photographer, serves on the Island Institute's Board of Trustees, and is a lifelong advocate for the sustainability of Maine's island communities.

Julie Canniff, PhD, launched the Maine Island Schools Project in 1985 and for six years, she collaborated with teachers and administrators to provide a range of professional development opportunities. She is currently an Assistant Professor in the Teacher Education Department, University of Southern Maine.

Nancy McLeod Carter is the vice president of knowledge management at the Island Institute.

Steve Cartwright, a freelance writer who lives in Waldoboro, is frequent contributor to *Island Journal* and the *Working Waterfront*.

Gary Comer was the founder of Lands' End and a founding member of the Island Institute.

Philip Conkling is president, and founder, of the Island Institute.

David Conover, a member of a well-known Maine sailing family, is a documentary filmmaker at Compass Light in Camden, Maine.

Shey Conover is senior programs director at the Island Institute.

Chris Crosman is an art historian, curator, educator and administrator with more than 25 years experience in American museums. He was director of the Farnsworth Art Museum from 1988 to 2005; currently, he is chief curator of the Crystal Bridges Museum of American Art in Bentonville, Ark.

Bill Curtsinger is a freelance photographer whose work has appeared in publications including *National Geographic, Life, Smithsonian, Outside, Time, Newsweek, Audubon* and *Natural History*. He has photographed seven books and his work is included in numerous textbooks, encyclopedia and aquarium displays.

Jane Day worked for *Harpar's Bazaar*, the *National Observer* newspaper, United Press International and served as the editor of the Camden Herald and managing editor of *WoodenBoat* magazine.

John de Visser is an award-winning photographer who lives in Cobourg, Ontario. His work has appeared in 65 books and in *Time, Life, Esquire, Arts Canada, Stern* and *Paris-Match*.

Steve Eayrs is a research scientist studying fish behavior and gear technology at the Gulf of Maine Research Institute.

Gillian Garratt-Read is marine programs coordinator at the Island Institute.

Cherie Galyean is a former Island Fellow and Island Institute staff member. She lives in Bar Harbor.

Nancy Griffin is the editor of *Gulf of Maine Times* and a freelance writer who lives in Thomaston.

Anne Hayden is an independent marine policy analyst based in Maine.

Muriel L. Hendrix, a freelance writer who lives in Phippsburg, is frequent contributor to *Island Journal* and the *Working Waterfront*.

Thomas Hoving is former director of the Metropolitan Museum of Art, former editor-in-chief of *Connoisseur* magazine, an author and also founded Hoving Associates, a museum-consulting firm.

Ruth Kermish-Allen is education director at the Island Institute.

Laura Kramar is fisheries marketing and branding coordinator at the Island Institute.

Bridget Leavitt is design coordinator at the Island Institute.

Frances Lefkowitz is a writer, editor and reviewer whose work has appeared in *Yankee, The San Francisco Chronicle, Body+Soul* and *Natural Health*. She divides her time between southern Maine and northern California.

Glen Libby is chairman of the Midcoast Fishermen's Association and president of the Midcoast Fishermen's Cooperative.

Kim Libby is a photographer who lives in Port Clyde.

Jennifer Litteral is the marine programs director at the Island Institute.

Carl Little took part in the 2004 Blaine House Conference on the Creative Economy as a panelist for a session titled "Landscape: How Our Cultural and Natural Resources Create Economic Leverage" moderated by Nick Spitzer, host of NPR's "American Routes."

Bill McGuinness is executive director of the Islesford Neighborhood House.

Chris Oughtred is a photographer and owns North Light Imaging Services in Chattanooga, Tenn.

Peter Ralston is executive vice president, and co-founder, of the Island Institute.

Siobhan Ryan, who lives on Swan's Island, served as an Island Fellow from 2005-2007, working with the Swan's Island Library, the Frenchboro Library and the Frenchboro Historical Society.

Alden Robinson was the Louis W. Cabot Fellow on Long Island from 2006 to 2008. He now lives in Portland, where he works as a web designer and musician and visits the island as often as possible.

Scott Sell was the William Bingham Fellow for Rural Education, working at the Frenchboro Elementary School, from 2006-2008. Following his fellowship, he has taught creative writing in a San Francisco youth arts program and will be working towards a master's degree in journalism at Columbia University this fall.

Arthur E. Spiess is the senior archeologist with the Maine Historic Preservation Commission.

Robert Snyder is vice president of programs at the Island Institute.

Joe Thomas is a photographer and interior designer who owns Just Eight Design, in Chattanooga, Tenn

David A. Tyler is publications director at the Island Institute.

Morgan Witham was Education and Library Fellow on Isle au Haut from 2007-2009.

James Wilson, PhD, is a professor of marine sciences and economics at the University of Maine.

PAGE 70: *Danny*, Daud Akhriev, 2007-2008, oil on linen, 53 by 48 inches.

PAGE 71: *Mainer*, Daud Akhriev, 2007, oil on linen, 27 by 39 inches.

PAGE 71: *Harbor Sunset*, Daud Akhriev, 2005-2009, oil on linen, 36 by 64 inches.

PAGE 72: *Melissa writing letters*, Daud Akhriev, 2005, pastel on paper, 19 by 22 inches.

PAGE 73: *Melissa with quilts*, Daud Akhriev, 2005, pastel on paper, 19 by 22 inches.

PAGE 74: *Mist*, Daud Akhriev, 2005, oil on linen, 23 by 60 inches.

PAGE 74: *After the Rain*, Daud Akhriev, 2008, oil on linen, 17 by 44 inches.

PAGE 75: *Clearing*, Daud Akhriev, 2007, oil on linen, 54 by 48 inches.

PAGE 76: *Frenchboro Harbor*, Daud Akhriev, 2006, oil cradled clay board, 18 by 36 inches.

PAGE 76: *Resting Boats*, Daud Akhriev, 2005, pastel, 10 by 22 inches.

PAGE 77: *After the Party*, Daud Akhriev, 2005, oil on linen, 13 by 22 inches.

PAGE 77: Daud Akhriev portrait by Joe Thomas.

PAGE 85: Excerpts from "A Climate of Change: A Preliminary Assessment of Fishermen's Observations on a Dynamic Fishery," 2008, published by the Island Institute.

PAGES 86-87: *Capturing the Commons: Devising Institutions to Manage the Maine Lobster Industry*, by James M. Acheson. Lebanon, NH: University Press of New England, 2003. "Atlantic Cod Structure on the Gulf of Maine," by Ted Ames, in Fisheries, Volume 29, Number 1, pages 10-29. Historical Maine Lobster Landings, Maine Department of Marine Resources.

PAGE 109: Excerpts from "A Fishery for the Future: How a Community of Fishermen is Collaborating to Preserve Their Heritage and Restore the Fishery," 2009, published by the Island Institute, with support from The Pew Environment Group.

PAGE 115: *A Guide to Bycatch Reduction in Tropical Shrimp-trawl Fisheries*, revised edition, by Steve Eayrs. Rome: Food and Agricultural Organization of the United Nations, 2006.

PAGE 115: "Modified diamond-mesh trawls off square mesh advantages," by K. Freeman, K. Maine: Journal Publications, Volume 73, Number 4, 1992.

PAGE 128-129: Newfoundland photographs courtesy of John de Visser. Photograph on page 128 courtesy of the Canadian Museum of Contemporary Photography, Ottawa. Both photographs originally published in *This Rock Within the Sea: A Heritage Lost*, by Farley Mowat and John de Visser. Boston: Atlantic Monthly Press, Little Brown & Company, 1968.

BACK COVER: "Chart 1203 Penobscot Bay and Approaches," by Philip Booth, used by permission of the estate of Philip Booth.